NOTHING

HAPPENED

NOTHING HAPPENED

A History

Susan A. Crane

STANFORD UNIVERSITY PRESS
Stanford, California

STANFORD UNIVERSITY PRESS
Stanford, California

Printed in the United States of America on acid-free, archival-quality paper

ISBN 9781503640115

First paperback printing, 2024

The Library of Congress has cataloged the hardcover edition as follows:
Names: Crane, Susan A., author.
Title: Nothing happened : a history / Susan A. Crane.
Description: Stanford, California : Stanford University Press, [2020] |
 Includes bibliographical references and index.
Identifiers: LCCN 2020013808 (print) | LCCN 2020013809 (ebook) |
 ISBN 9781503613478 (cloth) | ISBN 9781503614055 (epub)
Subjects: LCSH: History—Philosophy. | Collective memory.
Classification: LCC D16.9 .C73 2020 (print) | LCC D16.9 (ebook) |
 DDC 901—dc23
LC record available at https://lccn.loc.gov/2020013808
LC ebook record available at https://lccn.loc.gov/2020013809

Cover design: Rob Ehle

Cover photos: Historical marker altered from photo (Brian Stansbury) of a
plaque commemorating the Trail of Tears, Monteagle, TN, superimposed on
photo of a country road (Paul Berzinn). Both via Wikimedia Commons.

Text design: Kevin Barrett Kane

Typeset at Stanford University Press in 11/15 Mercury Text G1

A mind lively and at ease can do with seeing nothing,
and can see nothing that does not answer.

JANE AUSTEN, *EMMA*

CONTENTS

NOTHING

HAPPENED

EPISODES
IN A HISTORY
OF NOTHING

LUIGI TRASTULLI WAS KILLED on March 17, 1949. A steelworker in Terni, Italy, Trastulli was 21 years old when he took part in a rally outside his workplace. Workers poured into the streets to protest against the Italian government signing on to the North Atlantic Treaty, which was creating NATO. Police were called in to control what they termed an unauthorized march.

Violence erupted: Official reports suggest that the protesters started the violence by brandishing sticks and handmade tin signs that proved to be effective weapons; the protesters claimed that they were defending themselves against police aggression. Shots were fired. Trastulli, witnesses remembered, was trying to get away by climbing a wall. He didn't deserve to be shot; he didn't deserve to die. The only victim of lethal police action that day, Trastulli became a political martyr.

What happened next only added pain to the suffering: No one was held accountable for his death. No charges were brought, no trial was held, and no individual or agency ever publicly accepted responsibility. Nor did Trastulli's fellow workers protest, strike, or seek vengeance. Instead, outrage smoldered in Terni for decades.

The communities of Terni enshrined Trastulli's name in memory, not only because of his tragic death and personal connections to local people but also because of the way his killing remained an open wound. The significance of Trastulli's death grew in local memory such that more than thirty years later, when the historian Alessandro Portelli conducted interviews with Terni residents, they recalled not only Trastulli and their frustration with injustice following his death but also a host of related grievances, symbols, and myths that had formed around the incident.

Their memories about when the death happened were also confused. Was Trastulli killed during the anti-NATO strike or during the even more significant one that followed in 1953, when thousands of workers walked out following a massive layoff? Strikes became a part of Italian life in the twentieth century; memories of them might have blurred together. And given that Trastulli's death occurred only four years after the end of World War II, Italian memories of partisan warfare were recent and vivid. Gun violence in war and police action in peacetime might have blended to form a context that made sense to people thirty years later. What was most important to them, what they vividly remembered, was that after Luigi Trastulli was killed, "nothing happened."

In his 1981 article "The Death of Luigi Trastulli," Portelli discusses the memories held by participants, witnesses, and succeeding generations in Terni. As depicted in Portelli's influential analysis, the death of Luigi Trastulli is a case study in the creation and impact of collective memories that reside outside the official historical record. In one interview Portelli registers the powerful emotions released by the memories of injustice following Trastulli's death.

PORTELLI: What happened afterwards?

CALFIERO CANALI: Nothing! Nothing happened. Nothing happened because—I don't know why. . . . We didn't do anything because—of course, in those days, what could you do? They'd have blown us like bagpipes, if we'd attempted anything. And yet, there was so much bitterness inside your body, so much hatred!

[Portelli's reportage continues] The anger with which, thirty years later, workers still repeat that "Nothing was done after Trastulli's death" (Canali repeats it three times, pounding the table with his fist) is symmetrical to the complacent tone of the official sources announcing that "in the evening, the town was calm" (*Il Messaggero*) and that "order was restored and not further disturbed" (the district attorney).[1]

Those who witnessed or remembered hearing about this incident would tell Portelli that after Trastulli's death, "nothing happened." How was that possible? Obviously, life went on for everyone else and they remembered that nothing happened, so they were remembering not "nothing" but something they called "nothing happened." What was that something? Why was it called "nothing"?

Portelli's initial assessment is that the failure of accountability was "symmetrical"—that is, proportionate—to the "complacent" media representation of official statements. The police and press jointly ignored workers' demands and recorded only successful suppression of the protest. "Nothing happened" after the protest was shut down, which is evident because officials claimed that the site of the protest became quiet: "Order was restored and not further disturbed."

But as Portelli heard in testimony offered decades later, that same calm was remembered as incommensurate to the crime of killing a young protester, inappropriate as a response, and inadequate to their demands for justice. In other words, both sides agreed that

"nothing happened," and yet their understanding of that nothing was not identical.

Memories of silence and failures to act lingered among the communities of Terni workers. When they remembered this particular event of the past, a sense of injustice remained—and in this way, the death of Luigi Trastulli was not over. The man's life had ended, but the event continued to live on in memories that resisted the official version of the story reported in the papers. Those memories resonated around a sense that "nothing happened."

André Gide remarked in his 1899 *Le Prométhée mal enchaîné* (Prometheus Misbound; 1953) that a man writes a book not so much because he has an idea to express but to excuse himself for having had it.[2] The book you are reading is written by a historian who may be excused for noticing that Nothing happened and for realizing that this offers a way to understand the very nature of historical consciousness—that is, the way that we become aware that the past is somehow distant from but intimately connected to the present. Nothing, it turns out, is always Something, and in this book it's always Something about history.

§ THINKING ABOUT NOTHING AS A WAY OF DOING HISTORY

The past is what happened. History is what we remember and write about the past. Nothing could be simpler—or more complex. How could the past be Nothing, and how could a history be written about it? It's going to take some (possibly considerable) mental adjustment before you can see Nothing the way I have come to think of it, with a capital N. But to transform Nothing into a legitimate historical subject, all we have to do is see it that way. It's actually been there all along, in plain sight. It's just that no one valued it as having a history worth telling.

We can thank the pioneering scientist Louis Pasteur for this insightful formulation of serendipity: "Chance favors the prepared mind." But do we always remember the person who coined a cliché?

Or does the cliché persist regardless, even when we know Nothing else about it? The fact that I'm asking these questions already offers a clue that in this book I am always going to look behind the curtain, ask how something got there, wonder why Something came to be Nothing.

In the case of the serendipity that has resulted in this book about Nothing, I was preparing to teach a class on historical research methods to history majors at the University of Arizona. I asked my colleague Jadwiga Pieper-Mooney, a specialist in Chilean history and a practitioner of oral history, to recommend an introduction to her methodology. She directed me to Portelli's now classic article, where I found the story of Luigi Trastulli.

I would never have guessed that choosing a text for class would result in this book. Inspiration, like chance, happens randomly, even among those of us trained to practice historical scholarship ethically, responsibly, and as objectively as possible. Portelli, Jadwiga, and I share a common interest in studying historical memory, but Portelli would probably have been quite surprised that I took Nothing away from his work.

And that is how histories get going—not just by filling in the familiar outlines of nations and events but by browsing the library shelves or delving into archives, hearing a story, wondering about a related issue, and being inspired to ask questions about how this all started and what it has meant. As a historian, I've always been less interested in "what happened when" than in how people have chosen to remember the past. So too was Portelli, who conducted interviews with contemporaries to recover their understandings of a historical event. He was much more concerned with the ways people remembered and misremembered Trastulli's death and what it meant to them than he was with solving a murder case. Nothing could have been further from his mind. But it wasn't far from theirs.

Looking at Nothing in particular is a good way for the historian to think through a central problem: What does it mean to think about the past? I realize this sounds unusual. Most people don't bother to

think about the past at all. But they may have been looking at Nothing *and* thinking about the past without realizing it.

If I assert that there is, in fact, "Nothing to see," I immediately risk misunderstanding. That is, after all, what authorities tell you when they want you to keep moving past the scene of a crime: "Nothing to see here. Move along." If there is nothing to see here, why look? Because we suspect that there is indeed something to see, we just can't quite make it out. The word *nothing* encompasses a vast realm of meanings and objects that have been labeled—for many reasons, all of which deserve investigation—unimportant. And yet they continue to draw attention.

Many kinds of viewers, writers, and fans of Nothing have been looking at and writing about Nothing, including those interested in the mathematics of zero, quantum physics, existentialism, Buddhism, boredom, and Jerry Seinfeld, who famously wanted to "make a show about nothing." There are wonderful books, studies, popular culture (movies, television, blogs), and art about all of those kinds of Nothing. There is far more Nothing out there than any single book could encompass, though others have tried.

I will look instead at the Nothing invoked whenever people have looked at the past and remembered that "nothing happened" but also when they remember that "nothing is the way it was" or "nothing has changed." I find it fascinating that the same word is used for three quite distinct forms of historical consciousness. What is it about Nothing that allows it to be repeated in such different ways?

Some people are fond of saying that history repeats itself. But as any working historian knows, history doesn't repeat itself. It just feels that way sometimes, so people repeat themselves. They may be worried that something bad that happened in the past may be happening again. People might also say this when they are pleased to note a similarity between something happening now and something that happened in the past, which creates a positive sense of connection to the past. All these expressions of historical consciousness

are familiar, everyday occurrences—so ordinary that they happen all the time, repeatedly.

Whether they think the repetition is good or bad, people call it history to highlight its significance in the present. Historians, on the other hand, are attuned to the infinite scope of the past and are aware that the flow of the past into the present is constantly being tracked through the channels of current understanding. In other words, as the ancient Greek philosopher Heraclitus famously pronounced, you can't step into the same river twice, even—or especially—if Nothing has happened since the last time you did it.

I'm far from the first scholar to remember how Heraclitus formulated this principle. You can't put your foot into the same river twice, he noted, even when you return to the exact same location, because although the river may still be full of water, it's not the same water that was there before. The past is like that. It's a moving stream of events that we experience in the present as the appearance of either change or constancy. No matter how we see it, we are either in the river or looking at it, and we might be choosing to dip our toes in.

"Nothing" is also like that. Nothing is always the same: It's Nothing, and Nothing can change that—but sometimes it doesn't feel that way, especially when we are noticing that Nothing is going on and that's just boring, or Nothing has changed when something should have and that's just unacceptable. And if "Nothing is the way it was," then everything has changed, so how is Nothing always the same? How can "Nothing is the way it was" and "Nothing has changed" be true at the same time? This isn't just some funny little grammatical oddity of the notoriously quirky English language. It turns out that looking at Nothing in particular can be a good way of thinking about the meaning of the past, of changes good and bad, of what has happened and what could or maybe should happen. Thinking about Nothing can be a way of doing history.

To look at the past and see Nothing is to be aware of difference and change, because Nothing is the way it was. This is a cliché because it

renders the ordinary sensation of change over time in a commonsensical way: There's the way things were and there's the way things are now. They aren't the same. If Nothing is the way it was, then we can perceive difference between past and present, and anticipate a future in which the present won't look like the way it was either.

Without a perception of the need to account for change over time, history would be unnecessary; we humans would simply persist and there would be no need to interpret and explain a past. Instead, however, we have Nothing to explain, because Nothing is the way it was, and hence we need history to help us understand the past that has happened.

But if Nothing *is* the way it *was*, then, bizarrely, an oxymoron is buried in the baseline of modern historical consciousness. Nothing both is and was, which would make Nothing seem to be, in fact, The Same Thing rather than No-Thing. "Nothing is the way it was" offers an incredibly malleable metaphor for history, and not just for the apparently obvious reasons having to do with time and change. Nothing is worth pondering from the perspective of historical consciousness precisely because of its static nature: Everything changes, except Nothing. Nothing remains the same—that is, Nothing remains Nothing—and it turns out that history is a response to both change over time and to the continuum of Nothing remaining the same.

Nothing is, Nothing was, and Nothing is the way it was. Nothing doesn't change, it remains Nothing. And what a resonant Nothing it is. Is it only a void, emptiness, zero? Nonexistence? Or is it also a vast expanse of open sky or land? Isn't Nothing also everything that should have happened but didn't? Once you start seeing Nothing as a historical object, you realize you simply cannot take Nothing for granted.

Some thinkers and artists have pondered Nothing and concluded that it defies understanding; worse, that to continue to ponder is to court disaster. Art historian Francis McKee warns of the dangers about to be embarked on—and how we go there anyway.

Nothing is impossible. Or, put another way, "nothing" is a concept so fraught with paradox and contradictions that it defeats definition. . . . There is now a foolish and brave pantheon of writers, philosophers and scientists who have dedicated themselves to the elaboration of the subject.[3]

Fascinating, even alluring, Nothing resists definition but seduces thought. This is Nothing perceived as aesthetic, moral, or scientific conundrum: the void, the beyond, the future, the unknown, the ether. When it is understood, it will no longer be Nothing; it will acquire a firmer identity within a discipline or epistemology. In a Buddhist sensibility, Nothing raises positive valences of Nirvana achieved, world and self transcended. "Nothing is certain": Nothing certainly is Nothing, but Nothing is certain only when it has been redefined and is no longer "nothing."

"Nothing" is delightfully ambiguous and deviously precise, a word to be used when no other word suffices. Teenagers clearly understand this. Even when they are sounding their most frustratingly vague, when they utter, "I. Can't. Even." they are using an incomplete verb phrase to express extreme emotion, deliberately not giving voice (words) to the emotions. (Credit for this insight goes to my formerly teenage daughter Kimberly, an invaluable source of so much Nothing; and it's probably no longer actively in use, given that her mom is the one reporting it.) By saying nothing, they are expressing exactly how they feel; they are not inarticulate but rather hyperaware of the inadequacy of language. They are saying Nothing as aposiopesis, which is the English professor's way of saying that they are breaking off in the middle of a thought deliberately, unwilling or unable to continue.

When a child says, "Nothing happened," they may be insisting on innocence (and parents will know better; see Episode 1). "Nothing" might variously refer to innocence, failures to occur, boredom, or long stretches of time in which noteworthy events were scarce.

(Which is why, as we all "know," during the Dark Ages, nothing happened in Western Europe. More about that in Episode 3.)

When there is Nothing to do, time moves more slowly and tedium ensues and it all feels like too much Nothing. All these experiences qualify as historical events if we define a historical event as something that happened in the past and has meaning in the present. It doesn't have to be earth-shattering to be considered historical. Ask any child who wishes they hadn't done whatever minor thing they did to get in trouble with the parent: It happened. Nothing happens all the time, *in* time, and so it is remembered as part of the past.

When something should have happened but instead Nothing happened, as Portelli found among the Terni workers, the abeyance of justice is perceived as a failure of vast proportions. "Nothing happened to the guys who shot him" means that justice was not served. But in reality, it's not true that "nothing happened" to them: The presumed perpetrators experienced quite a lot of life in the years that followed, just not jail time, and the survivors experienced a delayed and deferred future in which what was supposed to happen didn't, over and over and always.

The history of injustice is long and painfully familiar to its victims, who are used to enduring frustration and have suffered the consequences. Oral history subjects such as those interviewed by Portelli have sometimes internalized the way justice's neglect of their needs and experiences relegates them to the sidelines of history. My colleague Fran Leeper Buss has noted over decades of oral history interviews that her subjects, many of whom have suffered physical and emotional abuse as well as injustice, will typically tell her that they don't understand why she wants to talk to them. They feel that their lives are too ordinary to merit particular attention, that their lives are not historically significant. "Why would you want to talk to *me*? I'm not important," they tell her. They think nothing happened in their lives that is worth the attention of scholars, when

it is precisely the fact that Nothing happened, that injustice persists, that has drawn historians to them.[4]

We speak of Nothing to express the extent of the absence, vast as empty spaces and timeless as boredom. As my dad would have said, "There's a whole lot of nuthin' out there." Coming from him, this usually meant that whatever he was looking at was uninteresting or that his idea of what was interesting wasn't to be found anywhere near where he was. The scope of Nothing is encyclopedic, global. The quantity of Nothing is so vast that once it appears under the historian's nose, it's rather difficult not to notice—and impossible not to wonder why it seemed invisible before.

History buffs as well as the losers of many types of conflicts are fond of saying, "History is written by the winners," implying that to the victors go the spoils of getting to assess and assign meaning, or value, to the past. Typically this also implies that self-congratulatory bias will infect the history that gets told, taught, and remembered, suppressing other interpretations in favor of those who hold power. But it also suggests that what's worthy gets written up; what's ordinary or typical is unremarkable and does not. In the end, if you are done with a history, there is nothing left to say. But we keep writing histories, which means that histories are written because there *is* "Nothing" left to say, and so histories of Nothing are always still ready to be written.

Historians have not entirely neglected Nothing, but scholars have not yet turned their attention to histories of Nothing. When historians read, we pay attention to the language used in our sources, the words and phrases chosen by the author to express meanings, meanings that perhaps even exceed the authors' intentions. When we read old manuscripts or books, we give them careful consideration as material records of the past. But although we may have sneezed when taking a book off a shelf or old papers out of a folder, we haven't typically considered the dust on the archival material as anything to write about. Nothing drew our attention to it; it was just there, just matter, not "what matters."

Historians—in particular the French writer Jules Michelet in the nineteenth century and the British scholar Carolyn Steedman in the twentieth—have described the realization that they had been inhaling the past while they were working in archives. Michelet was moved by a sense that the dead came back to life as "I breathed their dust." Steedman realized, with some concern, that it wasn't just the musty dust of the archive that was making her feverish, when she felt ill while conducting research; it was a potentially lethal pathogen. The dust she was breathing actually came from handmade leather bindings produced more than 200 years earlier using a tanning process that could well transmit meningitis. In her book *Dust: The Archive and Cultural History* (2001), Steedman considers dust as real historical residue. She riffs on how historians have been guilty of inhaling, not merely reading, as they attempt to reveal everything about the past.

> In the practices of history and of modern autobiographical narration, there is the assumption that *nothing goes away*; that the past has deposited all of its traces, somewhere, somehow (though they may be, in particular instances, difficult to retrieve).[5]

Historians pride themselves on getting as close as possible to knowing how and why the past happened as it did. We know that we will never know the entirety of the past, but we also dare to hope that "nothing goes away" and that if we could only find them, new discoveries would be possible. We are willing to devote much time and effort into recovering the most obscure bits and pieces that no one else has recently seen, those traces of the past that bear analysis, and polishing them into the historical nuggets that intrigue modern readers and students. Steedman contemplates Michelet's earlier experience with breathing in the dust of his ancestors, particularly those who participated in the French Revolution. Both scholars found that when Nothing goes away, the traces of it that you can inhale have the power to move you.

Dust is one of those traces of the past that, like Nothing, is usually seen as something to get rid of or ignore. Steedman, like me, like Portelli, is telling her own story as a working historian thinking about memory, which is something the reading public generally hasn't been demanding to hear. They expect to be taught about how the past really happened and aren't particularly concerned with dust unless it makes them sneeze or gets things dirty. What if, instead, we remembered how we thought that Nothing happened and discovered that Nothing was happening all along? How would we dust off our historical consciousness and breathe in Nothing?

I now see Nothing everywhere. I find it in sources I read years ago and have actively referred to continually, in texts I read now because I am looking for Nothing, and in books I reread and discover that Nothing was there all along, such as Jane Austen's *Emma*, which provided the epigraph to this book.[6]

In the age of internet search engines, searching for a phrase like "nothing happened" in Google Books can produce wonderfully serendipitous results, certainly more results than any one scholar should try to handle. In response to Google's algorithms and my previous searches, I was offered sources I might otherwise never have seen. I may recognize an author or be reminded about a title I had already read before I was looking for Nothing. Historians always make selections of their sources, choosing what seems most relevant and important from among the almost infinite set of available material. Whether working in an archive, at a library, or on the internet, we make choices about which sources we will work with. During this project, I have been frequently delighted by what Google Books has scanned and offered when searched. But how much of my "finding" Nothing happening was shaped by my already having seen it or read it and not paid any attention to it? Some combination of archive, algorithm, advertising dollars, serendipity, and the dusting off of my own history of reading with attention to historical consciousness has recovered all this Nothing.

§ EPISODES: THIS IS THE ONE ABOUT NOTHING

My goal is to illuminate the utterly ordinary ways we refer to the past as Nothing. I have come to believe that this history of Nothing is the natural result of a career spent thinking about historical consciousness, whether in the archives, in the classroom, or in my own reading and internet-searching mind. I went looking for histories in which Nothing happened. Sometimes I found them right in front of me, already on my bookshelves, amid the hundred-plus books I currently have checked out from the University of Arizona's library and dozens more I felt I needed to own.

How does a history of Nothing emerge from a recognition that Nothing always means Something? I looked at books with the word *nothing* in the title. I looked for "nothing happened" and "nothing has changed" as library catalog keyword searches. This produced way too much Nothing, so I had to narrow my focus. Even after I limited my searching to texts that dealt with historical consciousness in some form, I still found plenty of Nothing. And my colleagues, friends, and family have generously shared more, which I'm delighted to acknowledge as I proceed, because they helped me see Nothing.

I am exploring three "episodes" in the experience of historical consciousness, rather than chronicling a particular historical event, because Nothing breaches the levees of classical narrative frameworks. History has been told in terms of epochs, events, and dates, but it has left out Nothing—ironically, that makes it sound as though history has been all-encompassing, when it never could be. Instead, by paying close attention to Nothing, we can explore some of what history has left out, what wasn't considered important— what was "incidental," which is part of the definition of "episode." Most of the examples I have chosen occurred in the twentieth century, and although some of the historical contexts in which Nothing appears are undeniably violent and of world-historical importance (World Wars I and II; dictatorship in Chile; guerilla warfare in Peru), others may seem benign. The very ordinariness of Nothing as a historical object makes it a resonant choice. Each

of the episodes depicts Nothings from an ongoing series about remembering the past.

In the first episode, "Studying How Nothing Happens," I discuss how Nothing is happening in the present. By highlighting this apparently nondescript moment, we can consider what people are actually doing when they say, "Nothing is happening." This is how a history of Nothing *happens*, in the best tradition of modern historical scholarship, with attention to silences, absences, and agency in the past.

Episode 1 explores how doing Nothing and knowing Nothing are intimately related. Inactivity and human ignorance actually have a common object: Nothing. Historians have started to pay attention to agnotology (the study of ignorance) by looking at the impact of neglected knowledge, and I consider how their work offers a new field of Nothing to know. Paying attention to who is doing Nothing and who is knowing Nothing at any given moment in the past can shed light on structures of power and knowledge. These are not the usual suspects of history, but only because we haven't cared enough to know Nothing.

Whereas in Episode 1 I have fun with puns in the present when Nothing is happening, in the second episode I shift my attention to the sometimes painful, sometimes nostalgic experience of remembering Nothing. In Episode 2, "Nothing Is the Way It Was," I consider both the allure of ruins in a landscape and the grief that accompanies a sense of loss when ruins are all that remain.

When the past is seen to be insurmountably distant from someone who cares in the present, as though "there is Nothing left" of the places or communities that once thrived, looking back to earlier times or reviving memories can be painful. This is particularly the case even when—or perhaps especially when—those who remember "the way it was" have lived through the transformation that produced the loss. Wars are often the cause of ruined landscapes and of grief. When do we find ruins beautiful? And when do the ruins only cause pain?

In Episode 2 visual culture plays a significant role. Photographs of wartime and Cold War ruins, postcards from war-torn Europe, and literary heroines who paint such postcards for a living document the utterly transformative experience of understanding oneself to be living through historical change. The East German photographer Eva Mahn created images of her friends posing next to ruined walls in her homeland immediately before and after the collapse of the Berlin Wall in 1989. Her photography collection *Nichts ist mehr wie es war* (Nothing Is the Way It Was) explores the meaning of change over time and the way in which the fall of the Berlin Wall was as much a personal trauma as it was a world historical event. I watched the Berlin Wall become a ruin and then disappear while I was living on the other side of the wall from Mahn in 1989–1990. At the same time, I saw postcards for sale that depicted Berlin and other German cities in the aftermath of wartime bombing, often paired with images that contrasted the ruins to either the prewar or Cold War urban landscape in the same location. Then-and-now postcards show how Nothing is left, and yet there is something to see, ruins in a landscape.

Representation of ruins for aesthetic pleasure is Nothing new. But even if a "cult of ruins" or "ruinophilia" has resonated in the Western art world for hundreds of years, there are also always people who consider ruins to be eyesores that require demolition rather than merit preservation. If ruins remind viewers of how nothing is the way it was, is that sufficient reason to keep some ruins around? Or would we prefer not to be reminded of the changes wrought by war and only those (much more scenic) changes wrought by nature and time? Are some ruins more postcard-worthy than others? In Episode 2 I explore postcards from both world wars as a means of sharing ruin imagery visually.

Ruinenlust (fascination with ruins) resonates with the activities of self-designated urban explorers in the late twentieth and early twenty-first centuries. Urban explorers (UrbExers) pride themselves

on gaining access to restricted urban and rural ruin sites and then photographing the remains in distinctively eerie and beautiful ways. By exploring alongside the UrbExer who wants to tell us how to create ideal, idealized ruins photographs, we see how the allure of "Nothing is the way it was" is expressed visually.

UrbExers believe in "taking nothing but pictures and leaving nothing but footprints," just like environmentalists and campers do. Photography is intrinsic to their experience. Guidebooks offer instruction for fellow UrbExers to help them get the desired shots, which ends up with them making images designed to replicate previous explorers' experiences. I explore how imitative photography has contributed to the phenomenon of "ruin porn," which has implications for the politics of urban decay and renewal. When it comes to exploring abandoned spaces: Nothing ventured, Nothing gained.

If the past is full of vast quantities of time and events in which Nothing happened—and we know this because we've been told what was important to remember and what was not—then the past is as full of Nothing as the universe is full of Nothing. In Episode 3, "Nothing Happened," I begin by reviewing instances where historians themselves have designated moments when, apparently, Nothing happened in the past. These moments sometimes register as humorous or scandalous, but too often they are also instances of outrageous, tragic injustice.

For instance, Nothing happened in 1897. If you go online, you can purchase your own historical landmark sign that will attest to this "fact." No one seems to know who created the first faux-historical marker, but versions of it have appeared around the world over the past thirty years. I trace appearances of the sign outdoors as well as in print, tracking down patterns in its ubiquitous presence. This sign sums up a century of historical preservation campaigns with a knowing wink, raising the question, What's worth remembering when Nothing is worthy of a historical marker? and asserting that there is indeed Nothing to see here.

If Nothing happened all over the place, it should come as no surprise that Nothing happened all the time in the past too. Nothing happened every time the world didn't come to an end as predicted—for which we should all be grateful. Whether it was a failure of mutually assured destruction to break out during the Cold War or the repeated failure of apocalyptic movements throughout the ages, we can all be glad that Nothing happened on the day when the world was supposed to end. I consider the history of nonevents, where expectation of the "end of times" has played a foundational role in modern religions as well as historical consciousness. I focus on the problem of aftermath: What happens when prophecy fails? How do people come to terms with the failure of their expectations? I explore how millenarianism and experiences of cognitive dissonance frame an understanding of how, when Nothing happened, Nothing had to be done.

Expectations for justice that go unmet, like those articulated by the people of Terni after the death of Luigi Trastulli, create another enormous category of aftermath nonevents. What if justice demanded that, when Nothing happened, something had to be done? The dire circumstances of those for whom justice is passionately desired but is instead deferred or delayed because nothing happened to the perpetrators, makes it seem that the surviving victims are still powerless in the face of their persecutors. For them, Nothing has changed. And yet they can demand to be heard and seek alternative venues for their cries for justice.

The history of injustice is painfully and obviously vast. In the third and final episode, I look at poems, photographs, and films that offer testimonies to failures of justice and mourn because Nothing has changed. Poems themselves may not be able to instigate desired change, because, as W. H. Auden wrote, "Poetry makes nothing happen." But poetry does express particularly well the frustration of Nothing changing when injustices remain entrenched. I discuss poems written in Peru, Poland, and the United States that shed light on how Nothing happened in the aftermath of atrocities and take a

look at an extraordinary film by Patricio Guzmán, *Nostalgia for the Light* (2010), which uses poetry and imagery to illuminate memories of injustices haunting Chile today as a result of atrocities committed under the Pinochet dictatorship.

Nothing is always happening, here and now, in the past and in the universe, whose infinities defy ordinary human comprehension and are filled with, apparently, nothing. Lack of retribution for the perpetrators of the coup, lack of victims' remains to be found, lack of acknowledgment that the crimes even occurred—officials acting as though Nothing happened—have created huge empty spaces in memory. But memory remains, insisting on what the families of the disappeared know: that when it comes to accountability, Nothing has changed.

Nothing is the way it was.

<div style="text-align:center">Nothing has changed.</div>

<div style="text-align:center">Nothing happened.</div>

These statements are bookends to a modern historical consciousness, the awareness that now is different from then, and yet somehow the two are related or connected. Either we are experiencing radical change at a rate that defies comprehension, or we are temporarily feeling safe in the stasis of the present and can afford to look at the past without rancor. Either we are feeling nostalgic, or we are just glad to have moved on. Either we have agonized over the fact that Nothing has changed, or we have reconciled ourselves to the idea. Either way, Nothing happened and we are remembering that.

History is not the same thing as "the past." The past is everything that has happened, whether it was recorded or forgotten, whether it lasted for eons or instants. We will never know all of it. History, on the other hand, happens in the present—it's happening now, whether it's me writing this or you reading it. History is what happens when we remember, study, and write about it. It is an ethical

practice founded on research and interpretation that is undertaken whenever we choose to know something about the past, whenever historical consciousness has been aroused and we remember or learn what we want to know.

The narratives that historians craft guide us toward understanding the past. My pun-filled reading of texts and images provides a map of the void that has been present all along but overlooked or ignored. Now that we're aware of both the void and the avoidance, we can see that there's Nothing to be afraid of. As both you and the police already knew, there's genuinely Nothing to see here.

In the end, there is always Nothing left to say when historians write histories of Nothing. This is what happens when I am thinking about Nothing:

<div align="right">Nothing gets done.</div>

STUDYING HOW NOTHING HAPPENS

I STOPPED COUNTING THE NUMBER of times people of a certain age asked me whether my Nothing book was going to be about *Seinfeld* (originally broadcast 1989–1998). The show had been running for four seasons before its eponymous co-creator, Jerry Seinfeld, sat himself down opposite George Costanza (Jason Alexander) in a New York diner and listened to George pitch an idea for a "show about nothing" ("The Pitch," 1992). Seinfeld later explained that this really wasn't the origin story of the show, but it sounded so real that people wanted to believe it was. Collective memories form around myths just like they do around facts.

The idea of Nothing fills many gaps. If we wish to be open-minded and inquiring—cautious in an informed way—we say that we "assume Nothing." When we appreciate things or wish to be accommodating, we say that we "take Nothing for granted." This is all

fortuitous for an inquiry into how Nothing happens because we are clearly open to the possibility that Nothing is worth considering. I will never again take Nothing for granted. Because Nothing is actually happening all the time, it should not be surprising that it has also been remembered as "Nothing happened." Adding Nothing to the past—we don't have to add anything, it was there all along!—means that Nothing can be something that historians study. Yes, I'm writing a history about Nothing: That's the pitch.

In this episode I explore the ways in which "how Nothing happens" has become an object of inquiry, the subject of "-ologies." I begin by practicing "gerundology" (my own name for the study of the -*ing* forms of verbal nouns) using grammatical nerdiness to explore how the past is being experienced in the present. Knowing Nothing is one state of affairs; doing Nothing is another; and both are happening right now. Paying attention to the use of -*ing* verbal nouns isn't just a matter for English teachers: It helps us see how an activity called remembering brings the past into the present and historical consciousness to the front of our brains.

Another field of inquiry that will be good for Nothing was recently christened *agnotology*—the study of ignorance. Agnotologists are a particular type of historian; they delve into the consequences of knowing Nothing. The outcomes are usually not good, but there are surprises here too. Moving from ignorance to wisdom typically earns approbation for the positive benefits of education and enlightenment. Doing Nothing, on the other hand, is too easily perceived as an impediment to this progress. Ignorance about how Nothing happens has helped to hide it. Instead, I have been delighted by studying how Nothing is happening in unexpected and diverse realms—in music, for the good of science and medicine, in the slow growth of a forest, all of which I discuss later—and by discovering how varied the experience and memory of "Nothing is happening" can be.

Aesthetically minded appreciators of Nothing in the twentieth century created poetry, film, theater, and conceptual art that turned

"Nothing happening" into a high cultural affair. White-on-white paintings, sculptures composed of boxes of air, film of a person sleeping—these forms of art conceptualize Nothing in space and time. Viewers then contemplate whether they know Nothing about art or immerse themselves in the artist's creations of Nothing.

Precisely when we're most certain that Nothing was happening, we may draw a blank when trying to recall what, exactly, was going on. Drawing blanks is a sign of knowing Nothing. When we don't want to admit to ignorance or must feign ignorance or even have simply forgotten something we knew, we may be drawing a blank. Another recently opened field of study, amnesiology, the study of forgetting, has been proposed to help us study those blanks, if not necessarily to solve the problem of how conceptual art works.

New fields of study are responses to changes in perception. Once we start seeing Nothing as a historical object, we have a new way to understand remembering and forgetting and new questions to ask about the past. For example, how did early modern mapmakers represent lands and oceans unknown or not yet explored? If the mapmakers belonged to societies that wanted to make claims on the land, they drew empty spaces on the map and labeled them *terra nullius*, literally "no man's land" or "land belonging to no one." By blithely erasing the presence of real people in places they desired to take possession of, European explorers and colonizers acted as though Nothing was there until "civilization" arrived. Arid lands and vast oceans have been represented as though they are empty too, reflecting eons of ignorance about the natural world. The globe itself presents a vast realm for agnotologists to decipher and reveal the ignorance transmitted by travelers and colonizers.

Early mapmakers drew decorations over the blank spaces whose actual physical properties or inhabitants they knew Nothing about. Give children writing implements and they will draw, whether shapes or words—they will not draw blanks but rather fill them. Even if the paper, or the sidewalk, already has something on it, they will

add more, mapping their imagination onto the space. In an important sense, all the world is a blank page awaiting inscription: blank at first and perhaps purposefully blank later, because Nothing has been written on it yet. This is how meanings get made.

Historians always pay attention to words on pages in historical documents, but they should also pay attention to blank pages. The enticing presence of blank pages—waiting to be filled because no one has yet written in the specially bound book or the form has not yet been filled out—suggests that Nothing is happening when pages remain blank. Maybe someone is experiencing writer's block. Or a philosopher is publishing Nothing, on purpose, to make a point. I conclude this episode with such humorous examples, but there's a catch: Sometimes, for reasons of intentional secrecy, those who know must insist on ignorance, hiding covert operations by insisting that Nothing is happening.

As Christopher Robin told Winnie the Pooh, "What I like doing best is Nothing." Let's do Nothing now and Nothing else.

§ GERUNDOLOGY: NOTHING IS HAPPEN*ING*

Nothing is happening right now in what may be the slowest piece of music ever performed. There is a rest designated in John Cage's 1987 composition *Organ²/ASLSP (As Slow as Possible)*, which is currently being performed on a specially designed organ in Halberstadt, Germany. Note by note, sounds resonate from the organ for hours, days, months. Cage's instructions for the composition specify that it should be played "as slow as possible," and this has been interpreted in various ways, including marathon performances by individual musicians.

The human capacity for marathons, though, is limited to what a single body can endure. On the mechanically driven organ, a pause began on October 5, 2013, and lasted for seven years. It may seem counterintuitive to refer to a pause as being "performed," but only because in the unusually drawn-out nature of this performance,

the pause is magnified beyond moments into years, and it's hard to imagine a single performer doing this. The performance will stretch beyond years into decades, even into centuries: The current performance began in 2001 and will not end until 2640: 639 years later.

What is happening during a rest in a musical score, during a moment in which no musical note is being played? Is Nothing happening?[1] Musicians know that a rest in music is not inactive: It requires attention, counting, and interpretation of the composition itself. Singers may need to breathe, but breaths can also be inserted for effect, and there may be rests where the singer literally should *not* breathe or they may compromise the phrase. Rests are part of the musical patterns in the piece and may initiate deviation in the patterns: Silence can be highly significant or dramatic, even if apparently Nothing is happening. Like commas in a sentence, a pause denotes a stillness that the performance must maintain. Conductors will interpret musical phrases distinctively, changing the significance of the musical expression and the audience's experience.

And you thought you were just sitting there in the audience, waiting for something to happen. Your experience of silence has another name as well: Nothing is happening, and it is full of anticipation.

Nothing already brackets musical performances. Music emerges from silence and dissipates into silence, even as it is created from the universe of other ordinary sounds. While Nothing is being played or heard, the audience and musicians alike understand that the composition continues to inform the silence. Anticipation is growing as the audience awaits the momentous arrival of the next note; in the case of *Organ²/ASLSP*, that happened in September 2020. The performance is being documented and distributed on the internet, allowing a global audience to perceive Nothing as it is occurring (and allowing online commentators to quip, "You'll never hear the end of this one").

Our ears tell us that Nothing is happening at the moment. We experience Nothing as an event and understand that Nothing will

cease when the next note is played. Cage has amplified our aware-
ness that Nothing happens in the present, encouraging us to perceive
something we don't usually pay attention to. He has created the po-
tential for audible and embodied historical objects—composition,
performance, listening, memories—out of Nothing.

Cage published the now famous "Lecture on Nothing" in 1949.
The text was arranged on the page as a musical composition, with
directions for reading it as a performance "with the *rubato* which one
uses in everyday speech." Rubato, according to *Merriam-Webster*, is
"a fluctuation of tempo within a musical phrase often against a rhyth-
mically steady accompaniment." The avant-garde composer Cage
engages the practice of ordinary communication to express Nothing
musically. This is the text of Cage's composition without notation.

> I am here. And there is nothing to say. . . .
> What we require is silence; but what silence requires is that I
> go on talking.[2]

Silence forms the background of Cage's words, the necessary steady
accompaniment in which there is Nothing to say, but until and un-
less Cage speaks that Nothing as *rubato*, we will hear neither the
silence nor the Nothing. Cage makes Nothing happen so that we can
hear it. His composition *4'33"* features a pianist sitting at the piano
without touching it for 4 minutes and 33 seconds. First performed in
1952, the piece confounds audiences into hearing, deliberately (and
well before Simon and Garfunkel sang about it), that silence is full
of sounds—just not the ones they were expecting to hear.[3]

Nothing, in fact, remains astonishingly resilient. John Cage and
other artists have the genius to reveal this phenomenon as an aes-
thetic experience. Because Nothing is happening all the time, it
stands to reason that it leaves behind residues, historical artifacts
of various kinds. And this is how Nothing remains—Nothing *is* left
after Nothing happens.

Nothing *happens*. It happens *all the time.*

Usually that's precisely why we don't notice it. By definition, it's not worth noticing and certainly not worth remembering and therefore unlikely to become anything historically significant. Nothing, we could say, is what the past and the present always have in common. It is unchanging in its unworthiness of being noticed or remembered. It also provides continuity: Nothing is happening, and Nothing is still happening. Nothing was happening, and then something happened that was worth noticing so it got remembered and we called it History.

Nothing is happening right now. Yes, that's a joke, but it's also worth pointing out that just by reading that line, you're thinking about Nothing, right now, just as an audience is contemplating silence while listening to Cage's composition. This Nothing includes your reading and thinking about it, your looking at a text that someone else (I) wrote at some time in the past, and anything you might also think about Nothing happening, now or then or later. That's very much the way a historian works: looking at something someone wrote (but didn't write for you) at some time in the past. And while you're looking and thinking about the past, you're still you, with your self attached, and everything you know and feel and think about has come with you into the reading of that text. So as a historian, I read and think about the past and about Nothing. And that's another way Nothing is happening.

Whenever Nothing happens, it is happening in the present, and most of the time we don't particularly care about Nothing happening. But when you're bored and there's "Nothing going on" and you are waiting for what feels like an eternity, then you have recognized the fact that Nothing *is* happening, whether or not you're willing to acknowledge its historical significance. (As long as history is defined as What Is Important to Remember, you are unlikely to ever do so.) And worse: When an obstruction of justice is perceived as

the failure of morality and proper governance, the sense that Nothing is happening, when clearly something ought to be done, creates a festering memory that infects the present and connects it to the past in unbearable ways (more about that in Episode 3).

The word *nothing* can mean literally "no-thing" or "thing which is not." We may well ask, Why is there Something rather than Nothing? Philosophers aren't done arguing about this question, but I think it's safe to say that Nothing *happens.* The Nothing in "Nothing is happening" expresses the lack of significance of what is, ironically, being observed and commented on. If it was no-thing or actually not existing, how could it be happening? Language exists to help us communicate, but this is a classic case of a term tripping us up. We all "know" what it means, but do we? When Nothing is happening, we might be so frustrated, bored, angry, or full of anticipation that our ability to communicate is hampered.

You might ask someone, "What are you doing?" when you honestly have no idea what, if anything, they might be doing. If the response you get is "Oh, Nothing," pause for a moment and consider the age of the person you're asking. If the answer is coming from a child or teen, the parent in me says you should be suspicious, or at least dubious. Apparently innocent youthful responses could be harboring an undercurrent of "nothing happened (and I didn't do it)." Respondents of any age might be indicating boredom, but also possibly peacefulness: nothing happened, so all is well. Or maybe your mind has wandered and you are daydreaming, so you answer, "Oh, nothing." Be aware: Nothing always means Something. You need to ask more questions.

If the respondent has entered, shall we say, their golden years, responding in this manner might be a positive indication of well-being. Gerontologists understand why a perception that nothing is happening would be appealing to those in the process of advanced aging. Aging results in the gradual loss of muscle strength and agility; it also decreases one's short-term and recent memory capacities.

Among seniors, the ability to sustain memory or strength can feel like major victories against the inevitable. On a good day, Nothing is happening and Nothing (no one and no memory or ability) is lost, and the constancy of daily life is reassuring.

Playing into my fondness for puns, I think of the study of Nothing and historical consciousness as "gerundology." Understanding how Nothing is happen*ing* (note how *-ing* designates the gerund form of the verb) can actually help us remember Nothing. Paying attention to how memory happens in the present, how remembering is happening just as Nothing is happening, alerts us to the creation of historical consciousness: how we make distinctions between the past and the present based on what is considered worth remembering. Thankfully, it may now be outdated and cliché to say that history is written by old white men about dead white men. Perhaps now we can shift the relationship between Nothing and the past from a chronic gerontology to a historically conscious gerundology.

-Ing forms of verbs appear frequently in stories we tell about something that's already happened. Although we haven't called it gerundology, we could study how *-ing* words represent remembering. As generations of English-speaking students know, to their continual frustration, the way that English grammar copes with representing the past can be confusing. The so-called historical present tense allows writers to represent historical events and recount stories as though they were happening now.

According to *The Chicago Manual of Style*, the ultimate editorial reference source for historians, the historical present tense can be used to describe timeless facts or to narrate a fictional plot.[4] Students are often unsure whether to use this tense when they are writing history papers. They would prefer to use a simple past tense for something that's already over. However, the historical present tense is indeed how fiction and film work, telling a story in a way that allows the reader to imagine that it is happening as it is read or viewed. As the poet A. E. Stallings realized, this is why students get

confused: Are they writing about the past as it was, or the past as it is being remembered?

> The received wisdom about the historical present is that it makes a narrative more vivid and gripping. But it also makes for a curious stasis. Nothing happens; rather, it is always in the process of happening.[5]

The "curious stasis" is the present observing the past; the past and the observation of it are happening at the same time. In coining the term *gerundology*, I am emphasizing the *-ing* and remember*ing* that history is written in the present about the past. "History is happening" when histories are being written about what has been deemed important to remember. "History" is commonly conceived of as being about the important things that happened a long time ago. "Nothing" refers to what is unimportant, and therefore it is always left out of history. Studying Nothing as a historical object, however, restores its ongoing presence in our actively imagined historical world.

And it turns out that we have been talking about Nothing as a historical object all along. When an iconic figure passes away or an enterprise completes its run, we say, "This marks the end of an era." Whether we feel sad about this or not, we expect change to follow. We perceive that something fundamental to our understanding of the world has altered. If the change were less meaningful and we had not remarked on it, Nothing would be wrong. But if Nothing is wrong, then Nothing is what merits attention—that is, we are noticing that Nothing has changed or happened; we are relieved or comforted by familiarity, and we feel no need to be nostalgic.

So Nothing *is* happening *if and when* there has been no change. We could use "Nothing" as a synonym for the curious stasis noticed by Stallings. Our reaction to change, which is the defining element of historical consciousness, determines which kind of Nothing is happening: Either Nothing is the way it was, or Nothing has changed.

We know Nothing has changed, because we also know that "Nothing lasts." Nothing lasts forever, we might say, when we regretfully notice what is gradually fading or has been lost. But Nothing also lasts until something replaces it.

I live in the conflagration-prone American West and have seen the ravages of forest fires that transform familiar landscapes into ash and dust. After a forest fire, a favorite campsite in the Chiricahua Mountains lies bare and exposed, the lush green pines charred to black. Nothing will grow back in time for it to be experienced again as it was. In one lifetime it is impossible to replace mature, much less old-growth, forests; insufficiency marks the event's aftermath. While waiting for the forest to recover, it seems as though Nothing is happening because the forest doesn't reappear in its former glory on any given visit. The regrowth begins. Some trees sprout and some don't survive, but others do; you don't yet have the regrown forest, but you have the forest coming back into being. It seems as though Nothing is the way it was.

The old growth is gone, and until a new forest's mature growth covers the devastation, a visible reminder of loss will strike the visitor's eye. Nothing seems to be happening because the temporal scales of forest regeneration and human life are unequal. At any given moment, no one can see the change happening, and so it appears that Nothing is happening. One can hope that the new forest, if left undisturbed, many generations from now will become the new "old growth," and it will strike the first-time viewer as though Nothing has changed, as though the old forest has always been there.

Cycles of time on the level of geology, evolution, or cosmology are radically longer than a single human lifespan. To observe Nothing happening is to acknowledge that discrepancy in the minutiae of the present, by a single observer in the moment. The idea that Nothing is happening during an entire forest's rejuvenation may seem paradoxical, but a historically minded observer will always perceive Nothing more keenly than those who have no stake in the memory of what is

gone. Someone who knows what has changed and what is missing will remember what was and recognize its absence.

The director and writer Augusto Corrieri, in his book *In Place of a Show: What Happens Inside Theatres When Nothing Is Happening* (2016), asked what might be going on in four empty or indeed demolished theaters.[6] Any number of creative artists, philosophers, and writers have imagined what happens in the absence of human observation. "If a tree falls in the woods and no one is there to hear it, does it make a sound?" Do the inanimate objects come to anthropomorphic life, as in so many Disney films? It's never Nothing.

In his lovely rumination on empty theaters, Corrieri considers what is happening on stages when performance is no longer occurring. At the demolished theater in his Dalston neighborhood of London, Corrieri practices literally inhaling the spores of the building to recover its physical presence. He slows his day down enough to observe, in minute detail, everything in motion over the course of an afternoon on the site of the former theater. Tracking down the now-closed, now-reopened Hackney archive where photographs of the former Dalston Theater are held, Corrieri conducts historical research at the level of text and the level of daily life. All these activities, he suggests, are part of Nothing happening there: He notices them, and his notice creates a theater of possibilities that he can engage through his physical presence. In doing so, he suggests that human interaction with the building was what formerly created the significance of these theaters. Absent the humans, however, the place has always been alive with nonhuman activity, just as the rejuvenating forest is. In other words, wherever Nothing is happening, the theater of the nonhuman is alive.

Traveling to Vicenza, Italy, Corrieri observes a swallow flying inside the dilapidated beauty of Palladio's Teatro Olimpico. He ponders how the nonhuman use of the space could be imagined as what it was made for: an enclosure to be flown through. An unintended use, yes, but the theater is nonetheless in use. Nothing is happening onstage as

Corrieri stands in the theater with the other tourists, observing both a swallow and tourists using the space for something other than its intended theatrical purpose. The absence of theatrical performance makes it appear as though Nothing is happening, but a nonhuman performance unavoidably resonates with the audience in a theater. A swallow's flight becomes the Nothing happening in the theater.

§ AGNOTOLOGY: KNOWING NOTHING

Our high school English teacher, Mrs. Durham, once told my brother, "Ignorance is no excuse for not knowing." He was the second of four Cranes to take her class but neither the first nor the last to fail to meet her exacting standards. Her wisdom has resonated with me. What we don't know can't hurt us—until we need to know it, at which point ignorance is anything but bliss. We called her Mama Durham, and even though we all moaned about how strict she was, I'd like to think we sensed that her eagle eye for detail and her reputation for toughness were like a parent's desire to see her fledglings not only leave the nest but also fly well. When we knew Nothing, we were still in the nest; before we could leave, we had to know how to know that we knew Nothing, and then it was okay to fly.

It "is remarkable . . . how little we know about ignorance," writes historian of science Robert Proctor in his contribution to *Agnotology: The Making and Unmaking of Ignorance*.[7] Proctor created the term *agnotology* in response to his research on the American tobacco industry, in which he found a pattern of "fomenting ignorance to combat knowledge" about the hazards of cigarette smoking.[8] Proctor asks, "Why don't we know what we don't know?" Looking at the marketing campaigns deployed by the tobacco industry in the 1950s to 1970s, Proctor saw how "everyone *knew* that cigarettes were harmful, but no one had ever *proven* it."[9] A fine line emerged between not-knowing and knowing-but-not-knowing, a kind of willful ignorance that was promoted as the tobacco industry's due diligence.

Knowing Nothing is not an excuse for ignorance. When a political party that called itself the Know-Nothings formed in the United States in the 1840s, their agenda was virulently anti-Catholic and anti-immigrant. Supposedly the party got its name from its original secretive practices: When members were asked about local chapters of the party, they would reply, "I know nothing." By the 1850s the party had grown exponentially, and at the peak of its popularity in 1855, forty-three party members held seats in Congress. The party fell apart over the issue of slavery in the run-up to the Civil War, but its legacy endured as successive waves of immigration caused Americans to implement quotas, identity protocols, and other restrictions on migrant civil liberties.

A political party founded on protecting the privileges and rights of primarily Protestant white American men in the nineteenth century would understandably express its ignorance about the rights and needs of others as hypocritical, xenophobic political tenets. Being a Know-Nothing required remaining ignorant about human rights. Ignorance is a lack of knowledge, not an unwillingness to know. Then as now, being proud of knowing Nothing indicates a willful preference for remaining intolerant. To ignore what you could know is a specific form of ignorance.

Usually when we don't know something we want to know, we ask questions and try to find out something about it. But if what we want to know has been lost or forgotten or if silences cover up the absence of information, then the struggle to learn becomes much more difficult. Knowing Nothing motivates active recovery.

Silences that hide knowledge can transcend generations within a family or society. Consider memories of the Holocaust, the horrific genocide that occurred in the mid-twentieth century and is one of the best-documented crimes in the historical record. Despite this, anti-Semitic Holocaust deniers persist in proclaiming that Nothing happened, at least not in gas chambers built for the purpose of exterminating Jews and other victims of Nazi racism.

Pitting denial against vivid memory and historical reality should be merely ridiculous, but it remains a painful reminder of the roots of genocide and has driven active memorial efforts. Surviving victims and their families remember the Holocaust in specific ways that are meaningful to them. For survivors, the memories may be retained very much against their will, as unavoidable traumatic reminders. In the public sphere, vast realms of memory work include museums, films, books, memorials, and monuments dedicated to keeping Holocaust memory alive as an ethical imperative "never to forget."

Given its apparent commemorative global ubiquity, it might be surprising to realize that, at the same time, families and communities committed to remembering also may feel that memory is continually at risk, and not only because of Holocaust denial. In the past decade a trend in memorial tattooing has emerged (Figure 1). Grandchildren inscribe their grandparents' tattooed identification numbers onto identical places on their forearms, thus bearing powerful memorial testimony to the harm and trauma suffered by loved ones. As the journalist Jodi Rudoren reports, other families have followed suit.

> When Eli Sagir showed her grandfather, Yosef Diamant, the new tattoo on her left forearm, he bent his head to kiss it. Mr. Diamant had the same tattoo, the number 157622, permanently inked on his own arm by the Nazis at Auschwitz. Nearly 70 years later, Ms. Sagir got hers at a hip tattoo parlor downtown after a high school trip to Poland. The next week, her mother and brother also had the six digits inscribed onto their forearms. This month, her uncle followed suit.
>
> "All my generation knows nothing about the Holocaust," said Ms. Sagir, 21, who has had the tattoo for four years. "You talk with people and they think it's like the Exodus from Egypt, ancient history. I decided to do it to remind my generation: I want to tell them my grandfather's story and the Holocaust story."[10]

Tattoos may be popular today, but the tattoo forced on Yosef Diamant was part of his dehumanization by the Nazis. Our skin lasts as long as we do, and tattoos last a lifetime. In this act of resistance against forgetting, the tattoo's longevity, inscribed against the will of the victim, has been transformed by his family into a memorial. The victim's granddaughter was worried that the Holocaust seemed like "ancient history" and that her generation "knows nothing" about it. In response to knowing Nothing, the tattoo speaks for the past—not only for the surviving victims and their families but also for the silenced victims who already lost their lives.

The desire to testify about the past, to express historical consciousness against the evaporating effects of ignorance, is producing tattoo art beyond concentration camp identification numbers. I was alerted to this several years ago during a final exam I administered in my annual undergraduate course "The Holocaust in History and Memory." A student who had just completed her exam pulled me aside, saying she wanted to show me something. On her ankle, she had a new tattoo of Art Spiegelman's "mouse" face (in the artist's commix book *Maus*, his parents and other Holocaust victims are portrayed as mouse figures). She told me that she intended to be able to testify to anyone who asked about the significance of the Holocaust. I was impressed by her ardor for communicating what she had learned. It had not occurred to me that a tattoo could serve, in effect, the same purpose as a written history: to offer knowledge and to remind us to remember. When someone demonstrates that they know Nothing about the Holocaust, she will show them her tattoo and testify.

Pacific Islander tattoos attracted European attention as explorers traveled across the oceans in the sixteenth through nineteenth centuries. The practice was not unknown to them: Crusaders returning from the holy lands had brought tattoos back with them, and tattoos had long existed in the Mediterranean. However, the idea that tattoos were exotic emblems of primitive cultures got embedded in ignorance about the cultures in ways that proved difficult to overcome.

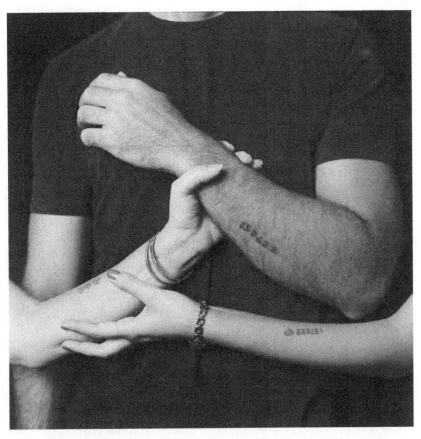

Figure 1. A photo from the collection "Numbered: Auschwitz Survivors Share Their Numbered Tattoos." The information accompanying the photo reads, "Yona Diamant [left], Eli Sagir [right], and Arik Diamant [center], daughter and grandchildren of Auschwitz survivor Yosef Diamant, are photographed on September 04, 2012, in Bnei Zion, Israel. Yosef was tattooed with #157622 from the Auschwitz concentration camp. Four of his family members had the same number tattooed on their arms more than 60 years after their grandfather." Photo by Uriel Sinai. SOURCE: Getty Images Reportage.

Herman Melville's first novel, *Typee: A Peep at Polynesian Life During a Four Months' Residence Among the Natives of a Valley of the Marquesas Islands* (1846), offered readers a "novel" glimpse of tattoos but also revealed the author's ignorance. In 1842, when he was 21, Melville spent three weeks on the island of Nukuhiva. Having arrived on the whaler *Acushnet*, Melville jumped ship and hid among the local people until he was able to leave on a different whaler, the *Lucy Ann*. Trading on his own adventures for authentic details, Melville has his hero in *Typee* "narrowly escape tattooing." He learned that tattooing was imbued with religious significance and feared that his hosts intended to convert him (the irony of this was perhaps lost on Melville's readers). He successfully resisted tattoo and conversion, but he remained confused: "Although convinced that tattooing was a religious observance, still the nature of the connection between it and the superstitious idolatry of the people was a point upon which I could never obtain any information. . . . It always remained inexplicable to me."[11]

Historian Greg Dening considers how Melville's ignorance about tattoos had been formed before his travels. As a 9-year-old, Melville spent a memorable holiday with his cousin. Both boys had seafaring family members whose libraries included the famous volume by Georg Heinrich von Langsdorff, *Voyages and Travels in Various Parts of the World* (1813). Dening imagines the young Melville gazing at what became one of the most enduring images of Polynesian tattoos, the portrait of Jean Baptiste Cabri, a Frenchman "gone native" and endowed with tattoos from head to foot (Figure 2). The book served as a visual primer for the world Melville would encounter, presenting many images of tattooed bodies. But Dening argues that Melville was never able to see "the tattoos as anything other than exotic ornamentation of the body. Melville could never enter the life and myth-cycle the images represented."[12] Dening describes the religious significance that Melville did not understand as well as the ritual performed by women to remove tattoos from the dead.

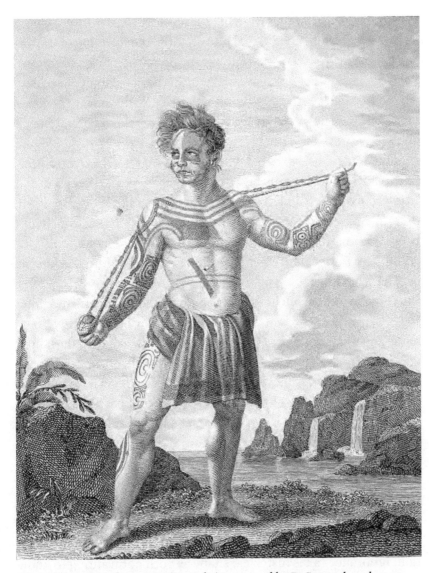

Figure 2. "Portrait of Jean Baptiste Cabri," engraved by R. Cooper based on an image by Alexander Orlovsky. Engraving from Georg Heinrich von Langsdorff, *Voyages and Travels in Various Parts of the World, During the Years 1803–1807* (London, 1813).

Without suggesting that Melville's ignorance was willful, Dening shows that despite vivid visual information, the meaning of the images didn't travel with the representation or memories of tattoos. Rather, the significance remained within the community of believers. As we shall see in Episode 2, this is frequently the fate of visual information: The visual image is typically unable to communicate knowledge indigenous to its creation.

That images are encoded with silences may seem counterintuitive to anyone who's ever heard that a picture is worth a thousand words. Usually we think that means the photograph speaks for itself, that it is itself a sufficient form of communication. But we should be wondering why we ever thought a photograph could talk. Our ignorance of the silences—the Nothing—encoded into the images may be what's speaking the loudest.

This is precisely what Proctor and his fellow scholars of knowing Nothing found when they looked at ignorance actively being made and unmade: lack of transmission of knowledge. In the edited volume *Agnotology*, Peter Galison tracks the effects of censorship on knowledge and Nancy Tuana finds similar effects in "coming to understand" the ever-elusive (to certain sexual partners, at least) female orgasm. Indigenous knowledge is lost in at least two transactions. Londa Schiebinger traces how West Indian abortifacients were "forgotten" in transatlantic trade, even though other Caribbean drug discoveries, such as quinine, were rapidly shared. Adrian Mayor shows how Native American knowledge about the North American fossil record was ignored as "savage myth" by eighteenth-century scientists who preferred their own "rational" sources of information. Ignorance takes historical shape as both not wanting to know and not knowing what you don't know.

We can thank Proctor and his colleagues for practicing agnotology, because now historians will understand that we don't have to know Nothing about ignorance.

§ THERE'S NOTHING GOING ON: DOING NOTHING

> And who would write it?
>> *Patrick McGuinness, "A History of Doing Nothing"*

Patrick McGuiness opens his poem "A History of Doing Nothing" by wondering aloud who on earth would write such a history. What scholar would care to write about Nothing? Historians, he muses, would have trouble measuring its developments and chronologies. They might attempt to register inaction as a prelude to an actual event: "In wars, it was inferred from the slack rigging / of warships." Or they might use the traditionally important main action as a gauge.

> Its founding epic still used heroes, battles, temples . . .
> Only for the spaces that lay between them. Events?
> No; the gaps that separate events.[13]

Minding the gap between the past and the arriving trains of thought, like a metaphysical version of a commuter on the London Tube, the poet-historian can indeed write a history of Nothing. There are long traditions of poets producing histories, going back to the oral folklore of antiquity and the bards of yore. Thus a poet speculating about "a history of doing nothing" is performing his own gerundology, as McGuinness does.

Poets have also considered the moral implications of doing Nothing. I'm not talking about turning away from the blank page with writer's block but rather about inactivity that constitutes passive choices being made. Fabio Lanza, my colleague who hails from Venice, Italy (and therefore knows his Dante), pointed out that Dante reserved a singularly bad place in his cosmology for people who sinned by not doing anything.

> Actually, Dante places these people (who lived without praise or infamy, "coloro che visser sanza 'nfamia e sanza lodo") outside the

actual beginning of hell, as they don't deserve even that. Sin re-
quires at least passion, and these people had none, so they should
simply be forgotten. "Fama di loro il mondo esser non lassa /
misericordia e giustizia li sdegna / non ragioniam di lor, ma
guarda e passa." Doing nothing was really bad in Dante's book.
(private communication, 2016)

The text referred to here is from *The Inferno*, Canto 3, verses 34–36.

And he told me: "This way of wretchedness
Belongs to the unhappy souls of those
Who lived without being blamed or applauded."[14]

I'm a historian of historical consciousness, so what strikes me is
Dante's opinion that those passionless souls who do Nothing de-
serve to be forgotten. They have done Nothing worth remembering
or worthy of inclusion in histories, so their memory should be oblit-
erated. That's harsh. Dante is prescribing the erasure of every per-
son who does Nothing. Whereas McGuinness is concerned about
the "gaps which separate events," Dante advocates creating the
very gaps in the historical records that mask real lives, choices,
and events. One could argue that the gaps are already there, that
events that were not important enough to be recorded have not
transpired. Either way, these two poets circumscribe a fundamen-
tal realm of historical decision making: What is worth recording?
And who will decide?

Like the flight of the swallow Corrieri observed in the Teatro
Olimpico, gaps in the records that separate historical events—
those periods in which it seems that Nothing happens—register
as unremarkable. Crucially, however, they have indeed been reg-
istered, and as such become historical records. To write a history
of doing Nothing, the historian only has to "do" Nothing: read the
records, looking for Nothing, minding the gaps. Here and in Epi-
sode 3, I begin with poetry and shift into history, because poets

are exceptionally talented at expressing the experience of Nothing happening. A history of doing Nothing means not only appreciating diverse forms of inactivity but also understanding unconventional topics such as inertia, sleep, and boredom as sites of historical human activity.

In modern medicine, doing Nothing has played a significant role in at least two areas of research: the effectiveness of placebos and the physical impact of inertia on astronauts in zero gravity. Since the 1950s clinical trials of drugs have relied on comparing the results of treatment with new pharmaceuticals with treatment, or lack thereof, with a placebo. Interestingly, the assumption that Nothing happens when patients are given something they believe might improve their health has not stood the test of time. The belief or hope that the patient has received a beneficial drug turns out to have a healthful impact in many people who were given placebos. New research suggests that the placebo response indicates a chemically driven mind-body healing process that merits further investigation. So even when Nothing happened and patients who received a placebo didn't get the benefit of the new drug, letting Nothing happen to them turned out to be a good thing.[15]

A 1966 exercise study geared toward understanding how astronauts would experience space travel included a component of inertia not related to gravity: enforced inactivity. As astronauts' avatars, the test subjects did Nothing for three weeks. Six college students, all male, were recruited to help researchers at the University of Texas Southwestern Medical Center study how the body reacts to extreme sedentariness, particularly with regard to blood circulation and oxygen intake. One might well wonder whether there weren't enough couch potatoes available in Texas at the time, since television viewing was already widespread in America by the 1960s, and whether the researchers couldn't have conducted a broader study with a larger sample size and diversity; but perhaps the researchers wanted to work with subjects closer to their own labs. It's amusing to imagine how many healthy students would have loved to be told

to do Nothing. Even better, the archival "item identifier" associated with the following image of some of the test subjects is labeled "nap" (Figure 3).

After collecting data about their ordinary health and fitness, the students were required to stay in bed for three weeks, no exercise permitted, in an effort to simulate the effects of weightlessness on the human body in space. Half of the participants were athletic individuals whose physiques had something like "the right stuff" expected of American astronauts. The remaining individuals were selected as a control group, healthy but not athletic. The Dallas Bed Rest and Training Study research team found that after doing Nothing for three weeks, participants' hearts had shrunk 11 percent. Two

Figure 3. Dallas Bed Rest and Training Study participants, 1966. Photographer unknown. Source: University of Texas, Southwestern Medical Center Image Archives. http://utswlibrary.contentdm.oclc.org/cdm/ref/collection/p16135coll1/id/217; Item Identifier nap_00224. Reprinted by permission.

of the control group fainted when put on a treadmill after weeks of bed rest. In all participants, oxygen intake was drastically reduced, as was the amount of blood pumped by each heartbeat. The results were striking, both for NASA and for healthcare practitioners. As a result of the study, hospital staffs began directing patients to get up and about much sooner after procedures, particularly those who had heart ailments. Attention to the benefits of regular exercise continued to grow during the rest of the twentieth century.[16]

Equally impressive was a follow-up study conducted on the original participants on the thirtieth anniversary, in 1996. The emphasis this time was on the effects of aging on cardiovascular fitness. Rick E. Lovett, who interviewed one of the participants, described the results of both studies. Strikingly, "30 years of aging had taken less of a toll ... than 20 days of bed rest."[17] Although the test subjects had gained weight and lost physical conditioning as they aged, their bodies were in better shape than they had been after the original experiment in 1966.

Doing Nothing for three weeks had produced a shrunken heart and triggered cardiovascular restrictions. No one would claim that Nothing happened to those men. And when the older men were put on exercise regimes for six months, raising their activity levels to 3–5 hours/week, their cardiovascular health rebounded to levels matching their college-age pre-bed-rest metrics. Doing Nothing made them less healthy. On the surface, this is entirely unsurprising to any parents who have ever told their kids to get up and go outside to play. But the study gave scientific ballast to that advice, in a culture bent simultaneously on exploring space and producing couch potatoes.

As we have seen, slowness has often been interpreted as Nothing happening because measurable changes seem imperceptible, but in fact something is happening and it's just too banal to register as anything more than "doing Nothing." The slowness that is occurring, for instance, at the rate of a John Cage performance or at

the speed of a snail's progress almost isn't worth registering unless you're really committed to it. Your observation of slowness amounts to doing Nothing. When one is bored, time appears to pass at a rate comparable to that of a snail's movements.

To add another new type of study to our consideration of gerundology and agnotology, Valerie Jamieson proposes that Dr. William Bean is "the king of boring-ology" for his ability to sustain the project of observing invisible growth over decades. To give slowness due credit, Dr. Bean, an American physician, began in 1941 recording his thumbnail's daily growth. A human thumbnail's growth, though measurable at the rate of a tenth of a millimeter a day, is invisible in any given moment. On average, he calculated, the thumbnail grew 0.123 millimeter a day during the ensuing 35 years of his data collection (by the time he was 61, it had slowed down to 0.100 millimeter/day).[18]

Periods of inactivity and the slow rate of the human fingernail's growth exhibit how Nothing is happening in everyday life. Another universal experience of Nothing happening, literally every night, is sleep. Sleep has long been understood to be restorative to the human body, but only recently have neurologists and other researchers begun to understand how active the human brain is during sleep. We just don't perceive it while it's happening (which may be precisely why the brain thrives while we sleep, because it's off consciousness duty). Like the past, sleep is seen as Nothing until it becomes an object of study or an observation by an artist, such as Andy Warhol. His eight-hour film *Sleep* (1963) focused the camera for eight hours on one guy sleeping, without pause. In *Empire* (1965), according to the website of the Metropolitan Museum of Art, Warhol filmed a single

> stationary shot of the Empire State Building . . . from 8:06 p.m. to 2:42 a.m., July 25–26, 1964—in order to "See time go by" . . . [and projected it] at a speed of sixteen frames per second, slower than its shooting speed of twenty-four frames per second, thus making the progression to darkness almost imperceptible.[19]

Warhol's successful efforts to both record elapsed time and depict the diurnal activity known as sleep during its actual occurrence were understood to be original creative responses to the ordinary, making art out of Nothing particularly interesting in and of itself. Like Marcel Duchamp taking a urinal and relabeling it as a work of art, Warhol "found" art in the everyday with his Campbell's soup cans and his film work.

My colleague Martha Few reminded me that historians have written about sleep in medieval and early modern Europe, finding the significance of sleep as a historical object without necessarily understanding it to be Nothing. Roger Ekirch's research revealed how in early modern England, sleep happened in two separate intervals: a "first sleep" after dark and a "second sleep" before dawn, with liveliness and particularly sexual activities happening in the middle of the night.[20] The science of sleep continues to discover aspects of brain function that would have been unfamiliar to Warhol, much less early modern Brits. But the sense that rest and sleep are downtimes in which Nothing is happening remains in circulation.

Doing Nothing has been understood as boredom and inactivity, as reprehensible inactivity worthy of being forgotten (for Dante), and as rest and sleep. All of these everyday activities form the backdrop against which history will happen by standing out as difference, change, action, and significance. History seems to happen during the day, or at least during the daylight; until reliable night lighting emerged in modernity and the night shift came into practice, historical human activity was daytime activity.

Nothing happens at night—except sleep and sex and, with the advent of the modern age and electrical lighting, many kinds of labor and sleep deprivation. And, as we shall see in the next section, night is the time for covert observations and operations, which are not new to modernity but have acquired new technological apparatuses. In minding the gaps that doing Nothing seems to present in historical understanding of the past, we need to pay closer attention to empty spaces, from the blank pages of books to the wide-open deserts and

plains, to understand why they have been remembered as empty or blank. They are always present and full of life, or at least space to write upon, and Nothing happens there until you do.

Because Nothing is happening all the time and Nothing happens until you do something, being unable to act creates a particular kind of crisis. "There was nothing I could do!" is the universal cry of helplessness, outrage, and frustration. Has anyone written a history of futility? Doing Nothing would be the historical event of feeling unable to prevent or deter something bad from happening.

The anthropologist Marc Augé suggests that a sense of futility permeates what he calls the world's current state of "over-modernity."[21] The modern world we inhabit is rapidly expanding while shrinking, with instant communication telescoping distances at the same time that international mobility and migration is supplanting the notion of identity as locally determined. With too much knowledge virtually available and too little ability for any individual to act on all of it, Augé argues from a European perspective that

> under the weight of information and images, each one of us has a feeling of being not only a witness to the events of the world but somehow to western civilisation itself. This reaction produces a feeling of discomfort, of crisis, which is linked to the consciousness that each one of us can see everything and do nothing.[22]

What ability does any one person have to prevent global warming? Famine? War? Does knowing more about international conflict help prevent it? Optimists hope so; pessimists may feel overwhelmed or skeptical. To do Nothing is to feel inadequate, helpless, and useless. Or as the philosopher Martin Heidegger tried to elaborate and generations of readers have tried to understand, "What does Nothing do? Nothing."[23]

Some critical observers of international aid agencies, such as the United Nations or those fighting to get global warming acknowledged

and addressed, have contended that these agencies seem to get Nothing done, so inadequate is their response to any crisis. Perhaps this is what Dante had in mind when he wouldn't even send those who do Nothing to hell. But as the writer Rebecca Solnit points out, environmentalists and other activists sometimes have to be grateful that Nothing worse than apparently Nothing happened.

> After all, most environmental victories look like nothing happened; the land wasn't annexed by the army, the mine didn't open, the road didn't cut through, the factory didn't spew effluents that didn't give asthma to the children who didn't wheeze and panic and stay indoors on beautiful days. . . . Go east to Oklahoma and you'll arrive in the sites where in 1993, after years of work, environmentalists, including the group Native Americans for a Clean Environment, and the Cherokee Nation shut down 23 percent of the world's uranium production. All these places are places of absence, or at least the absence of devastation, a few of the countless places in which there is nothing to see, and nothing is what victory often looks like.[24]

The activists that Solnit cites have clearly done something and had an impact, but it looks like Nothing is happening on the sites of their action, or like children hiding indoors to escape pollution. Perhaps because only one site of uranium production has been shut down but so many more remain, it's the proverbial drop in the bucket. There is a negative history of inadequacy that's usually written as the narrative of the victors, the ones who win the right to write the story of what did happen. This history usually scripts failure as a loss and futility as its cause. In overmodernity, that is an overdetermined conclusion. Doing Nothing deserves its own narrative.

When flights arrive from international destinations, modern airports are equipped to process passengers through customs declarations. Those who have not spent vast sums of money abroad and are

not bringing food or livestock into the country pass through customs relatively quickly, through doors signposted for those with "Nothing to Declare." Every day, thousands of people have Nothing to declare. We are so accustomed to doing Nothing that we have Nothing to say about it. There are forms to fill out before one enters customs. Blank forms are what we use when we have Nothing to declare.

§ WHEN NOTHING IS THERE: DRAWING BLANKS

In honor of every writer who ever despaired in front of a blank page, the following publication from the *Journal of Applied Behavior Analysis* is reprinted here in its entirety (Figure 4). Dr. Upper, a clinical psychologist who passed away in 2018, is likely to be remembered as much for what he did not write as for what he did. His gentle self-parody of scholarship has retained popularity for its canny precision. This isn't just a one-off joke, a blank page snuck in under the noses of a scientific journals' editors, but rather an insider's tour of academia. Upper's work was not previously presented at the expected annual conference. The treatment was "unsuccessful" but reported nonetheless. Sticking to ethical research standards, the journal notes that they published his 1974 work "without revision" but also appends a comment from enthusiastic (and necessarily anonymous) Reviewer A, who wryly notes that this "most concise manuscript" meets the highest standard of scientific review: Its lack of results can be replicated. The blank page signifies Nothing but writer's block, which occurs repetitively and endlessly among what is now called "the creative class." To paraphrase John Cage, there is Nothing there—and we are seeing it.

Dr. Upper's inability to replicate his results and the reviewer's confirmation that this reproducible failure was the sign of a successful experiment may have itself harkened back to another scientific parody. In the 1970s my marine biologist father subscribed to *The Journal of Irreproducible Results: The Science Humor Magazine*, which originated in 1955 and continues publication today.[25]

JOURNAL OF APPLIED BEHAVIOR ANALYSIS 1974, 7, 497 NUMBER 3 (FALL 1974)

THE UNSUCCESSFUL SELF-TREATMENT OF A CASE OF "WRITER'S BLOCK"[1]

DENNIS UPPER

VETERANS ADMINISTRATION HOSPITAL, BROCKTON, MASSACHUSETTS

REFERENCES

[1]Portions of this paper were not presented at the 81st Annual American Psychological Association Convention, Montreal, Canada, August 30, 1973. Reprints may be obtained from Dennis Upper, Behavior Therapy Unit, Veterans Administration Hospital, Brockton, Massachusetts 02401.

Received 25 October 1973.
(Published without revision.)

COMMENTS BY REVIEWER A

I have studied this manuscript very carefully with lemon juice and X-rays and have not detected a single flaw in either design or writing style. I suggest it be published without revision. Clearly it is the most concise manuscript I have ever seen—yet it contains sufficient detail to allow other investigators to replicate Dr. Upper's failure. In comparison with the other manuscripts I get from you containing all that complicated detail, this one was a pleasure to examine. Surely we can find a place for this paper in the Journal—perhaps on the edge of a blank page.

Figure 4. Dennis Upper, "The Unsuccessful Self-Treatment of a Case of 'Writer's Block,'" *Journal of Applied Behavior Analysis* 7(3) (1974): 497.

Its cheesy humor was right up his alley. The journal's contributors featured names such as U. R. Wright and I. M. Ron, Hippo Campus, and the Association of Rejected Scientists and Engineers (ARSE). The publication's history, according to the current website, indicates that "as far as we know: volume 1 was a joke and never existed, volumes 2–3 had 1 issue each, volumes 4–6 had 2 issues each." Appropriately, in this journal's run the first volume was blank because it never actually existed (although it was no. 1 and therefore existed in the sense that it originated a series). Nothing was happening that could ever be repeated (except among those in on the joke).

Another deliberately blank article appeared in the journal *Dialectica* in 2016 (Figure 5). British philosopher Tyron Goldschmidt published an article that, depending on your point of view, was a parody of scholarship, a weak joke, or a lively provocation to further debate.

Philosophers had fun with this one. Was this article to be taken seriously? Or would that have been to take it too seriously? The blogosphere lit up with witty replies as well as humorless posts providing references to literature that would refute the ridiculousness of Goldschmidt's provocation.[26] Kei Hirano, an economist who delights in such intellectual exchanges, alerted me to the blog posts, from which I would like to highlight the following:

Joshua Miller · February 22, 2016 at 12:01 pm
Does the absence do the causing or the presence (of a title, author, and DOI)?

Because if it's the absence doing the causing, I must sadly accuse the author of plagiarizing my own unwritten paper on this topic.

Alan White · February 22, 2016 at 2:10 pm
I tried to think of other papers but drew a blank.

Peter Bele · February 22, 2016 at 10:23 pm
Poor editors! Imagine the challenge of finding reviewers for this

dialectica

dialectica Vol. 70, N° 1 (2016), p. 85
DOI: 10.1111/1746-8361.12128

A Demonstration of the Causal Power of Absences

Tyron Goldschmidt[†]

[†] Department of Philosophy, Wake Forest University, Winston-Salem, NC, USA. Email: goldsctc@wfu.edu

Figure 5. Tyron Goldschmidt, "A Demonstration of the Causal Power of Absences," *Dialectica* 70(1) (2016): 85.

article: "Let's see. We need a couple of philosophers who know nothing..."

AnonyMoose · *February 23, 2016 at 9:50 am*
> If, as is plausibly the case, all papers have the empty paper as a sub-paper, this issue brings to light plagiarism on an unprecedented scale.

The comments wring elaborate insider jokes out of Nothing. The blank page equates to every unwritten paper, whereby the same unpublished paper then potentially underlies every published paper as a source, creating a universal and pervasively copied publication (for further discussion of plagiarism and Nothing, see Episode 3).

And as every philosopher who's ever had to try to explain their research process to a funding agency—much less to their relatives—knows, the general public already thinks philosophers sit around doing Nothing all the time. From the literal-minded among Goldschmidt's readers, several respondents recommended that the author consult scholarly publications about "causing and nothingness," "omissions as possibilities," and "causation by omission." This scholarship is genuinely fascinating, and surely Goldschmidt is not unaware of its existence, given that he is the editor of *The Puzzle of Existence: Why Is There Something Rather than Nothing?*[27]

But is the insistence on scholarly rigor really necessary to debate the resonances of the blank page? Or might it not be possible that the outrage experienced by those who feel that Nothing, really, is happening when a blank page is published, is rather more an expression of frustration that Nothing is happening without a cause? Causes, after all, are what historians hope to find at the root of historical events, as well as motivating philosophical debates.

This is not a case of the emperor's new clothes; these published pages really are mostly blank. But they are also not devoid of words. Upper and Goldschmidt have titled and credited their work. The journals added their banner titles, notes, and bibliographical

information. All of this is standard practice and not even mentioned in the readers' responses. But without these trappings of academic credibility—trappings we scholars take quite seriously—the published blank pages would not have been so provocative.

Blank pages have appeared in publications ever since Gutenberg, often as extra leaves at the back or as inserts between typed pages. In the age of digital libraries and Google Books, we often see an otherwise blank screen in the middle of a scanned text, with a parenthetical note "this space/page intentionally left blank." That deliberately blank page will of course be surrounded by the computer screen's search tabs, the format of the digital book, its searchable features, the database's presentation framework, advertising, and a whole bunch of navigational links that I have never found any use for, because I actually want to just read the book page by page. In other words, the blank-page screen is full of Nothing I will use and it is full nonetheless.

All these blank pages have something in common with historical consciousness: Nothing is happening until we take notice that Nothing is happening. At that point, a process of meaning-making begins. What we choose to find significant about the Nothing that is happening is what we will remember, and whenever we designate something about the past as "remembered," we are engaging in historical consciousness. A blank space holds meaning in abeyance; memory adds meaning, as it always does when the past becomes part of a history. As historian John Gillis pointed out in his discussion of nineteenth-century historical consciousness, forgetting often figures into the blankness as well.

> Changes occurring at the economic as well as political level created such a sense of distance between now and then that people found it impossible to remember what life had been like only a few decades earlier. The past went blank and had to be filled in, a task taken up with great fervor by professional historians from the early 19th century onward.[28]

The absence of memory is one kind of blankness; a past that we seek to recall, which has eluded our grasp, may appear blank or empty, even forgotten. But if we can still perceive a past, Nothing has been lost entirely—which is to say, Nothing is still there.

> Album: "A blank book in which to insert autographs, memorial verses, original drawings, and other souvenirs; according to Johnson, 'a book in which foreigners have long been accustomed to insert the autographs of celebrated people.'"

This is the second definition of "album" provided by the *Oxford English Dictionary*; the first cites an ancient Roman usage, defined as a tablet for proclamations. Either way, the album and tablet are blanks to be filled with what is desired to be remembered. This early form of blank book boomed in the nineteenth century, in a Victorian age imbued with sentimentality and rife with new technologies for visualizing and remembering, such as the camera. Consider the plethora of deliberately not-quite-empty pages featured in the section on "blank books" in the *American Dictionary of Printing and Bookmaking* (1894) and by Lisa Gitelman in her book *Paper Knowledge: Toward a Media History of Documents* (2014). In a chapter called "A Short History of ——," Gitelman lists the kinds of record books that "job printers" generated in the early days of modern bureaucracy.

> Address-books, bank-books, bankers' cases, bill-books, blotters, books of design, buyers' price-books, card albums, cash-books, check-books, collection-books, composition, exercise and manuscript books, cotton-weight books, day-books, diaries, drawing-books, engineers' field-books, fern and moss albums, flap memorandums, grocers' and butchers' order books, herbariums, hotel registers, indexes, invoice-books, ledgers, letter-copying books, lumber and log tally-books, manifold-books, memorandum-books, miniature blanks, milk-books, money receipts, notes,

drafts and receipts, notebooks, order-books, package receipts, pass-books, pencil-books, perpetual diaries, pocket ledgers, portfolios, receiving and discharging books, rent receipts, renewable memorandums, reporters' note-books, roll-books, salesmen's order-books, scrap-books, scratch-books, shipping receipts, shopping-lists, tally-books, travelers' ledgers, trial-balance books, tuck memorandums, two-third books, visiting-books, writing-books and workmen's time-books.[29]

These books' pages were not entirely blank; they had ruled lines, headings, and logos. But their primary purpose was to provide blank spaces that would be filled in specific ways to create a format for preservation of information. Forms have a purpose: to be filled. "Job printing," as Gitelman points out, was intended to be read but was commonly understood less as a text than as a register for users to interact with.

As records of transactions between users, filled forms became vital historical objects that were not always appreciated as such at the time. Historians such as Lucy Maynard Salmon (1853–1927) were derided by colleagues for paying attention to laundry lists and receipts, even as she pioneered the way for twentieth-century social histories that recovered women's history. The critics believed, correctly, that "nothing is there"—but, coming from them, that wasn't a compliment or a discovery worth celebrating.

Blank spaces can also serve as a conduit for knowledge that is implied and understood as such. Gitelman reminds us that eighteenth-century Anglophone literature was filled with dashes and hyphens, another kind of blank indicated by a line. When authors mentioned public or famous people but wanted to protect themselves from being held accountable for doing so, they wrote a name as "M. S——" and left it to the informed public to laugh, point fingers, and count themselves among those in the know. This style of name-dropping by not naming names was popular for hiding identities

while simultaneously printing them, as it were, in banner headlines, by drawing attention to what was missing.

The hyphen or dash works as a placeholder, withholding full disclosure in favor of a tantalizing first initial or two. For instance, the writer Jonathan Swift cannily pronounced, "We are careful never to print a man's name out at length; but, as I do, that of Mr. St——le . . . although everybody alive knows who I mean."[30] The dash makes a verbal wink that indicates an inside joke and protects the joker from being called out on their public jest, just like the blank spaces in the pages of philosophy or psychology journals or the *Journal of Irreproducible Results* do. As artists, filmmakers, comedians, historians, researchers, and job printers alike have shown, drawing a blank is about the best way to show Nothing happening and get away with it. Saying Nothing, hearing Nothing, knowing Nothing about Nothing that is There—it should come as no surprise that Nothing *is* being remembered.

Bare walls, like blank pages, offer considerable space for innovative reflections on Nothing (I also consider a series of photographs staged in front of walls in Episode 2). That they can be fascinating in their own right, however, as spaces where Nothing is happening, has been most fully demonstrated by modern artists and museums. Consider the theft of the *Mona Lisa*, painted by Leonardo da Vinci in 1507 and stolen from the Louvre Museum in 1911. It is now so patently obvious that it may sound silly to mention that this work is famous; the words "Mona Lisa" conjure up an icon. But before the theft, the painting had only barely begun to register as a masterpiece in the art world. After the painting disappeared, as museum studies scholar Helen Rees Leahy recounts, throngs of visitors, including the writer Franz Kafka, poured into the Louvre's famed Salon Carré, setting attendance records; they wept and left flowers and other mementos of grief at the site of the bare wall.[31]

The painting's fame derived as much from the theft and residual blank wall as from Leonardo's merits. "Mona Lisa smiles" appeared in so many replicas of the painting, in advertising, posters, and magazine covers, in what Leahy calls "the expanding mediascape" of memory,

that the absent painting became in a way less important than its sig-
nifiers. When the *Mona Lisa*'s spot was filled with a Raphael portrait,
interest in the missing art dwindled; even the painting's return was anti-
climactic. The wall remained magnetic only so long as it was blank.[32]

A blank wall is the ultimate projection screen. The golden age of
cinema was also coming into its own at the time of the famous mu-
seum theft, and its screens drew throngs as well. Waiting for the film
to begin, anticipation played into the expectations for entertainment
and drew on remembered imagery. As with the silences in Cage's
modern composition, the emptiness of the screen heralded what
was to come: out of Nothing, something visual, aural, and visceral.

Midcentury artists playfully and rigorously explored the blank
wall and empty room as expressive forms. Absence and presence
were evoked through whiteness and blackness, emptiness and gaps,
voids and blankness. A 2006 exhibition titled "Nichts/Nothing" at
the Schirn Kunsthalle Frankfurt surveyed conceptual art produced
from the 1960s on that represented the aesthetic potential of Nothing
happening.[33] Stefan Brueggemann stacked numerous identical card-
board boxes and labeled them "Nothing." Karin Sander asked artists
"to make works available that would not be 'shown' physically but
only described on the audio guide. . . . People wearing headphones
stand in front of white walls and imagine art that isn't visible—which
doesn't mean that it's not there." On four otherwise blank sheets of
paper, Robert Barry's untitled work from 1969 offered one typed
line on each page:

Something I was once conscious of, but have now forgotten
Something which is unknown to me, but which works upon me
Something that is taking shape in my mind and will sometime come
 to consciousness
Something that is searching for me and needs me to reveal itself

Barry's text speaks specifically to the experience of knowing Noth-
ing. We might well ask, What did visitors take away from the exhibit

if not impressions that led to memories of Nothing? Exhibit visitors may be curious about what it means to look at Nothing, go to the exhibit where apparently Nothing is going on, and come away with what they intended to find: memories referring to blankness. Memories of the visit are a form of historical consciousness tied to blankness, just as the visitors to the Louvre wanted to remember the absent *Mona Lisa* by gazing at a blank wall.

Then there are the photographs that didn't come out. It looks like Nothing is there. My daughter Kimberly, source for so many Nothings, brought home a souvenir from her art history class trip to the Metropolitan Museum of Art and other New York sites: a small-format Polaroid photograph made with a friend's camera. She said, "This is my memory of Lincoln Center. It didn't come out." The Polaroid's trademark white borders surround a black space; on the reverse side, the words Fujifilm and "instax" are the only other visible features. Does she remember the museum and the performance at the theater? Yes. Does she remember that the camera didn't work? Probably. Did she throw out the photo because it didn't come out (even though the Polaroid print came out of the camera, the image didn't show up)? No, because this is her souvenir of Nothing happening—and now my historical artifact.

We are usually drawn to the content of an image, which is why looking at Nothing seems like such a strange thing to do. Looking at a blank piece of photographic paper, we might wonder where the photograph went. The photographer Alison Rossiter explores the historical potential of blankness by recovering expired photographic paper and camera film and then making prints from them. She began her work as a "lament, because the beautiful materials were gone," but soon her process transformed into a recovery of latent images in photograms.

The photographer who originally started to use the paper might have worked fifty or a hundred years earlier and never developed it, or the paper may have sat unused and gotten damaged by light,

dampness, mold, or bugs. As Rossiter "pours chemistry down the page," her darkroom chemicals interact with the silver in the paper and she makes photographs without ever using a camera. As she works, "the prints are instantly old when I develop them."[34]

The blank papers were not valuable historical objects because they were beyond their expiration dates and therefore unusable for photography that might fill the form, turning the paper into a photograph. They could only serve history if they were preserved as artifacts of an earlier era in technology. But Rossiter shows them to be historical objects that have successfully withheld their significance: What appeared to be blank, decrepit, and unusable papers are revealed to be full of images from the past that look like landscapes or are filled with patterns with their own aesthetic appeal. In an almost ghostly apparition, the past appears on the blank page, because Nothing was there all along.

Blank spaces have also appeared on pages in far more nefarious ways, inscribing absences onto the historical record to deliberately erase actual presences. Ignorance about indigenous peoples and places was actively recorded in the annals of Western civilizations' explorations of the globe. Here agnotology meets the history of mapmaking and ignorance meets art.

First of all, medieval mapmakers were handicapped by not knowing the actual planetary geography of the continents and oceans and so produced genuinely inaccurate maps. No one is blaming them for the limits on their knowledge. But in their depiction of the world beyond their ken, mapmakers also reflected their own "known world," with all its ignorance and prejudices, by creating imaginary sea monsters in the vast oceans and populating foreign lands with devils and half-human, half-fantastical creatures. Since at least the seventeenth century, a *horror vacui*, or fear of leaving open spaces on the drawn map, led cartographers to decorate maps of the world with elaborate illustrations, often strategically placed in the widest open spaces—ostensibly full of Nothing.[35] This is how the oceans were frequently

presented, covered up by the decorations of civilization. While aesthetically pleasing to consumers and, most important, patrons, this method also allowed mapmakers to mask their ignorance behind images that could be used to convey ideas about power and the "natural" order. Mapmakers and Melville had this in common.

The logical consequence of following maps made by cartographers who relied on Western explorers and settler-colonialists for information was the declaration of large expanses of newly reconnoitered territories as *terra nullius*, Latin for "nobody's land." This is what happened in Australia in 1819. New South Wales was declared "desert and uninhabited" by its British colonizers, backdating to the arrival of the First Fleet in 1788 and legally determining claims to land into the 1970s. Conflating categories of "unowned land" and "unpopulated space" conveniently allowed officials to ignore the presence of some 250,000 Aboriginals (the number is disputed but likely much higher) on territory that no existing court had designated as belonging to someone.

As the historian Patrick Brantlinger argued in his book *Dark Vanishings: Discourse on the Extinction of Primitive Races, 1800–1930* (2003), designation of *terra nullius* was followed by two centuries of colonial and missionary writings predicting the imminent demise of the "savage races." Whether in woeful and morally outraged terms or, more commonly, in terms of inevitability and the glory of the civilizing mission, white residents of Australia and the governments of the British Empire expressed their conviction that a land previously uncivilized was a land previously uninhabited and that a land properly civilized would be a land devoid of natives, who would either assimilate or vanish. That's how easily they rationalized from "Nothing is there" to "Nothing is left."

In the case of the person publicly declared "the last Tasmanian man," William Lanney or "King Billy," who died in 1869, or "the last Tasmanian woman," Truganini, who died in 1876, the supposed first-ever extinction of a primitive race served colonial agendas. By

erasing the actual presence of mixed-race people in the same Tasmanian communities, officials could ignore claims to land, restitution, and more. Predictions of extinction essentially created an empty category (*terra nullius*) as grounds for legal claims to land, thus offering the blank page on which to inscribe the eradication of indigenous peoples.

Empty spaces are where Nothing happens, and empty spaces are drawn on maps when mapmakers don't know what exists there. We know there *is* something, but we either don't know what it is or prefer not to acknowledge it or to treat it as worthy of knowing. Empty spaces and blank pages can be seen as a threat to systems of knowledge in which everything must have a place. Nothing occupies a conceptual space as well as a physical one; it is a realm of ignorance and forgetting, of pages that should be filled and filed.

In his still relevant novel *1984* (1949), George Orwell invented the term "memory hole" to represent the deliberate erasure and revision of official knowledge: Historical documents were dumped into tubes that led straight to the incinerator. We need new terms to express the kind of ignorance that obliterates memories. As scholar Liedeke Plate suggests, English isn't the only language that doesn't have a word for it.

The process of remembering produces memories; the process of forgetting produces—. Neither in English nor in my native Dutch is there a word for what is forgotten. . . .

[But in French] to forget is "oublier" and what is forgotten is "un oubli." . . . The existence of this word in French—as well as derived words, such as "oubliette," which refers to a secret dungeon with only a trapdoor through which people were literally thrown into oblivion, for it was designed for people condemned to be locked up for life—suggests that it is Germanic languages which produce the lack of a language to speak about forgetting.[36]

Lacking a word for "that which is forgotten" sounds like a joke (did we forget the word that does exist?). Ignorance would then be an excuse for not knowing the word. Plate and I needed new terms to identify our object of inquiry. My notion of gerundology is a bit more awkward and punny; Plate coins the term *amnesiology* to open up realms of forgetting and the forgotten for scholarly research. How do we study the history of what's not there, what's been forgotten, what no one wants to acknowledge? By acting as though, indeed, Nothing happens for a reason.

The Know-Nothing Party was formed on the secret handshake pledge not to reveal the party's meeting locations. Secrecy also happens for a reason: desire and/or need to hide the truth. If you ask someone about something they are supposed to be keeping secret, they may act as though they are drawing a blank and just can't remember or are absolutely ignorant about whatever they're being asked about. The 1960s sitcom *Hogan's Heroes* immortalized this form of ignorance in the figure of Sergeant Schultz, who kept insisting "I know nothing, *nothing!*" whenever his Allied POWs during World War II were up to their usual tricks. Regardless of the preposterousness of Schultz's ineptitude, his poker face was priceless—and useless, since Schultz's propensity for divulging secrets enabled Hogan to conduct all manner of resistance operations.[37] An imperturbable poker face is required for those who must keep official secrets. Secrecy is a kind of silence; both are replete with Nothing happening.

Secrecy is genuinely required for information that is never supposed to be made public but that is known to those who use it. So-called black sites and black ops involve places, people, and conduct that are officially sanctioned but also officially not happening. Nothing happens all the time in the realm of black ops, and this can be seen, though only unofficially. Photographer Trevor Paglen's efforts to document reconnaissance operations and black sites has involved telephotography, astrophotography, and a great deal of persistence and investigation.[38]

One collection of Paglen's photographs, *Invisible: Covert Operations and Classified Landscapes* (2010), features images of the sky, with traces of satellite trajectories depicted as time-lapse tracks of the classified object moving across a dark or blue horizon, revealing the presence of reconnaissance satellites. Paglen relies on information about the satellites located by amateur astronomers, who are using only publicly available information, binoculars, and stopwatches to track them.[39] His images of black sites, where classified American military and intelligence operations are conducted, are made at distances measured in miles. In both cases—the "other" night sky illuminated by satellite tracks or the officially nonexistent sites in the Western U.S. deserts—Paglen creates both blurry and sharply delineated photographs of the ways Nothing is happening, and he is watching it happen. His photography is art as well as document, record of official erasure and record of secrecy.

Documents collected and preserved in archives become records of transactions and events, decisions and secrets. Their persistent presence appears to guarantee that Nothing will be lost, if it was intended to be kept; or as Carolyn Steedman said in the introduction, the dust in the archive makes it seem as though Nothing goes away. But historians also know that archives hide as much as they hold. The archives include maps of empty spaces and blank pages in record books, and a vast amount of the past never made it into the archives to begin with. Nothing, indeed, goes away; it has already gone away. We don't even know everything that's not in the archives, so vast is the realm of our ignorance, worthy of years of agnotology—or history.

Archives will keep historians busy, but they will never be the only place where history happens. Studying how Nothing happens means observing the production of history in the present, which is not the historian's usual stomping ground. Historians supposedly look at the past in the past. Asking historians to do Nothing sounds

not only counterintuitive but the very opposite of doing. "Do Nothing!" is more likely what someone says when they are telling you not to act. Instead, you should refuse to act, wait, hold off, or act only on condition: "Do Nothing until/unless . . . " Insisting that Nothing should happen in the present but might possibly in the future, the imperative resounds with abeyance and deferred meaning. But historians might want to rethink their present stance. We should study the past wherever we can find it, including where Nothing is happening and where the historically conscious observer is looking back on when Nothing was happening and thinking, "I want to know about *that*."

Historians can do Nothing—or at least, we won't do Nothing any more than anyone else, because we all do Nothing sometimes. What historians do is research and write. We wouldn't be able to have a history of doing Nothing, as Patrick McGuiness said, without doing the writing. And who would want to read it? Well, you've made it this far: You are reading it and I am writing it so we are doing Nothing together.

NOTHING IS
THE WAY IT WAS

I LOVE TELLING PEOPLE I'm working on the history of Nothing. My topic usually sparks humor and puzzled curiosity—which is much more engaging than the blank stares I usually get when I say I work on historical consciousness, although it's actually the same thing.

It is utterly unremarkable for a historian to say, "Nothing is the way it was." Without change, there would be no history. End of discussion. But when a historian says she's working on the history of Nothing, one might well wonder, History of what? Since we are no longer doing Nothing, let's look at what happened while we weren't thinking about it.

Historical consciousness is that moment when you notice how the present is different from the past. Nothing was happening, and now something tells us that what was happening is now in the past.

What is that something? Did we notice the change while it was happening, or only afterward? Could we see it? One visible form of change over time is the object we call a ruin: the architectural remains of human construction that have decayed or been partly destroyed at some point in the past or over time. Paintings of ruins have been made for ages; and for more than 150 years, photographs of ruins have preserved their memory, even as ruin continued to happen or perhaps humans intervened to preserve them. Pictures of ruins offer tremendous scope for the historical imagination: We can see the way it is *and* the way it was, or at least, we can try to remember by imagining what we never saw or knew about for ourselves. That's how histories always begin: in our minds' eye, in imagination.

Whether in a natural or man-made state of destruction, ruins show us that Nothing is the way it was. Ruins persist as remnants and reminders of mortality, offering themselves for contemplation of what has been, what has been lost, and how everything comes to a natural end. Appreciation of ruins has inspired inklings of the sublime, translated into art and poetry. But if we don't find them attractive or meaningful, the same objects will seem like rubble rather than ruins, and we may think that a bulldozer would be more useful than a historical marker for this particular leftover from the past. Rubble or ruin? That is always a question, and artists are not the only ones who make decisions about how to frame the response.

One group of people charmed by ruins interact with them in a particular way: They break into them. So-called urban explorers (UrbExers) are enchanted by the eerie beauty in modern ruins, which they attempt to capture and preserve in photographs. How-to manuals for urban exploration (UrbEx) photography offer insights into how the practitioners understand their responsibility to the ruins and to themselves as photographers who should "take nothing but pictures and leave nothing but footprints." Looking at abandoned spaces alongside UrbExers allows us to be historically conscious travelers in the present.

What might a history of historical consciousness look like? It could look like a history of ruins appreciation, starting with a list of those ruins still existing, a supplement on those that are not, and a discussion of aesthetics then and now. British author Rose Macaulay wrote a famous book about this in 1953, which I consider in this episode. But a history of ruins seen from the perspective of "Nothing is the way it was" looks a bit different. Instead of telling the history of ruins per se, I explore how people have interacted with visual representation of ruins in the twentieth century, particularly in the German states. As a historian, I have worked on nineteenth-century German history and done research in West Germany, East Germany, and Germany. I found not only ruins and a fascination with them but also postcards that depicted ruins. Why is there a market for postcards that depict ruins? Postcards of ruins have circulated for over a hundred years, particularly after both world wars. What do postcards of ruins tell us about the fascination with ruins and, in turn, about historical consciousness? Placing the UrbEx how-to manual next to the ruins postcard, we can see a wide variety of responses to ruins that go beyond art history surveys or historic preservation debates. Historical consciousness is never only something that historians theorize about: It is a lived experience, and sometimes worthy of a postcard, even in this digital age.

Having done Nothing, we are left to ponder what it means once Nothing is the way it was. When, exactly, did Nothing happen? Historically conscious minds want to know. Living in Berlin in 1989, I was thinking about history all the time, and I still had no idea how relevant this question would become.[1]

§ THE FALL OF THE BERLIN WALL:
LIVING THROUGH HISTORICAL CHANGE

The photographic image is full, crammed:
no room, nothing can be added to it.
<div align="right">Roland Barthes, Camera Lucida, 89</div>

It's customary for scholars working on photography to cite the French critic Roland Barthes. His iconic 1981 book on the medium is even more complexly interesting than scholars realize—and there are many who have contemplated this text—because *Camera Lucida: Reflections on Photography* is full of "nothing."[2] The word *nothing* appears on at least ten different pages in significantly different ways. After Barthes gets to the image at the core of the book, the absent photograph of his mother, Nothing fills the page.

> [The] horror is this: nothing to say about the death of one whom I love most, nothing to say about her photograph, which I contemplate without ever being able to get to the heart of it, to transform it. . . . I have no other resource than this *irony*: to speak of the "nothing to say."[3]

Barthes goes on to note that both the modern discipline of history and the invention of photography were products of the Western nineteenth century. They grew up together and produced Nothing—that is, they engendered a fascination with the ironic condition of distance from the subject of our passionate interest: the past and the dead. So when we think about the past and write histories about it, we are speaking all about and around the Nothing that eludes our grasp. Both history and photography attest to the irony of talking about what we only know as the absent past, which we either lived through or are experiencing as memory of the past in the present.

Nothing *is* "the way it was"—that's how we experienced Nothing happening in the present. Nothing is always the same; it's always Nothing. And "Nothing is the way it was" because that's how we express a sense of the change between past and present. "Nothing" is full of meaning and potential; so full that, like Barthes' photograph, Nothing can be added to it. Only to the unaccustomed eye (or someone unfamiliar with Episode 1) would Nothing appear to be blank or empty. People have tended to think of the past as over and

done with and, as such, fixed: It happened, that's the way it was, you can't change it. The past is complete in itself, almost infinitely vast in scope and scale, so full that Nothing can be added to it. Which is exactly what happens: Nothing is happening (that's the present), and then it has happened and has become part of the past. Nothing gets added to the past all the time.

But to assert that Nothing is the way it was is also to acknowledge the persistence of the past in the present, lived in our own bodies (mine certainly isn't the way it was, but I'm still here) and whose meanings are changing as we live through the aftermath of the then becoming the now. Neither the past nor the present is static. Nothing *is* the way it *was*—they're identical, not antithetical, in their nothingness.

When a photographer says that nothing is the way it was after 1989, she is perhaps suggesting that there are two blank sides to a geopolitical coin. There's the way it was and there's the way it is, and now both those things mean something other than they did before. The East German photographer Eva Mahn created images of people and streets in her adopted hometown of Halle; these were published in 1992 under the title *"Nichts ist mehr wie es war": Eva Mahn, Bilder 1982–1989* (Nothing Is the Way It Was: Eva Mahn, Photographs 1982–1989). Mahn was born in Aschersleben in 1947. From 1969 to 1977 she worked as a model for East German fashion magazines while becoming a photographer herself. She also pursued an academic career in art from 1972 to 2011, earning her doctorate at the University of Leipzig in 1991. In her book the photographs offer images of real presence: faces and landscapes that seem to contradict any assertion of nothingness. Her title is eloquent; like a caption, it changes everything you might think about the images.

Colloquially, when you say, "Nothing is the way it was," you are acknowledging that change happens over time, but you're also asserting that the natural temporal flow is more marked in times of crisis. We live through time and its normal passage, so the realization

that nothing is the way it was usually appears abruptly. Mahn made her images over a nine-year period, from 1982 to 1991, but for her title she chose an endpoint whose meaning is overdetermined in modern German history. The book's dedication also indicates the profound sense of loss she experienced in 1989, well before the fall of the Berlin Wall: "For Matthias, who left East Germany on March 15, 1989, eight months before the opening of the border; this news was received like a death notice." In the book, Mahn explains that Matthias was a painter and her partner for over twelve years. After he left, clearly, she felt that nothing is the way it was anymore. His leaving made her question why she stayed, as well as why he rejected her and their family.[4]

Mahn's image of a November 1989 Monday Protest (Figure 6), one of a cascading series of events that led to the fall of the Berlin Wall and the end of East Germany, is the only one in the collection that specifically depicts the political turmoil of 1989. That 1989 could mean the transformation of more than one kind of Nothing should indicate that overdetermined meanings are just that and that one kind of transformation of geopolitical significance can be eclipsed and implicated in others, transformations enmeshed in politics and culture but also in individuals, relationships, and memory.

In a nation that transformed itself no fewer than five times in one century, what does it mean, after all, to say, "Nothing is the way it was"? Mahn photographed Halle, a city whose architecture was relatively intact after World War II, making its historical buildings all the more distinctive. Their presence would seem to contradict Mahn's framing of them as Nothing; other German cities that lost those structures surely have a greater claim to the title. Yet Halle's facades offer reflections of the recent past in which histories of regime change intersect with the natural histories of destruction. At what point, exactly, did Nothing become the way it was?

Mahn's images of iconic streets, such as the Bölbergasse, seem almost timeless, invoking the nineteenth century as well as the present, with cobbled streets and sidewalks, *Heimat* (homeland)

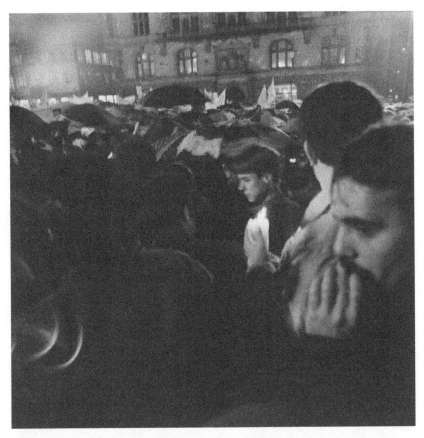

Figure 6. Eva Mahn, "Montags-Demonstration [Monday Protest] in Halle, 6 November 1989." Reprinted by permission of the photographer.

sensibilities, and *Fachwerk* (timber-framed) architecture that survived twentieth-century calamities or got repaired in the spirit of the old days (Figure 7). And yet Mahn offers these images in the context of the profound changes of 1989, which fundamentally altered previous understandings of both personal and national pasts and futures. Photographs made to assert the presence of their subjects, to insist on their unique identities and location in place and time, were assembled to suggest radical change and the unreliability of static identity.

The empty street, devoid of people, suggests an early morning hour before pedestrians are up and about. Like the depiction of Berlin awakening during the opening moments of Walter Ruttman's classic 1927 film *Berlin: Symphony of a Metropolis*, Halle appears still to be slumbering into a new day. At dawn, quiet and change are pronounced together on the Bölbergasse. The sunlight, transcending borders as it always does, bends its way around a corner and is reflected in the store window. Sunlight travels 8 minutes before reaching the earth. Did the light arrive before or after the Wall came down, and would this make any difference in what the photograph can be said to represent? Does the sunlight in the window reflect the past and the city's origins, or does it only illuminate what was already there, because, after all, there is nothing new under the sun?

This photograph of Bölbergasse (Figure 7) was made in August 1991. It is one of five images in the collection made after 1989, although it is the only one of those that appears in the section "Faces of a City"; the other four appear together at the end, following a more regular chronological order. The light of a new day might have meant something quite different in the mid-1980s than it did in 1991. A photograph's original contexts do not always travel with it.

Like her contemporary Helga Paris (Figure 8), Mahn uses her camera to represent the cityscape of Halle at a time when its ruination, a result of pollution and neglect, was causing public outcry in East Germany. Paris created a series of photographs titled "Houses and Faces, Halle, 1983–85" in which she said she tried to photograph "Halle as though it was a foreign city in a foreign country" in "an attempt to forget everything I could know and understand. As though I was taking photographs in Rome, for example."[5]

It's not coincidental that Paris chose to imagine the past as a foreign country by using the example of Rome, which is full of famous architectural ruins. Empty streets allow one to see the historical architecture, particularly the edge of a peaked roof at the intersection,

Figure 7. Eva Mahn, "Bölbergasse, Halle, August 1991." Reprinted by permission of the photographer.

Figure 8. Helga Paris, "Untitled," from "Houses and Faces, 1983–85," in *Helga Paris: Fotografien/Photographs,* ed. Inka Schube (Berlin: Holzwarth, 2004), 163. Reprinted by permission of the photographer.

and imagine that Nothing has changed over time. In Figure 8 only the street light and antennae betray that the image was not made in the 1920s or earlier. Both Paris and Mahn play with the idea of different kinds of "faces" visible in a cityscape, including portrait-style images of people as well as exteriors of buildings and streetscapes. In Mahn's collection, a section titled "Faces of the City" draws particular attention to the way a blank wall is one kind of face (Figure 9) that, like a face in a crowd, is usually anonymous, hidden beside an adjacent wall or commingling with neighboring structures.

Figure 9. Eva Mahn, "Am Neuen Theater [At the New Theater], Halle, November 1989." Reprinted by permission of the photographer.

Only an address distinguishes the blankness, or a date; the photograph in Figure 9 was taken in November 1989, but whether it was taken before or after the fall of the Berlin Wall on November 9 is not indicated. The wall retains the shadows of prior neighbors, a history that has been erased by the open space beside it; Nothing is there. Foundations, outlines, and extensions document the building's past without offering any indication of the meaning of its future beyond the persistent presence of the building.

Helga Paris also focused on blank walls and empty space in one of the images from her series "Houses and Faces" (Figure 10). A narrow building faces a corner along a narrower street, and all around it open space expands the sense of absence, destruction, and abandonment. Paris's images are arguably grimmer and more Brothers-Grimm-ish than Mahn's, but it's worth considering: Are these photographers' works similar because they are both East Germans in Halle? Are these photographs distinctively *East* German—or, for

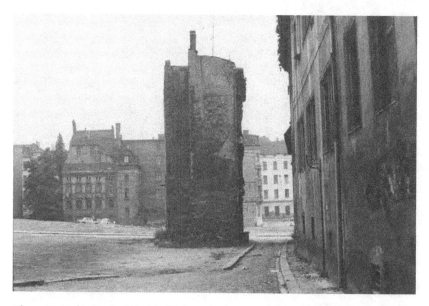

Figure 10. Helga Paris, "Untitled," from "Houses and Faces, 1983–85," in *Helga Paris: Fotografien/Photographs*, ed. Inka Schube (Berlin: Holzwarth, 2004), 179. Reprinted by permission of the photographer.

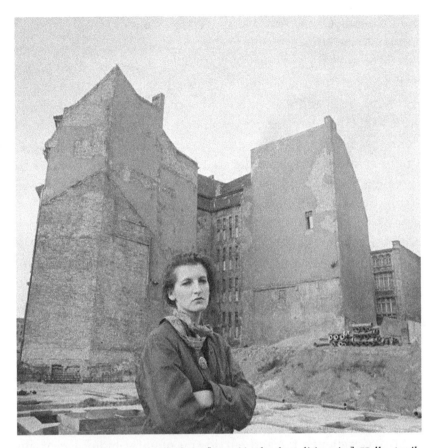

Figure 11. Eva Mahn, "Conni in Abriss [Conni in the demolition site], Halle, April 1989." Reprinted by permission of the photographer.

that matter, *German*? Are they also *Roman*? Or better yet, *Romantic*? Is there an elegiac gaze at work here that defies political-ideological constraints, harkening back to Romantic sensibilities about the appeal of antique architectural ruins?

Paris usually separates her buildings and her people, focusing clearly on one or the other. Mahn poses her subjects next to blank exterior walls, doubling the faces and inscribing multiple identities on what photography curator Joel Smith calls "the sentient wall."[6] The walls know that they are doomed; a demolition site in the middle of the city is a place where the past is being torn down.

A woman, Conni, poses laconically in front of a building (Figure 11). Excavation and demolition are clearly in process behind her, although there is no evidence of it in progress; there are only piles of dirt and rubble, so it's unclear how long the demolition has been going on or how long the ruins have been in this state. Mahn highlights the textures of the looming walls, the lines demarcating former connections to neighbors and structures. Conni is in the middle of the changes. There are no borders to the mess, either temporally or geographically, only the image frame; everything the photographer sees is *in Abriss* (in the process of demolition). The wall will not stand much longer to bear witness to how nothing is the way it was. This demolition was inaugurated before the political transformation was imagined, much less occurring.

This image of Conni is also from the first half of 1989, but already, Nothing is anymore the way it was. And this has been happening, failing to happen, and staying the way it was since the war ended. The East German national anthem was called "Risen from the Ruins," and it began, "Risen from the ruins / Turning toward the future." Risen from the ruins of the war and enduring the ruination of both former national identities and the Cold War's segregation of the two Germanies, the anthem dreams of unity and peace. Mahn and Paris depict the ruins of the dream amid the ruins of the city: Blank walls, empty windows, and people turned away from the ruins as from false hopes for the future.

Conni had already appeared a few pages earlier in Mahn's book, identified as "housekeeper, painter." In Figure 11 the housekeeper stands next to a mess. She is facing away from both the wall and the camera, turning her head slightly toward Mahn, with rubble piled up behind her and windows torn from their frames or blocked up. The roof sags. Will this building's ruination proceed, or does the demolition only happen to lie between Conni and the blank wall?

A blank wall, like a blank slate, can be inscribed from scratch. It has Nothing on it. Nothing is happening, Nothing is the way it was

or the way it will be; all is in limbo. The present is when Nothing *is*; or the present *is* the way it was—lingering in an expanded present that includes now, then, and what's next, demolition and construction. Conni is not directly involved. She neither observes nor comments. She is simply there and Nothing is *happening* in the present. Is this an indictment of the state, which must be responsible for the slow pace of demolition and reconstruction, both literally and figuratively? As Barthes commented, "It is in proportion to its certainty that I can say nothing about this photograph."[7]

Mahn took several images at demolition sites, with and without people, in the spring and summer of 1989. In one image an unidentified man and woman stand on the street corner, looking away from the camera (Figure 12). Ironically, they are standing beneath an advertisement for a "window decoration" business. There are no shop windows to admire, nor houses with attractively decorated windows; instead, the couple looks away from the crumbling curb, peeling stucco, and construction materials piled up against the building. Is this an optimistic gaze? Is looking away the same thing as looking toward the future? Or is this an escapist gaze, unwilling to engage the reality around them? Or are they overfamiliar with the surroundings, and did they see something more interesting nearby, outside the frame? Were they told to look away?

The photograph in Figure 12 highlights how, for historians, no image stands alone and speaks for itself. Mahn contextualizes this image by placing it in proximity to others and by blurring the line between 1989 as past and present. We know that Mahn is East German and that her subjects are East Germans, and we therefore know a lot about the possible parameters of the historical context. But otherwise, we would know precisely Nothing other than what we can describe: a man, a woman, a building, crumbling curbs, foreground and background, black and white and gray. The ambiguities of the man and woman's gazes, as well as the photographer's and our own, multiply the possible contexts in which this image might appear as an illustration of a historical interpretation. By definition, and in

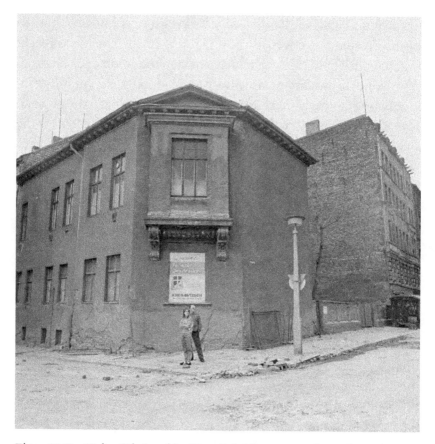

Figure 12. Eva Mahn, "Abrissgebiet Harz, Ecke Georgstrasse [Demolition site Harz, corner of Georg St.], Halle, April 1989." Reprinted by permission of the photographer.

my own experience, historical transformation is something not understood at the time it happens. Meanings are formulated later to help the participants and observers understand what it meant, and those meanings are neither fixed nor true. The meanings serve as markers for the demolition of previous meanings and the creation of new ones: for the construction of historical meaning from the ruins of the past.

I visited Berlin for the first time in 1988 to conduct preliminary research for my doctoral dissertation. I moved to Berlin in August

1989 and spent the following year being constantly surprised by the way history happened around me, and that experience has profoundly affected my historical scholarship. Even if everyone agreed that something unpredictable and new was happening on November 10, 1989—something that began in the late hours of November 9, with the opening of the borders becoming the fall of the Berlin Wall as it continued to play out over a long, euphoric weekend—it didn't become "the fall of the Wall" immediately. Stunned, excited, exhausted participants and interested observers made it so. Everyone agreed that Nothing was the way it had been; everything had changed. But no one knew for sure what that meant. Nothing was certain.

Eva Mahn and I were both in eastern Germany making photographs in 1988–90. We both watched the Wall become a ruin while her Berlin was off limits to me and mine was off limits to her. She had the majority of Berlin's historical monuments on her side, and buildings still marked by the violence of World War II. I had World War II ruins as memorial in the Kaiser Wilhelm memorial church around the corner from my apartment in 1989–90 while I, like Mahn, was conducting dissertation research. I missed the beginning of the event, the opening of the border on November 9, because I wasn't in the habit of watching or listening to the news at night, so I didn't have a camera with me on November 10. Diligently going to the library that morning on the bus, I got my first clue: Lines were forming outside the banks as the East Germans came to collect their "greeting money" from the West German government. And this is how I learned that history happens even when you have Nothing to record it with but memory.

Thanks to my fellow diligent graduate student in German history, Sue Marchand (who was also at the library but, typically, knew what was going on), we left our books and walked to Checkpoint Charlie in plenty of time to share the excitement. Jubilant East Germans were driving through the checkpoint and being greeted by equally jubilant West Germans, who threw carnations at them and popped bottles of *Sekt* (German champagne) over their cars before passing

the bottles to them. Eventually we went home, got our cameras, and went to un-iconic locations: Instead of the Brandenburg Gate, we went to the Wall near the library that night; the next day we got off the U-Bahn at Invalidenstrasse. I don't remember why we chose that crossing point, but I do remember being startled by the long line of Trabis we saw heading *back* into East Berlin in the late afternoon. Reunification was far from a given at that moment.

After that euphoric, surreal weekend, I took weekly and then more irregular walks between the national library and the Reichstag throughout the coming year, photographing the disappearance of the Wall. After several months, even I couldn't be sure where it had been. There was Nothing left to guide me but my own snapshots.

As Susan Sontag noted in her book *Regarding the Pain of Others,* "The problem isn't that people remember through photographs, but that they remember only through photographs."[8] (You can't talk about photographs without talking about Susan Sontag either.) My mom kept looking for her Susan in the news photographs from Berlin, or on TV. She knew I was there, but there was Nothing that represented me. Even iconic photographs—or especially those—leave out a lot about what people want to know, and yet they are the most likely to be recirculated, thus inscribing insufficient images into collective memory. Soon there was Nothing left of the Wall but souvenir chips chiseled off the western, graffitied side and the sections of Wall that were purchased or gifted internationally to be preserved as historical artifacts.

A wall is many things: a barrier, a support structure, a design element, a place to hang pictures and diplomas, or a place to insert openings for doors or windows. We tend to expect walls to stand. But in German history, the Wall is only ever one thing—even if it had different names, depending on which side of it you were on, such as "antifascist protection barrier" on the eastern side—and that Wall required demolition.

Mahn photographed people and made portraits against the background of construction sites. But, to her, were these sites just ruins,

or were they walls? A series of interior portraits place nude people in empty rooms, against bare walls and light-filled windows, leaving open the possibility of inscribing meaning in space (Figure 13). A child's play and rapid movement transform the enclosure into a playground, in which the adults assist or observe, while also letting themselves be observed. As historian Paul Betts has suggested in his book *Within Walls: Private Life in the German Democratic Republic* (2010), the domestic interior, particularly the living room, was the most private place to make a photograph in East Germany, the place most often chosen for visual expression of non-state-sanctioned subjectivity.[9]

Mahn's exterior portraits, placed against blank walls that were not originally created to be visible, reflect that same subjectivity. Ironically, walls frame her subjects by offering them the most open sky—as on the plains or in a desert, where the horizons are broad or, like a screen, open and flat and available. Ruins provide an expansive backdrop—so much Nothing, in fact, that subjectivities formerly relegated to interiors could expand and express themselves outside, in public. Ruins on the demolition site, *in Abriss*, enabled the photographer and her subjects to speak freely.

The image of the rubble at Martin Luther University of Halle-Wittenberg is my favorite from Mahn's book (Figure 14). The balding gentleman in his dark coat, I imagine, is any professor shambling along on his way to class on a venerable campus. That's just my impression, nor would I suggest this is in any way what Mahn intended. Because it's labeled "Universitätsplatz [University Square], Halle, November 1989," I read the figure as professorial, despite the fact that he holds a shopping bag in his hand and not a briefcase. This is a willful reading, perhaps, because I am a professor and fascinated by ruins. In this image the aesthetics of ruin meets the documentation of demolition head on, and that's because of my subjective investments in the topic as much as because of the historical significance of the image or the photographer's vision.

Figure 13. Eva Mahn, "Aus der Serie 'Menschen im Raum' [From the Series "People in Rooms"], 1982." Reprinted by permission of the photographer.

It's worth considering how historians choose the images that they use to illustrate their narratives. Like quotes we use for evidence, we choose an image that best exemplifies a point we want to make, one that seems to sum up a key idea pithily and directly, one that illustrates the point even better than we might be able to elucidate it. Like quotes, images should not be presumed to speak for themselves; they require explanation of their origin or provenance, their contents, the contexts of their making and their recirculation, and their appearance in the text or presentation. You have to explain why you chose *that* one.

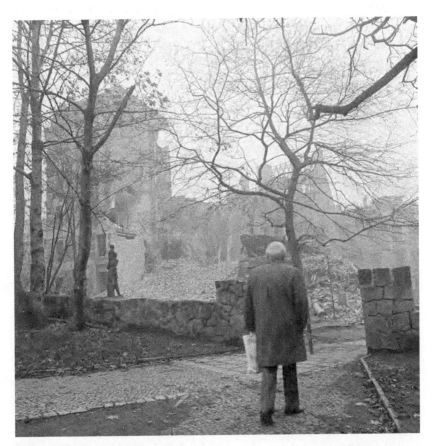

Figure 14. Eva Mahn, "Universitätsplatz, Halle, November 1989." Reprinted by permission of the photographer.

The visual archive on the twentieth century is vast, and we have barely begun to explore the surface of it. Mahn's book presents only a fraction of the images she made. Each photograph is a piece of what's left from the past in the present, and photographs of rubbles and ruins make this point most vividly. Each photograph *is* a ruin: the remnant in the present of that part of the past it constructed. As a material object, as a reproduction in a book, as a slide in a presentation, or as a digitized image, each photo is a bit of rubble that reminds us that Nothing is the way it was.

How does Nothing stay the same when change is inevitable? Isn't it deeply ironic that Nothing is something that stays the same? Are photographs uniquely able to facilitate this understanding of interrupted temporal flow, making them ideal kinds of historical evidence of Nothing?

Considerable scholarly energy has been turned to the production and circulation of iconic images of German city ruins from World War II, bringing them back to the front burners of academic attention, and I will return to the circulation of these images on postcards later in this episode. You could be forgiven for thinking that Mahn's photo of Barfüsserstrasse (Figure 15) dates from World War II, despite the Trabis at the end of the street. (Actually, there's probably not *enough* rubble to think that, but it's suggestive of wartime, another way in which we bring our own mental archive of images to bear on any one that we look at.)

Mahn's image of Barfüsserstrasse evokes that past as well as her present, which is itself located on shifting sands. How does Nothing become the something that resists change by asserting its perpetual, static presence? Man-made ruins created in wartime instantiated a new reality that might or might not be temporary, depending on context. Local responses to the new state of affairs varied according to needs, energy, and available funding, whether from individuals or collectives. Decisions could be made to restore or demolish and clear away, and those plans could also change. Nothing was the same anymore—on that, everyone could agree—but the meaning of Nothing varied substantially.

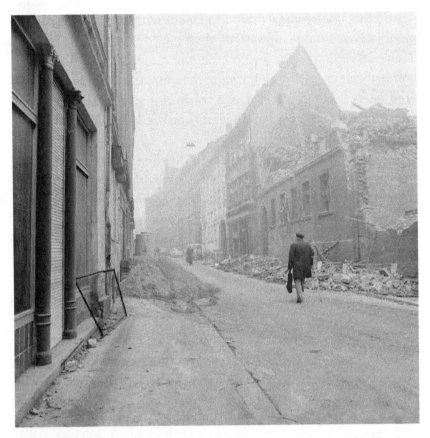

Figure 15. Eva Mahn, "Barfüsserstrasse, Halle, Nov. 1989." Reprinted by permission of the photographer.

How ordinary Germans interacted with their ruined cities has been a subject of recent scholarly interest, much of it focused on the influential expatriate author W. G. Sebald, who drew on his own wartime experiences in Dresden. In *On the Natural History of Destruction* (1999), Sebald cites novelist Alfred Döblin's observations of residents encountering their surroundings in a bombed-out cityscape in 1945: "People walked 'down the street and past the dreadful ruins as if nothing had happened, and . . . the town had always looked like that.'" Sebald reads "as if nothing had happened" as a token of apathy, the antithesis of which

would be "the unquestioning heroism with which people immediately set about the task of clearance and reorganization."[10] There is, in fact, something to be encountered as Nothing in a bombed-out city. Only a minimum of landmarks need to be recovered before reconnoitering can resume. A street can be cleared and remains in place. People can then walk down it as though nothing had happened.

Döblin and everyone else there at the time knew perfectly well that the city had been bombed. That's why they could behave as though Nothing is the way it was. They had to have known it, experienced it, remembered it—"it" was an aerial bombardment that changed everything to nothing being the way it was. A street is not Nothing when it is still there. It is not, however, what it once was. Its context is completely altered, so much so that it seems "the town had always looked like that," so natural is the history of its destruction.

Ruins are what persist in reminding us of what is no longer there. Nothing has stayed the same, but ruins are necessary as evidence that Nothing is the way it was. Ruins in this sense are like photographs: All photographs are remnants of a historical past that is no longer present. Only the photograph, taken out of its original context, remains as a material artifact and landmark of what is no longer the way it was. And just like the people who walk down the ruined streets, viewers of photographs look at them as though they had direct access to a past that is full of Nothing that has yet changed.

I am looking at Mahn's image of Halle in 1989 (Figure 15) to talk about what Döblin saw and Sebald felt in 1945 because the image suggests both pasts to me. But analogies require explanation, and no historian should use a photograph without explaining, in text and with a specific reference to its presence nearby on the page, why that image is there and what it is being used to represent. The biggest, most common mistake historians make is using an image as

illustration, as though the photograph not only speaks for itself but also silently and obviously illustrates something of what that past might have been *like*.

Historians know better. We wouldn't let a quotation appear on a page without a citation, so why do we reprint historical photographs as mere illustrations, sans caption or reference? We probably put them there because we liked them. But just because they're our favorite, because they seems the best illustrations of something that is more importantly stated in words on the page, doesn't mean that we don't have to treat them the same way we would any other historical document. I'm thinking here of most historians who, like myself, are not specialists in histories of photography or for whom the photograph is not the subject of their inquiry. Liking an image may motivate its presence in historical analysis, but its likeness to the past we feel we know requires explanation. *Likeness* is another word for *portrait*, but portraits are best made from life, and the past isn't alive except in memory. What we see isn't "the past"; it's a representation in a photographic ruin from the past. We must recognize it as a material artifact, and it needs to be treated as such, like any other historical document.

The British historian Raphael Samuel demonstrated clearly how historians' interest in the visual artifacts of the past coincided with the emergence of a market for historical photography. In *Theatres of Memory* (1994), Samuel showed how in the 1960s a collector's market for historical photographs emerged and historical postcards became fashionable.[11] "Old photographs" appeared as decoration in shops, on book covers, on posters, and anywhere mass marketing occurred.

By the end of the 1970s, as Roland Barthes was writing *Camera Lucida,* Western popular culture had become saturated with historical photographs, and heritage publishing grew to satisfy the demand for images from local places. A modern appreciation that "Nothing is the way it was" was substantially fostered by historical photographs, which, combined with the reinvigoration of ruins fascination as the

fiftieth anniversary of the war's end approached, produced a histori-
cal context in which Eva Mahn's photographs could appear as arti-
facts of another era rather than as images of the present.

Mahn's photographs provided me with insight into Nothing in its
transitive sense—the perception of change represented through the
static medium of the photograph—and how this can be understood
both by the historically conscious photographer and the historian,
but also perhaps by any historically conscious viewer. Photographs
were once thought to be mirrors of reality, direct and unmediated
representations of the moment preserved by capturing light. Now
we understand that photographs, whether analog or digital, are me-
diated objects that have always represented virtual realities—"the
past," after all, exists only in memory or remains.

As Barthes wrote, "The photographic image is full, crammed: no
room, nothing can be added to it."[12] Nothing could be further from
the truth—but whether you think that's a true statement will depend
on whether you think I've been talking about Nothing all this time,
or whether Nothing *can* be added to the evaluation of photographs.

§ NOTHING IS LEFT: POSTCARDS FROM THE RUINS
An unprecedented and devastating epidemic of foot-and-mouth
disease broke out in Cumbria, England, in 2001. As flocks of sheep
succumbed and the local population reeled from the economic
and social outcome, one local man in Castle Carrock expressed his
sense of shock and horror as "Suddenly there was nothing, abso-
lutely nothing there."[13] He was looking at empty fields, devoid of
the flocks of sheep that normally grazed there. Emptiness was a
sign of the crisis, with empty fields indicating death and loss rather
than Nature or landscape. Photographers such as John Darwell
captured this painful sensibility in images of wide-open spaces
barren of human habitation and absent of sheep (Figure 16).

Nothing is left of the livestock trade or the livelihood of the
sheepherders. The absence of humans is implied in the built

Figure 16. John Darwell, "Closed Footpath, Kirkstone Pass Looking Towards Ullswater," from series "Dark Days," 2001. Photo courtesy of John Darwell. Reprinted by permission.

environment and paved road: They built it, and they have gone. In terms of the epidemic and its impact on the community, a decline in Lake District tourism was an equally devastating result, as the usual hikers and scenery tourists avoided the quarantined space. The ruin of the local economy is visualized in a landscape devoid of humans and beasts.

An uninformed viewer may not see it, perceiving instead the beauty of the terrain as it is captured by the photographer, but to the informed eye, this landscape lies in ruin. When there is Nothing left and this absence is being mourned, photographs become an important mode of documenting and remembering erasure. Photographs of ruins, whether depicting the architectural ruins of earlier civilizations or modern decay or a deserted landscape, show that Nothing is left. In other words, there *is* Nothing to see here.

Darwell's color photograph documents the site of the disaster, the now empty landscape, but it depends on the viewer's knowledge of the epidemic. A random viewer, not from that place, might see only a quiet landscape, misty clouds shrouding steep inclines, rocky walls, and a road wending its way through a pass. Even the caption does not clearly explain the context of the epidemic; it remarks on a closure, which is ironic in proximity to the open road.

As we saw with Eva Mahn's photographs, information about the context in which a photograph is made does not always travel with it. The photographer's intentions and the other photographs in the series of which any photograph is a part remain unconnected to any given photograph unless someone cares a great deal about preserving them. In fact, we know Nothing about a photograph that we did not make ourselves. We see an image and make some sense of it based on what we think we recognize, without considering how we are lacking most of the knowledge necessary to inform us where, when, how, and why the photograph was made, much less what exactly is depicted.

And when the photograph appears to be of Nothing, making sense of it can overwhelm our senses and imagination, even if we care about the subject and already know something about it or even if it is aesthetically appealing. Ruins often have this appeal. But if we aren't drawn to the visual image or are not engaged in the reasons it was made or is being seen, we will see Nothing of particular interest and merely register the visual elements: grass, road, hills, rocks, fences; colors, black, white; sloping angles, triangular sky.

"Suddenly there was nothing, absolutely nothing there." The man looking at the emptiness, not at Darwell's image, is highly engaged. He is so struck by the death of the flocks and the ruin of the economy that it is almost incomprehensible to him. Its apparent and senseless suddenness makes it all the more shocking and upsetting, just as modern ruins disturb viewers differently than ancient ones do. Not only is there Nothing, there is "absolutely nothing," lest there be any doubt about the totality of the loss.

Only in colloquial speech do we modify the word *nothing*, which is otherwise so vast in its scope that it is unambiguous and needs no intensification. How can you have "more" Nothing? Its vastness is typically visualized as an expansive blank, as unrelenting blackness or whiteness, without border. But although this conceptualization is abstract, realistic photographs also depict the vastness of empty space within a border, that of the frame or edges of the image. There was always "more" that could have entered into the frame and "more" that could have been seen or was seen but not captured in the photograph. The totality of what was really there and the totality of what was recorded are always incommensurate. There is always more Nothing there.

John Darwell's landscape photography of the Cumbrian countryside during the epidemic reminds us that what we see is also a representation of what is not there: first and foremost, sheep. In another sense, though, Darwell's focus on the landscape in order to depict what is no longer visible resonates with the history of photography. Visual culture is full of internal references to its own histories, so those familiar with nineteenth-century landscape photography may recognize in Darwell's composition of his image a reference to a famous photograph of a Crimean War battle site (Figure 17).

The title of Roger Fenton's battlefield photograph, "The Valley of the Shadow of Death," hints at many things that are not there, among them the soldiers and the dead, but also evokes a poet and a poem, Alfred Tennyson's "Charge of the Light Brigade" (1854). As a caption, the title provides context, but it works best for viewers who know the history of the conflict and the quoted poem, and in turn the poet's invocation of the biblical psalm. In other words, a photograph's title tells us Nothing we didn't already know. The title of Darwell's photograph in Figure 16, "Closed Footpath, Kirkstone Pass Looking Towards Ullswater," might be better understood through Google Maps than through literature, but the result is the same. The caption is an addition to the photograph, even

Figure 17. Roger Fenton, "The Valley of the Shadow of Death," 1855. Digital image courtesy of the Getty's Open Content Program.

if it was in the mind of the photographer at the time the image was being made. Sometimes a caption illuminates the image for the viewer; sometimes it just adds words that mean "absolutely Nothing" to the viewer, other than that they constitute The Caption. The caption's words remind us of what is missing only if we already knew something about that.

Photographs reference each other, just as the first daguerreotypes referenced the history of painting and smartphone selfies mirror each other. Viewers literate in photography will read them differently if they recognize the references, even if the referenced photographs are immediately visible only in memory. The sheep are not present in the Cumbrian countryside, but they are visible in the memory of the man from Castle Carrock, who might

look at Darwell's image and mentally populate flocks back into that space.

Whether the viewer sees a photographic landscape as half-empty or half-full, a vast nothing or a scenic space, depends on how the viewer feels about what they see. An informed viewer in Cumbria cannot bear the "Nothing, absolutely nothing" that he only begins to comprehend and cannot bear to know. A viewer unassociated with the locale or the event—for instance, a viewer of historical photographs—might miss the context and the references entirely (although, as a historian, they might be in search of them) and instead enjoy the scenery or the composition of the image; or, alternatively, they might find it altogether uninteresting. The informed viewer sees death and ruin; the uninformed viewer sees Nothing to disturb and possibly much to admire.

If we weren't already familiar with the history of a ruin, we might not respond to it emotionally. As we will see later, there are many types of appreciators of ruins in the long history of *Ruinenlust* (desire for and fascination with ruins), but there have always also been those who are unmoved by antiquity and its remains. Looking at ruined landscapes or ruined buildings might not move us. We might feel Nothing, and possibly even feel that our lack of response is inappropriate because we know that ruins are supposed to be significant.

Even though the Romantics insisted that it was natural and human, even divinely inspired, to react with passion to the sublimity of ruins, this was never the only way that humans and communities have interacted with ruins. Many people have felt, in many cultures over time, that ruins are emotionally resonant reminders of mortality, divinity, and Nature's relentless power, but ruins have just as often been ignored, repurposed, and destroyed.

A ruin from antiquity stands as a reminder that there is Nothing (else) left. Ironically, what remains—an empty landscape, a landscape ruined as a battlefield, a partial or empty building—is a sign that Nothing is left. And that sign may quite literally appear later as

a historical marker, a caption that informs us what we need to recognize (because we must already know) a ruin as a historical site (as I will discuss in Episode 3).

When we want to tell other people about what we know, to share the feeling inspired by Nothing being left, we may take a photograph, participating in a ritual that is now almost 200 years old, commemorating historical consciousness through photography. And then we may post an image on social media, just as, back in the nineteenth and twentieth centuries, we might have shared the photograph in the form of a postcard.

The preservation of ruins by way of photography, which we have now seen in several forms, contributed to a visual culture of ruins imagery that tautologically and repetitively asserted the significance of ruins.

Advocates of ruins aesthetics have always coexisted with dissenting collectives, which neither preserved nor conserved ruins, which instead actively tore them down or just as actively ignored them, and this had also been going on since antiquity. And in the case of the British novelist and essayist Rose Macaulay (1881–1958), it was also possible to have it both ways: to experience the destruction of war and being bombed out of her own home and still think that ruins are wonderful.

In her now canonical survey of the ruins of antiquity, *The Pleasure of Ruins* (1953), Rose Macaulay left no stone unturned. Her sources ranged from poetry to painting, her own wide ambit as a global traveler, and a sense of purpose that far exceeded her publisher's intention to produce a stimulating travel guide. This was a woman who wrote the classic opening line, "'Take my camel,' said my Aunt Dot," which struck many of Macaulay's class and generation, as well as admiring readers to follow, as the epitome of imperial insouciance and female autonomy. Her novel *The Towers of Trebizond* (1956) presents two independent and strong-minded British women, Laurie and her Aunt Dot, traveling in the Levant through modern Syria and Turkey, visiting historical sites and ruins.

Macaulay's fictional *Ruinenlust* was preceded by the intensively researched survey. With mordant wit and a confidence born of experience, Macaulay asserted, from the very first line of *The Pleasure of Ruins*, a universal desire to value the remains of the past: "To be fascinated by ruins has always, it would seem, been a human tendency."[14] Delineation of that fascination would occupy her for a further 454 pages. Like historically minded collectors before her, Macaulay assembled and presented the fragments and traces of the past, collating aphorisms and literary images from generations of ruins-fascinated writers.

Macaulay produced the first modern inventory of *Ruinenlust*. Dora Apel credits Macaulay with coining the term, but it is more appropriate to say, with Brian Dillon, that she resurrected a term that mysteriously appears in no German dictionary but was in use at least by the time of the Romantics.[15] Macaulay revived many ruins-fascination terms and clichés, such as "There's a fascination frantic / in a ruin that's romantic,"[16] but she also concludes that this was never merely a Romantic obsession; rather, it was a universal, transhistorical phenomenon.

> Ruin is part of the general Weltschmerz, Sehnsucht, malaise, nostalgia, Angst, frustration, sickness, passion of the human soul; it is the eternal symbol. Literature and art have always carried it; it has had, as a fashion, its ups and downs, but the constant mood and appetite is there.[17]

Although the truth of this statement is debatable and characteristically Eurocentric in its assertion of local cultural values as universal (see Wu Hung's discussion of Chinese evidence to the contrary in *A Story of Ruins* [2012]), Macaulay's perception of the persistence of *Ruinenlust* has certainly been borne out in the late twentieth and twenty-first centuries. Popular at the time as a travelogue and as a learned appreciation of archaeological sites around the world,

The Pleasure of Ruins has become a standard reference for anyone writing about ruins in art, architecture, and literature.

Macaulay's work typically forms half of a pair of references in the literature, the other being German sociologist Georg Simmel's poetic essay "The Ruin" (1911), which was first translated from German into English in 1959; it is unlikely that Macaulay was familiar with it. Simmel famously distinguished between the ruins caused by natural forces over time and the ruins caused by humans. Nature's destruction was a source of sublime inspiration and spiritual reflection, whereas human-created ruins produced ugly and lamentable rubble. Both Simmel and Macaulay imbibed the *Ruinenlust* of such Romantic painters as J. M. W. Turner and Caspar David Friedrich and of late-eighteenth- and early-nineteenth-century Romantic poets and writers who had elevated appreciation of the natural ruin to new heights. Their art and literature has inspired like-minded viewers of ruins ever since.

But the Romantic fascination with the ways in which Nature reclaimed man's best architectural efforts had always neglected the actual context of ruination: human-inflicted violence, particularly warfare. Most of the romantically ruined castles, fortresses, and cathedrals that so dramatically fill the landscapes of the poet's and painter's imaginations were initially ruined in battle, often in wars of religion, and were left unrepaired for centuries because of either lack of funds or regime changes. Nature's reclamation projects usually took over when societies did not, and Rose Macaulay had the opportunity to experience this firsthand.

When Macaulay was bombed out of her London flat during the Blitz, she was "devastated," writes her biographer Sarah Lefanu.[18] While this is surely not surprising, given that she was a victim of bombing during World War II, the fact that Macaulay endured the ruination of her city must be taken into consideration when attempting to understand how the author of *The Pleasure of Ruins* came to view ruins so romantically. How might this be

understood as an expression of grief over ruination, the emotional consequence of disaster, when physical loss and grief are translated into pleasure over ruins? Or, as the Romantics characteristically understood such an apparent conundrum: Was it both logical and emotionally necessary to express grief as related to the experience of the sublime?

Surveying literary life during the Blitz, scholar Lara Feigel concluded that "the ruins of London provided [Macaulay] a physical equivalent for the pain of grief."[19] Romantic *Ruinenlust* comprised a sensation of sublime transport and heightened spiritual awareness, as well melancholy and grief. Although Macaulay had lost her material possessions and home, she retained an emotional connection to the Romantics, who had found both pain and pleasure in the aspect of the decrepit cathedral or "enjungled" castle ramparts of their forefathers.

On the night of May 10–11, 1941, during the last bombing attack on London during the Blitz, more than 500 German aircraft hit major landmarks, such as the Houses of Parliament and the British Museum, bringing death and injury to thousands of civilians. For the 60-year-old Macaulay, who had been bravely driving ambulances and providing assistance throughout the Blitz, the last attack brought the desolation home: "House no more—bombed and burned out of existence, and *nothing* saved. I am bookless, homeless, sans everything but my eyes to weep with."[20] Nothing was left: Nothing was preserved but memory and tears, which bore corporeal witness to the fact that only useless liquid, which could not have quenched the bomb's fires, had poured from her. She was bereft and forced to move.

In becoming homeless, Macaulay lost a library containing four generations' worth of books. Macaulay was related to the British historian Thomas Babington Macaulay, on both sides of her family, and she had inherited volumes dating back to the seventeenth century from him and other relatives, such as her father's valuable editions of Milton.[21] The bombs claimed all her research for current

and past projects, and, most heart-wrenching, some twenty years' correspondence with her lover, Gerald O'Donovan, who was then dying of cancer. Because her affair with the married O'Donovan had been a closely held secret, Macaulay was not free to mourn the loss of the letters publicly.

Her notes to close friends at the time can be understood as alluding to the magnitude of this loss, and *nothing* is the term she returns to repeatedly to express its extent.

> Luxborough Towers have fallen down. Saturday night I returned there after the weekend to find it bombed and burnt to bits—everything—destroyed. I am desolated and desperate—I can't face life without my books. . . . I have no clothes, nothing. I feel like jumping into the river.[22]

Both Feigel and Lefanu note the proximity of this event to the suicide of Macaulay's colleague and competitor, Virginia Woolf, who had committed suicide by filling her pockets with stones and walking into the River Ouse only weeks before. Like Macaulay, Woolf had lost her home to the Blitz. With her lover dying and fellow pacifists like Woolf giving up hope, Macaulay mourned loss of home, impending loss of love, and loss of an archive simultaneously, perhaps inextricably.

Macaulay's initial response to the devastation contains no mention of ruins, only the sense that Nothing was left after ruination happened. Obliterated buildings and treasured objects had vanished. There was nothing there anymore, and Macaulay felt as though the ground had shifted beneath her feet. She could no longer find her bearings amid the emotional turmoil, because in her new sense of the present, Nothing is the way it was.

For Macaulay, paradoxically, Nothing *happened*, or was produced, on May 11, 1941, the night she was bombed out of her home. In the article "Losing One's Books" that she published in the fall of 1941

in *The Spectator*, Macaulay used a dispassionate, deceptively stoic tone, implying that she was only one of many such people affected and that in solidarity, as Brits, "We'll soldier on."

> It happened to me last May to lose my home with all contents in a night of that phenomenon that we oddly called *Blitz*, though why we should use the German for lightning for attacks by bombs I do not know, unless to appease by euphemism, like calling the Furies Eumenides. Anyway, whatever the thing was called, it destroyed my flat, leaving not a wrack behind, or rather, nothing but wracks.[23]

Macaulay plays with the ambivalence of absence and erasure by teasing out the essence of ruins, the way in which a pile of rubble, as a wreck or "wrack," appears as evidence that what was once there is now not, or rather only as remains rather than an intact whole. Nothing *is* left, and that is how it happens: Nothing is what is left behind as wrack and rubble. Obliteration does not entirely remove all traces. Even though a building is rendered uninhabitable, the place remains visible, visit-able, and at the same time lamentably ruined; the home has vanished, and yet there is Nothing left and one can see that.

The ruins of one's home, as countless generations of those rendered homeless by war, terror, or natural disaster bear witness, offer painful evidence of damage and loss. But just as Macaulay noted in regard to casualties of bombing raids, the ways in which Nothing happens to only some people in a population render its devastating effects distant and less painful to those who "live safe in your warm houses," as Primo Levi would say of those fortunate enough not to be Holocaust survivors in the preface to his 1947 memoir, *Survival in Auschwitz*.[24]

Macaulay worked in the British Ministry of Public Information during World War I and, through exposure to the production of

propaganda, had become cynical about efforts to rouse the British public to martial enthusiasm. Like others of her generation, Macaulay became a pacifist in response to the losses inflicted among her friends, such as the death of the poet Rupert Brooke, during the war. Patriotic collective response to war and death proscribed recognition of personal loss, which was so painfully common as to be typical and virtually unremarkable. Describing earlier Blitz damage and her ambulance driving to a friend in 1940, Macaulay noted the media's tendency (enforced by public policy) to gloss over individual injury and death in an effort to sustain the public's morale.

> One wonders all the time how many people are at the moment alive under some ruin, and how much they are suffering in body and mind. But it doesn't do to think much in these days, or to start wondering what "There were a few casualties" covers.[25]

Everyone in London knew firsthand that bombing was causing damage and death, but unless they knew the dead or injured personally or lost their own homes, even Londoners could maintain some minimal distance from the effects of the transformed cityscape—as though "nothing had happened" to them in their "safe houses," while something assuredly had happened to someone else, somewhere else.

Nothing, as experienced by Rose Macaulay thus far in her life's story, would lead a reader to expect the book that followed in 1953, which celebrates the pleasure of ruins. Even amid the bombing, in January 1941, Macaulay had given a radio broadcast that was transmitted to the United States, reporting on the state of London during the Blitz. She called it "Consolations of the War," and in it she allowed herself to indulge the sublime, directly referencing "romantic scenes" such as those painted by Turner (Figure 18), in ways she would do again in her book.

I am mentioning ruins-seeing . . . the beauty of the black nights
and the moonlit ones, the romantic scenes during raids (fire light-
ing the sky, etc.) increased companionableness, shelter life, the
pleasure of waking up still alive each day.[26]

It is as though this is a Macaulay ignorant of the pain and suffering
being experienced throughout London, or else a Macaulay willfully
playing along with the propagandists' intentions and encouraging
soldiering on with one's British companions-in-war, with whom one
shelters even as one loses one's first shelter, one's home. The sub-
lime emerges as a silver lining of the war, offered as recompense and
taken as a gift. The fire lights up the sky as though light is dawning,
as though a new day is approaching in which one can savor life again,
and in this sublimely beautiful moment, one can forget the maiming,

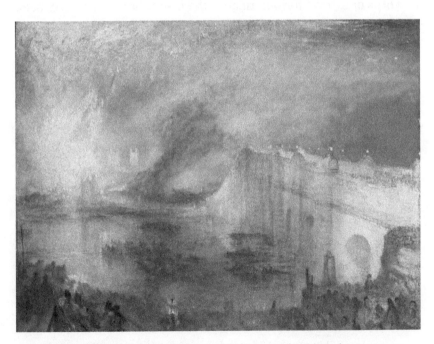

Figure 18. J. M. W. Turner, *The Burning of the Houses of Lords and Commons*
(1835). Digital image courtesy of the Philadelphia Museum of Art.

killing, separations from loved ones, and other terrors that are oc-
curring outside the shelter. As Lara Feigel suggests, many writers in
Macaulay's circle found "the love charm of the bombs" to be a thrill-
ing, titillating benefit of living life on the edge: In a highly charged
atmosphere of "This all could end at any moment," sexual relation-
ships flourished and, like the experience of the sublime, offered brief
but powerful connections to primordial life forces.

"The pleasure of waking up still alive each day" next to a lover was
an important aspect of this silver lining, and one that Rose Macaulay
was losing during the war. Sexual liberty was not escapism but rather
an acknowledgment that there was Nothing one could do about forces
beyond one's control, except to re-engage the senses and emotions in
ways that honor humanity. Just as the Romantics felt overwhelmed by
the sublime in nature and couldn't immediately express the sublime
in words or artistic form until after the inspiration had passed, been
named as such, and thereby distanced, so too Macaulay and other
lovers who lived through the bombing struggled to reconcile their
experiences and their memories while Nothing happened.

In her postwar life and postwar novels, Macaulay continued to
explore the ruins created by bombing. Macaulay found parts of Lon-
don exposed that had not seen the light of day since the era of their
construction centuries before. In her 1949 essay "In the Ruins," pub-
lished in *The Spectator*, Macaulay imagined the societies of other
times, whose ghosts now emerged.

> The vaults and cellars and deep caves, the wrecked guild halls that
> belonged to saddlers, goldsmiths, merchant tailors, haberdashers,
> wax-chandlers, barbers, brewers, coopers and coachmakers, all
> the ancient City fraternities, the broken office stairways that spi-
> ral steeply past empty doorways and rubbled closets into the sky,
> empty shells of churches with their towers still strangely spiring
> above the wilderness, their yawning window arches where green
> boughs push in, their broken pavement floors, the ghosts of tav-
> erns where merchants and clerks once drank.[27]

Curiously, Macaulay chooses to comment on becoming aware of a long-dead past on the sites where death has actually occurred quite distinctly and recently. The bombs have not so much destroyed her world as opened up a tomb. Already "enjungled," where "green boughs push in," her modern world has quickly become a wilderness where nature reclaims its sovereignty and time expands to include far-distant pasts in the present. Macaulay imagines the medieval and early modern past that occupied these spaces; she knows that the ruination occurred only recently and violently, but the ruin has opened up to her imagination an earlier time, the quintessential time of that place, not its most recent iteration. Her imagination is drawn further back because she experiences a sense of connection at this place that defies immediate credibility.

> Yet it has familiarity, as of a place long known; it has the clear dark logic of a dream; it makes a lunatic sense; it is a country that one's soul knows.... Mighty symbol dominating ruin; formidable, insoluble riddle; stronghold, refuge or menace; or mirage and gigantic hoax?[28]

Exposure of the historical roots in this landscape facilitates access, just as viewers of ruins often have a sense of gaining entrée to otherwise restricted premises. Macaulay is delightfully confused, thrilled by a sense of danger in which "primaeval chaos" dominates and resists human efforts to tame or rebuild.

> So men's will to recovery strives against the drifting wilderness to halt and tame it. But the wilderness might slip from their hands, from their spades and measuring rods, slip darkly away from them, seeking the primaeval chaos and old night which was before Londinium was, which will be when cities are ghosts haunting the ancestral dreams of memory.[29]

Macaulay feels the ghostly presence of several pasts, Roman and pagan as well as Christian and medieval. Ruins inspire dreamlike

trances amid the insistent, chaotic presence of nature. The impulse to tame nature is expressed as an effort to rebuild, to insist on civilization, progress, and modernity as noble efforts to resist the ultimately irrefutable triumph of nature's enjungling.

For a writer who could be scathing about the uselessness of autobiography, Macaulay apparently had no qualms about mining her own experiences for plot, character, and themes in her novels, often producing stories that directly mirrored her life. In Macaulay's postwar novel *The World My Wilderness* (1950), London is weedy and its ruins are covered with ever-encroaching greenery. Several passages of the fiction are drawn directly from the 1949 essay. The youthful British heroine, Barbary, has fought as a maquisard in the French Resistance and is unwillingly repatriated to her devastated homeland by her parents. As a traumatized war refugee who has experienced some form of sexual violence in her Maquis espionage, the details of which Macaulay leaves unspecified, Barbary continues to hide from "the fascists" among the ruins, casually committing petty theft. Her unusual name resonates with the North African coast famous for its pirates and slave trade.[30]

Barbary prowls London's modern catacombs, exploring the ravaged, exposed inner workings of the financial center of the city while subverting its capitalist foundations in the name of fighting the fascists. Reluctant to accept money from her father, she paints watercolor picture postcards of bombed-out ruins and sells them to tourists.

> "The postcards are a shilling each," Barbary told two ladies who stopped to look. They were standing in the Fore Street, outside the wall, outside the gate of Cripplegate, at the door of the ruined café. Barbary's postcards were spread out on the low wall. "Look Julia," the ladies told one another. "They are really very nicely done. Did you paint them yourselves, my dears?" "Yes. I expect we are selling them too cheap. Would you pay one and six?" The ladies would. They were real ladies, and one and six was chicken

feed to them; they might have paid half a crown if asked, for they liked bomb ruins, and liked to take mementos of them back to Bournemouth, where they lived.[31]

Class and gender identities play out against the bombed-out ruins as though Nothing had happened to alter prewar British society's norms, and the bomb sites simply offer new venues for transactions and opportunities to purchase mementoes of things "they liked." Macaulay, Barbary, and the ladies all "like" ruins, although for different reasons. Another type of customer in postwar Europe likes bomb sites "still more."

> Sometimes Americans would go by, and they liked bomb ruins still more, not finding in Britain as many as they had been led to expect, and wanting to convince their friends back in Maine or Philadelphia that they had really seen the scars of war. For the Americans Barbary put up the postcards to half a crown. When they went back to lunch this Sunday, they had taken twenty-two and sixpence.[32]

For the Americans who pay more because they have seen less, London after the Blitz fails to live up to its reputation. Nothing is the way it was supposed to be; that is, they expected more Nothing, in the form of ruins, than they found. American funding props up the ruins economy because the tourists expect to really see "the scars of war"; to be worthy of viewing, the ruins must live up to heightened expectations of what had been worth fighting against. The damage is supposed to look as bad as the Nazis have been found to be after perpetrating not only aerial bombardment but also the Holocaust. That Nothing is as it was expected to be threatens to undermine the belief in the nature of Nazi evil. When the real thing isn't up to snuff, paying for a postcard of snuffed-out buildings is the next best thing and provides income to feed the antifascist living among the ruins.

Macaulay's novel concludes with the ruin not only of London but also of her heroine's body. Barbary cannot reconcile memories

of wartime dangers with postwar safety and confuses British peace-time police work with Nazi terrorism. She is guilty of theft and trespass, and she hides; when she fears her friends are in danger, she emerges, disastrously.

> She had crossed Wood Street and reached Addle Street and Philip Lane, and was running between St. Alban's and St. Mary the Virgin's, when the other Gestapo appeared. . . . Startled, she forgot to look where she trod, stepped forward into nothingness, plunged steeply down a chasm into the stony ruins of a deep cellar, and there lay still beneath a thorn-apple bush, among the medieval foundations of Messrs. Foster, Crockett and Porter's warehouse. They—Messrs. Foster, Crockett and Porter—had been used to make surgical instruments, which were what she would now require.[33]

The chapter ends abruptly with Barbary's devastating injury, her step "into nothingness," in which the vast depths of the ruined space no longer provide shelter or safety or income and instead harm her body. Barbary experiences both the Romantic sublime of ruins and the chaotic rubble that has not been cleared, a wilderness in which medieval and modern structures collapse together and are enjungled, "where the ravines were deep in dripping greenery that grew high and rank, running over the ruins as the jungle runs over Maya temples, hiding them from prying eyes."[34]

Both types of ruins offer shelter and sustenance, but in the end, both recede into the natural state, the prehuman past from which civilizations have risen and fallen and which transcends civilized chronologies to reassert authority over bodies and souls. Nothing is the way it was: The war has transformed the city into wracks, and surgery will be required if recovery is to succeed. But Macaulay's vision of recovery rests on solid, indigenous foundations. The medieval spaces that have come back into view by means of the destruction of modern impediments will now provide healthful restitution for the

harm modernity has caused through its nothingness. (If "Nothing happened in the Dark Ages," then Nothingness will have to happen in the present; in responding to their experiences during the war, the existentialists complied.)

Barbary's flourishing trade in postcards is itself a souvenir of a predigital era, when the mail offered the best means of visual and verbal communication among people in disparate locations. The international heyday of the postcard occurred during the fin de siècle and early twentieth century, including World War I. The emergence of total war coincided with the popularity of disseminating images of ruins by means of postcards.

There is a tremendous archive of World War I ruins postcards, including hand-painted and reproduced art cards as well as photographic cards. The genre of watercolor ruins postcards depicted by Macaulay was already well established along Romantic lines during the Great War. I found all the World War I postcard images reproduced here on a website, metropostcard.com. Alan Petrulis created this terrific one-man project on the history of postcards. I asked him about watercolor-painting postcards and whether he knew of any from World War II, such as Macaulay describes. Though he did not, he had seen many from World War I, such as a British card depicting the destruction caused by fighting in Arras (Figure 19), which also seems to reference Turner's work.

Petrulis notes that the postcard industry was struggling on the eve of the Great War, as a rush of cheaply produced cards flooded the market. But the popularity of depicting war on postcards was strong, and as a result, Petrulis suggests, the "golden age of postcards" culminated in World War I with an unprecedented number of postcards depicting elements of the conflict from the battlefield to the home front.[35] Photographs of French and Belgian towns ruined by German bombardment had huge propaganda value and were popular image subjects for postcard publishers, such as the photograph of the ruined cathedral of St. Martin's in Ypres, Belgium (Figure 20).

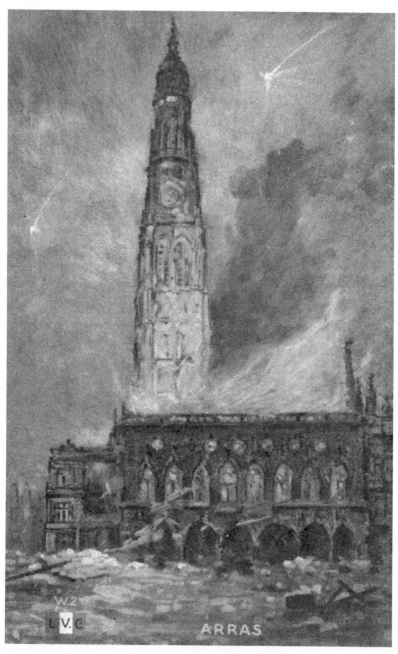

Figure 19. Postcard, cathedral in flames, Arras, France. Published by London View Co. From the collection of Alan Petrulis. Reprinted by permission.

By framing the church against a blank sky (blank because in the black-and-white image, the sky appears light or white and blurs into the frame on the edge of the card), with rubble and weeds in the foreground, the photographer has produced an image that could have been made at any time since the invention of photography: the Romantic ruin. Such images usually depict the current state of castle, church, or fortress ruination that began decades if not centuries before. As we saw with Darwell's images of Cumbria and Fenton's of the Crimean War, unless some caption was provided, the viewer would have to be knowledgeable about history to understand who or what had caused the ruination, whether it had been religious warfare, empire building, or neglect—and how recently. Those who cared, knew and sighed; everyone else could sigh over the aesthetics and melancholy of being reminded about humanity's self-destructiveness.

The postcard's depiction of St. Martin's Cathedral revives the timeless, enjungled aesthetic of Romantic ruins imagery, but the caption places the destruction firmly within the recent war,

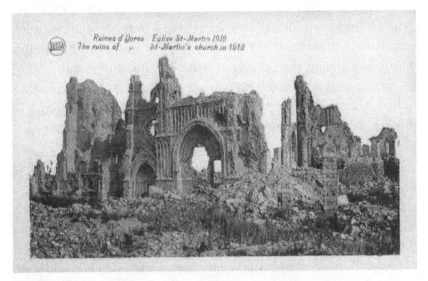

Figure 20. Postcard of St. Martin's Cathedral, Ypres, Belgium. From the collection of Alan Petrulis. Reprinted by permission.

documenting its current status in 1918. (It's technically possible that the image was made after the war ended on November 11, but the heavy fighting in Ypres from 1914 to 1917 had already produced the ruins, as any contemporary or veteran would have known. The church was completely rebuilt in the 1920s.)

The propaganda value of the image among Allied audiences was its suggestion of deliberate attack on sacred and culturally valuable sites by "barbaric" Germans. It's worth considering how the propaganda played off a century of Romantic ruins imagery, especially when the Romantic images often depicted ruins produced by religious, particularly Reformation-era, warfare. In the ruins of churches, as in the propaganda value, Nothing had changed, even though, in the ruin of the churches, there was Nothing left.

Another postcard from Ypres (Figure 21) combined painting and photography in ways that suggest all the propaganda messages about the destruction of culture and civilization by barbarism and also up the ante by honoring art and culture in the figure of the painter working in the courtyard of the still intact New Church. Multiple levels of representation are at work in this postcard. The painter artistically interprets the building for aesthetic purposes and posterity, and we see the arches of the church on his canvas. The photograph on the left depicts the painter at work on-site, thus documenting his presence and the painting in progress. The documentary value of both the painter's work and the photograph of him at work is projected onto the photograph on the right, of the ruins that now occupy the site.

Petrulis notes that the Photo Anthony Company of Ypres, Belgium, produced most of the then-and-now images that were used on numerous postcards by the French publishers Neurdein & Co.[36] Although they did not invent this genre, they certainly grasped its popularity, and we will see further evidence of this in the discussion of postcards from World War II later in this episode. Then-and-now postcards specialize in retrospection. Nothing much is left of what was depicted in the first photograph: Not only has the building been

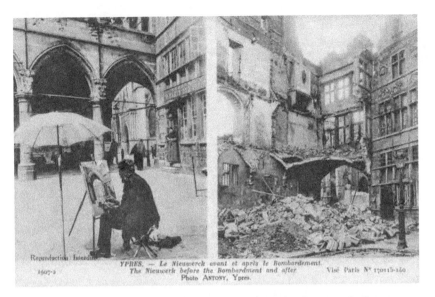

Figure 21. Postcard, "The New Church before the bombardment and after," Ypres, Belgium. From the collection of Alan Petrulis. Reprinted by permission.

lost, but so has a wealth of information about people and place; in short, the context has utterly changed, and the ruins testify to this. We do not know whether the painter or painting survived, any more than we know who the woman in the doorway or the man in the archway of the first photograph are, or where they might have been when the second photograph was made (see Figure 21). We are only shown that Nothing is the way it was—but culture persists because a photographer was there, then and now.

The destruction of the Gothic cathedral at Reims was widely deplored and vividly represented in postcard propaganda at the time. In one postcard, a black-and-white photograph (Figure 22) is colorized to provide a heightened propagandistic appeal by showing the ruination as realistically as possible, in progress and unstoppable. This photograph's billowing cloud of smoke is more akin to a movie still, capturing action in medias res, even though the postcard viewer would know that it represented destruction that had already

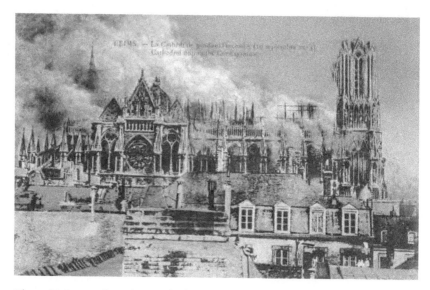

Figure 22. Postcard, "Reims Cathedral during the conflagration," Reims, France. From the collection of Alan Petrulis. Reprinted by permission.

produced a ruin. From the perspective of gerundology (see Episode 1), we could note how the postcard is depicting damage-ing rather than damage, how its realism hints at the ruin to be and promises a fulfillment of the reality that is now known. We are looking at what has already happened; the postcard implies both now and then.

Watercolor-style postcards, such as those made by Barbary, were also to be found in postwar Berlin. In one series of postcards from the Deutsches Historisches Museum archive, the theme of "nothing is the way it was" is prevalent (Figures 23 and 24). The images contrast the postwar ruined state of major Berlin landmarks with their 1933 appearance. The date of contrast is provocatively ambivalent, because it could refer to the Nazi seizure of power as the turning point toward disaster or to the brief couple of months in 1933 before the Nazis took control, as a last moment of innocence and thereby lack of responsibility for what followed.

The location in the first image, "Reich Chancellery" (Figure 23), certainly connotes a center of Nazi power, and yet the image is

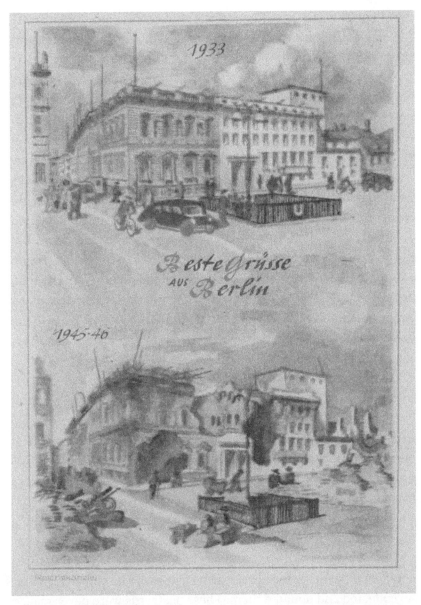

Figure 23. Postcard, "Best Greetings from Berlin, 1933/1945–46, Reich Chancellery, Berlin, Germany." © Deutsches Historisches Museum/I. Desnica. Reprinted by permission.

devoid of Nazi symbols. Similarly, in the second image (Figure 24), the viewer aligns with the people in the foreground, looking east through Brandenburg Gate, and the only red color highlighted in the picture is not background for a Nazi swastika but rather a banner across the Gate's pediment that links it visually to the blurry poster centered behind it, marking the Soviet zone. Both postcards erase the Nazi era while displaying the consequences of Nazi rule.

By marking 1933 as "then" versus 1945–1946 as "now," the postcards conceal as much as they reveal. The representation of Hitler's headquarters, the Chancellery, is a deliberate choice to highlight Nazism. From a postwar perspective, that might not be remembered positively (even if, in 1933, it had been experienced that way). But the postcard's 1933 is also being remembered as a time when Berlin was intact. And what does it mean to label the present as more than one year? "1945–46" designates a Germany divided into zones of occupation, not under national control. It doesn't exactly refer to the fall of the Third Reich, because "1945–46" includes January–May 1945, when the nation was still Nazi.

The postcards draw a line between past and present, using the ruined present as an indicator that something has been lost—whether innocence or safety or the built environment of the city or the unified nation—without according blame or holding anyone responsible. If both cards seem to be suggesting that Nothing is the way it was, it's unclear who or what was happening in between. Everyone knows that it's not like Nothing happened, but as we saw with Sebald and the empty streets, everyone knows what happened and Nothing more needs to be said for life to be resumed in the rubble.

I don't know who might have bought or circulated these postcards; a staff member at the former German Historical Museum in East Berlin collected and donated them. These postcards were never mailed and are blank on the reverse side. Just as Barbary found that her customers had varying motives behind their purchase, so too we can suggest that these ambivalent cards could have appealed to different

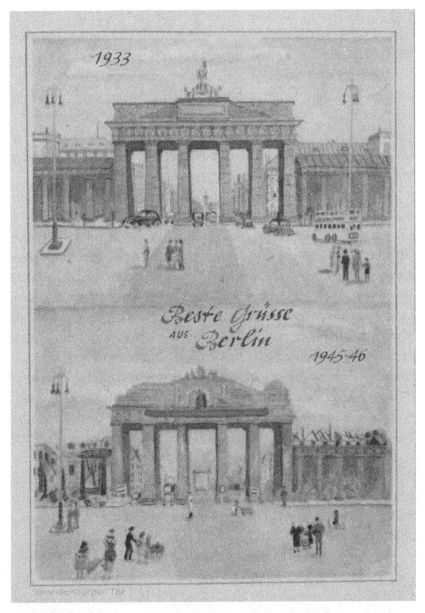

Figure 24. Postcard, "Best Greetings from Berlin, Brandenburg Gate, 1933/1945–46." © Deutsches Historisches Museum/I. Desnica. Reprinted by permission.

kinds of audiences. "Best greetings from Berlin" could be read a variety of ways: self-congratulatory and possibly ironically, by victors circulating ruins cards as a sign of the times and successful regime change; sadly, by vanquished residents and others who feel a personal connection to the city and who now must painfully acknowledge that the devastation was brought on themselves; or still yet tragically if problematically (to those with postwar, antifascist sensibilities), by vanquished residents and others who feel that the war ended badly and that Nothing is left of a once-grand dream.

Barbary's watercolor postcards, which supplemented the shortage of expected ruins, and the Berlin series, which raised provocative questions about which past was being present-ed, offered artistic interpretations of historical events and sites. At the same time, they documented reality sufficiently to provide the "you were there" evidence desired by postcard purchasers. Contemporary postcard publishers also responded to this market demand with photographs of bomb sites, using them to provide unassailable documentary evidence of the damage and its new daily existence as ruin. The vividness of these images was perceived at the time to proffer a dangerous veracity whose untamed reception could produce negative feelings, such as shock, pain, regret, and grief. After the war Allied censors in Germany cleared such atrocity images in the hope that evidence of the damage would help denazification proceed. What anyone thought when they bought or sent or read these postcards remains largely unknown, unless someone wrote how they felt on the card itself, but some contemporary observers noticed the traffic in ruins photograph postcards and found them troubling.

Hannah Arendt, the émigré political philosopher and Jewish survivor of Nazi Germany, trenchantly noted in 1950 how readily Germans circulated picture postcards and argued that this was actually an example of how they were doing Nothing. In an article published in the American periodical *Commentary*, Arendt was scathing in her depiction of German postcard senders, who either had retained or still preferred postcards depicting only the "then" half of the then-and-now equation.

Amid the ruins, Germans mail each other picture postcards still showing the cathedrals and market places, the public buildings and bridges that no longer exist. And the indifference with which they walk through the rubble has its exact counterpart in the absence of mourning for the dead, or in the apathy with which they react, or rather fail to react, to the fate of the refugees in their midst. This general lack of emotion, at any rate this apparent heartlessness, sometimes covered over with cheap sentimentality, is only the most conspicuous outward symptom of a deep-rooted, stubborn, and at times vicious refusal to face and come to terms with what really happened.[37]

According to Arendt, both denial and apathy were at work among the ruins because Germans were immersed in the stages of mourning, identified by psychologists, which preface and preclude facing death. Moreover, non-Jewish Germans will never move along to those later, therapeutic stages because they feel that the loss of their Jewish community was nothing compared to their own losses. Arendt observes a lack of willingness to accept responsibility for the deaths of either Jewish or non-Jewish Germans in the war that was waged in the name of the German nation.

Similarly evasive is the standard reaction to the ruins. When there is any overt reaction at all, it consists of a sigh followed by the half-rhetorical, half-wistful question, "Why must mankind always wage wars?" The average German looks for the causes of the last war not in the acts of the Nazi regime, but in the events that led to the expulsion of Adam and Eve from Paradise.[38]

The self-excusing sigh, which universalizes human propensity for warfare and relegates specific Nazi German acts to a generic human tendency, occurs amid the physical ruins of German cityscapes. The sigh that accompanied the Romantic sublime is thus transmuted into a sigh of regret, not for what was done by the Nazis but for

what humans cannot prevent: their own propensity for destruc-
tion, which will always produce ruins, which will always revert to
their enjungled natural state. Arendt's mind boggles, even though,
as a product of elite, pre-Nazi, German education and culture, this
astute thinker describes what she knows perfectly well is happen-
ing: Nothing.

> The result is that while Germany has changed beyond recogni-
> tion—physically and psychologically—people talk and behave su-
> perficially as though absolutely nothing had happened since 1932.[39]

Arendt's condemnation of postwar Germans sheds light on the ques-
tion raised about the Berlin postcard series and its dates (1933 and
1945–46). By designating 1932 as the cutoff point, Arendt insists that
the entire Nazi era be acknowledged as a morally corrupt state of
being. Complicity with the regime as well as mere survival demand
a moral reckoning, which only a few nonsocialist German intellec-
tuals were willing to make after May 1945 (the socialist and Com-
munist intellectuals had been doing it all along).

"1945–46" awkwardly straddles a temporal borderland of lib-
eration and the so-called zero hour, which Allied forces encour-
aged Germans to understand as a line between the Nazi past and a
Western-allied future. The incipient Cold War encouraged recession
of old enmities and rebuilding of new alliances, as well as of actual
structures. Clearly it was ridiculous to assume that an entire popu-
lation should leapfrog over its own lived experience of Nazism and
war, as though Nothing had happened between 1932 and 1946, but
the temptation to act as though this were the case, and to have that
facilitated by the victorious Allies, was clearly too great.

Had Germany "changed beyond recognition" during the Nazi
era and World War II? Arendt asserts this to be true, and certainly
this reflects her experience of return from New York to postwar
Germany, her own shock that the places and culture of her youth
were alienated from her. And though a ruined urban landscape, like

London after the Blitz, obscured many landmarks and opened both the subterranean basements and the newly visible sky to curious eyes, neither London nor Dresden, Berlin, Nuremberg, Cologne, Hamburg, nor any other targeted German city was in fact unrecognizable or unnavigable. But perhaps it is not complacency that promotes a sense of the perpetual, static presence of Nothing-that-is-something. Perhaps what enables negotiation of a cityscape in ruins is precisely the sense that Nothing is the way it was. There is something to be encountered when it seems as though Nothing is left. Only a minimum of landmarks need to be recovered before reconnoitering can resume.

Sebald argues that the suppression of memory about the "it" that had happened was a necessary part of the postwar revitalization of civil society and that collective silences about bombardment trauma characterized the aftermath cultures of both East and West Germany. But if all memory actually had been suppressed—if a dementia had resulted—no one would have been able to navigate the ruins. Instead, Sebald states, "Today it is hard to form an even partly adequate idea of the extent of the devastation suffered by the cities of Germany in the last years of the second World War, still harder to think about the horrors involved in that devastation."[40]

Some of the ruins photographs that illustrate Sebald's *On the Natural History of Destruction* appear to be on postcards, in that they feature printed text, such as "Kämmererstrasse: No House Withstood the Inferno" (Figure 25); but more likely, because Sebald is reproducing photographs found in a booklet published after 1955, the label may have come from that municipal publication. At least two humans inhabit this image, standing at the end of the street; likely others remain invisible, buried, or lurking in the rubble. The label comments only on the street, cleared of the rubble that had been piled into the uninhabitable ruins, the houses that could not withstand the fire's heat (and yet are still recognizable as ruined structures). The street is navigable and nameable even though "no house withstood the inferno" and Nothing is left intact. The booklet

Figure 25. "Kämmererstrasse: No House Withstood the Inferno." Illustration from W. G. Sebald, *On The Natural History Of Destruction*, trans. Anthea Bell (New York: Random House, 2003), 6. Copyright © 2002 by W. G. Sebald. Translation copyright © 2002 by Anthea Bell. Used by permission of Random House, an imprint and division of Penguin Random House LLC. All rights reserved.

paired this image with another at the same location, years after the war, which Sebald also published on the next page; it was labeled "More beautiful and wider, it has re-arisen."

Sebald is concerned with a lingering memory issue about how Germans maintained a silence after the war about their own traumas, whether out of shame or out of fear of outraged, condemnatory international response if they dared to voice their pain. He believes that the nature of the trauma created by the firestorms of Hamburg and Dresden must have rendered any survivor or eyewitness incapable of adequately expressing their experiences.

Photographs must then stand in as mute testimony to what cannot be spoken of. Sebald includes one image of corpses littering the ground, but nowhere does he link the images to his text, either

through caption or in-text reference.[41] All connections between images and text are implicit, to be discovered or intuited by the reader. The photographs that represent the ruins of cities and bodies are themselves relics of the camera, photographer, and context in which they were made. Perhaps Sebald intended that the reader should experience the silences encoded in the images as evidence of the silencing of German memories. Perhaps the silences echo those of the depicted dead, who can say Nothing.

Ruins are what persist in reminding us of what is no longer there. Nothing has stayed the same, but ruins are necessary as evidence that Nothing is left. Ruins in this sense are like photographs: All photographs are remnants of a historical past that is no longer present. Only the photograph, taken out of its original context, remains as a material artifact and trace of what is no longer the way it was. And just like the people who walk down the ruined streets, viewers of photographs look at them as though they had direct access to a past that is full of Nothing that has yet changed. Sebald remembers how photographs of the ruins, including atrocity photographs, circulated clandestinely after the bombings. Film was scarce, but photographs existed, were copied, and were shared among survivors.

Then-and-now images of wartime ruins have been available for sale in German cities since the end of World War II. I inherited some postwar then-and-now postcards from my great aunt, an inveterate transatlantic traveler between the wars and after. She tentatively dated one card as being from 1946 (Figure 26), the same era in which Macaulay's heroine Barbary was producing her watercolor postcards. I never thought to ask my aunt why she bought the postcards. I assumed they were souvenirs of her trip. More than seventy years after the end of the war, I can't help wondering why these kinds of postcards were popular enough to find a market, then or now.

If historical consciousness were a universal phenomenon and always simply meant "a sense that time has passed" or that "things change," then one might attribute the postcards' popularity to documentation of change. So-called black tourism—the tourist interest

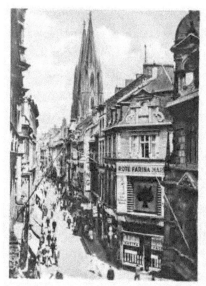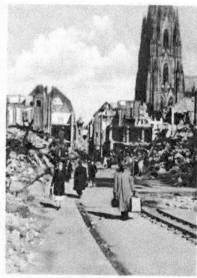

Köln. Die Hohestrasse

Figure 26. Postcard, "Köln. Die Hohestrasse." On the back the postcard is captioned "Das schoene Köln, wie es war—und wurde" ("Beautiful Cologne, as it was—and became"). Collection of the author.

in catastrophe or atrocity sites—might similarly compel interest in purchasing, collecting, or sending postcards that depict massive wartime destruction. Either nostalgia or morbid curiosity could motivate interest. Fascination with World War II in popular culture continues unabated; perhaps anything to do with that war always has a market. What, exactly, might the postcard publisher or purchaser be nostalgic for or fascinated by? Are their fascinations congruent? The market for ruins postcards was there; the question remains, however, What did modern consumers desire from the postcards? Reminders of ruin? Access to the past? Nostalgia?

The scholar Helmut Puff wrote about the miniature landscape models of burned-out German cities that were created after the war. He notes in his book *Miniature Monuments* (2014) that such postcards were for sale in Frankfurt "for a long time."[42] Ruins postcards

proliferated in the 1990s in anticipation and commemoration of the fiftieth anniversary of the intense bombing raids that destroyed major German metropolises and of the war's end. Sebald saw them too and reproduced a then-and-now postcard of Frankfurt in *On the Natural History of Destruction* (Figure 27).

The Frankfurt postcard's yesterday and today imagery evokes the ruins of the postwar in contrast to the sparkling "Bank-furt" of the recovered present. Recovery is celebrated, as it was in the pair of images from Worms that Sebald featured in the previous pages of his book. Invincible historical buildings are seen in both images, surviving the bombing and surviving being surrounded by modern architecture and changing tastes. By focusing on development at the same location, the postcard speaks through the visual icon of a text bubble, as a title pointing in both directions, toward past and present. Nothing is the way it was, and yet the locations are identical and so, the postcard suggests, is the essential, underlying identity of the people who built them and the city that survives.

These then-and-now postcards emphasize restoration of both historic city center and newly erected skyscrapers. They also hide the removed rubble by insisting on progress, even if that progress includes pride in having removed the rubble successfully. Nothing is left to impede access to the recovered city, neither rubble nor ruin. And yet, indeed, Nothing is left out, meaning that the tribulations of the past are there to be seen, emblazoned on the postcard to heighten the contrast to the present. Viewers are invited to compare and contrast, to fill in from memory, or to learn from the observed surfaces. Nothing is left to the imagination.

Postcards offer an illustrated side and a blank side, one for visual communication and one for personal inscription. The photograph(s) on the front might offer food for thought on the back, or not. Did Arendt or Macaulay know what anyone wrote on them? Could they tell who preserved the blank cards as souvenirs, as my great aunt did? Neither of these formidable scholars nor I have investigated the actual traffic in postcards: the photographers who earned a living by

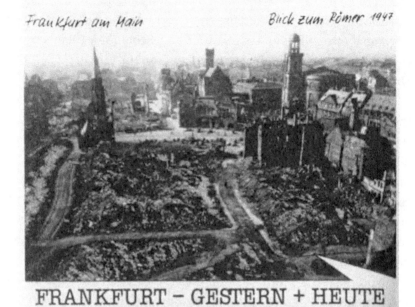

FRANKFURT – GESTERN + HEUTE

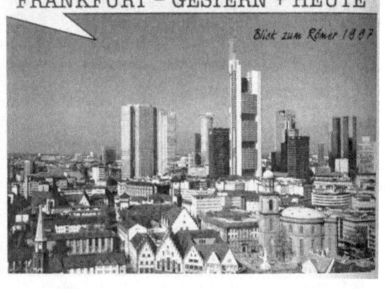

Figure 27. Postcard, "Frankfurt: Yesterday and Today," views of the medieval Römer building, 1947 and 1997. Illustration from W. G. Sebald, *On The Natural History Of Destruction*, trans. Anthea Bell (New York: Random House, 2003), 8. Copyright © 2002 by W. G. Sebald. Translation copyright © 2002 by Anthea Bell. Used by permission of Random House, an imprint and division of Penguin Random House LLC. All rights reserved.

shooting images for them; the printing companies that produced them; the shopkeepers who stocked and sold them; the tourists and locals who bought them, sent them, or kept them; the people who received them, kept them, or threw them out; the recycling of paper, the production of landfills, and so on. Obviously, there are many histories to be explored here. Arendt, Macaulay, Sebald, and I saw postcards available for purchase in Germany and England at different moments in time, but we each wondered what this market for ruins postcards said about the people who wanted them. It would be facetious to claim that any of us really know, because there never was only one reason, any more than we could claim that such postcards were "popular." They are, simply, part of the postwar visual landscape we still inhabit.

Then-and-now postcards remind us of former conditions that no longer exist, but we can recognize this only if we understand that change has happened over time. Ruins that have been removed or "fixed" become part of the rubbled past, of which Nothing is left. More glamorous ruins, ancient and early modern, the kind that have inspired *Ruinenlust* for centuries, get featured on a different kind of postcard as the sole object of admiration. But when we are faced with more recent ruins in abandoned spaces, we are less sanguine because a decision has not yet been made: rubble or ruin? Should we celebrate their beauty or bemoan their ruination? What if the natural histories of destruction have combined with ordinary human neglect and fiscal mismanagement? Can they not produce equally compelling ruins? There are photographers who celebrate the beauty of modern urban ruins by letting their historical consciousness drive them into abandoned spaces, and there is a market for consuming their beautiful images. Postcards are much less widely circulated now than they were in their heyday a century ago. Today's *Ruinenlust* is disported on the internet.

§ "TAKE NOTHING BUT PICTURES, LEAVE NOTHING
BUT FOOTPRINTS": URBEX RUIN PHOTOGRAPHY
Growing up in a Southern California beach town in the 1970s, I had a few specific fears: Bigfoot, the boogeyman hiding under my bed, and that someday my street would lie in ruins. I blame the

last fear on being born into the Vietnam War era and the fact that I lived near a naval air station, so I was accustomed to the distinctive sound of their helicopters, which I will forever associate with war. I was also a budding historian who was spellbound by a British documentary about World War II, *The World at War*, that my family watched on PBS. I knew what could happen as the result of aerial warfare and saw no reason why it couldn't also happen to me and my street.

This fear precociously blended an awareness of the historical significance of ruins with a conviction that someday my world would be someone else's antiquity. I was too young to see *Planet of the Apes* (1968) with its famous ending, where the ruins of the Statue of Liberty astound Charlton Heston into realizing that he'd been living on Earth, and in the former United States, all along. But when I saw *Logan's Run* (1976), I recognized that my fears were not unique. The story is set in a postapocalyptic future where survivors are sealed off for safety in a domed world. Everyone is supposed to enter "Carousel" when they turn 30 to "be renewed" (die) rather than be allowed to grow old. Two escapees emerge into daylight and unwittingly stumble upon the ruins of Washington, D.C.'s famous landmarks, including the Lincoln Memorial. They wonder: Is that what an old man looks like? I wondered: Is this what it's like to live amid the ruins of your own society?

And yet I was still shocked, as so many observers were, to see the kind of imagery emerging from Detroit at the beginning of this century. Detroit's "beautiful, terrible ruins" were long in the making, the result of economic decline and fiscal mismanagement on an enormous scale, but as Dora Apel and other scholars have argued, "ruin porn" photography tends to mask this all-too-human failure and its real-life consequences in favor of gazing at the enormous scale of the ruins themselves, as though they were the products of natural decay.[43]

The wealth that produced elaborately decorated public buildings in the twentieth century had long since fled when *Ruinenlust* was revived in Detroit. Photographer Andrew Moore and his French

colleagues Yves Marchand and Romain Meffre were at the cutting edge of Detroit ruin photography (see, for example, Moore's image of an enjungled café; Figure 28), producing images of the Grand Central terminal, abandoned public libraries and schools, and scenes of enjunglement that Rose Macaulay would have recognized as typical of nature reclaiming its own. It was shocking to see what was once the epitome of the modern American industrialized city and center of the auto industry looking like a war zone enveloped in drought and famine. Then 9/11 and Hurricane Katrina arrived, producing American landscapes that were in fact a war zone and a climate disaster in major cities, unlike anything Americans had known before. Many Americans felt, after 9/11, that Nothing would ever be the same again.

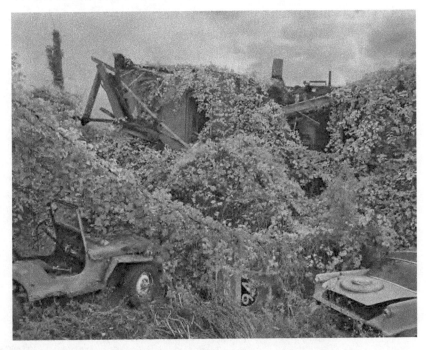

Figure 28. Andrew Moore, "Karwash Kafe, Detroit" (2008–2009). Photo courtesy of Andrew Moore. Reprinted by permission.

The term *ruin porn* is derogatory, implying that those who make beauty out of the city's distress are exploiting the suffering of Detroit's (predominantly black) communities, who must live in the ravaged landscape, often without the clean water, sanitation, and power infrastructure that most Americans take for granted. In other words, they have Nothing but themselves to look to for help, whereas photographers have found beauty in the ruins and tourists clamor for the "ruin tour."

The definition of *ruin porn* is problematic in many regards. Is every photograph of Detroit's ruins "porn"? Is anyone who is shaken by the tragic beauty of these images engaging in consumption of ruin porn? None of this debate is actually about pornography per se; rather, it is about ruins being seen and used in exploitive ways. Nothing could be further from the intention of the UrbExer, the intrepid interloper into abandoned places, who brings a camera not to exploit but to preserve. And not to preserve the ruin so much as to preserve the experience of having been there, "taking nothing but pictures, leaving nothing but footprints."

The UrbExer community defines its values anarchically: Enter despite regulations; do no harm once you're there; leave the way you came; and leave the site as you found it. The mantra of environmentalists, "Take nothing but pictures, leave nothing but footprints," is equally relevant to urban exploration. In his guidebook for would-be urban explorer-photographers, *Urban and Rural Decay: How to Capture the Beauty in the Blight*, J. Dennis Thomas winds up a preliminary section on "legal issues" with this sentiment:

> There's an old, oft-repeated adage: take only pictures, leave only footprints. This is a great saying that can be applied to nature photography as well as decay photography. Leave things as you found them for other photographers and explorers to enjoy. The less of an impact photographers and people make on a scene, the less likely that the building will be locked down. Discretion is paramount.[44]

Whereas the early ecology movement's advocates urged caution when entering natural environments in the hope of protecting them from further human pollution, UrbExers hope to hide their presence both from the property owners and from other explorers who may follow. Both the urban site and the natural site demand that protection be provided by those who believe they value it most. Every ruin is potentially an environmentally fragile Galapagos island destined to be overrun by ecotourists.[45]

Anyone can point a camera at a site that has been designated as interesting by someone else who's already been there and said so. Urban ruins tourism, like any other type of tourism, is conducted for any multitude of reasons, but in the end it's still characterized by an intention to replicate someone else's desirable experience.

Like vacation photos posted on social media, UrbEx photographs will be shared, either digitally or in lushly illustrated books. They are offered to the public as proof of unique and dangerous access and as a model for other would-be explorers. Here, they seem to say, is the place you too may want to try to find and enter. Here is how to make the photograph that will memorialize both the visit and the place to the utmost atmospheric effect.

The glamor of ruins is directly linked to the access that has opened up: As the interior and structural elements of the building are exposed, so too are the entrances into formerly private spaces. A castle's unprotected ruins allow anyone to see what once had been heavily guarded. The ruins of a veterinary school, monastery, or mansion offer outsiders a view into the life of professional, religious, or economic elites. And, where the spaces were previously public and their dilapidation is now a matter of public outrage and concern, such as the Detroit central train station, access to the walled-off remains offers the memory of a more prosperous past. Enter the space and you have earned the right to say, "I can tell that it once was glamorous, and I have the picture to prove I saw it for myself." The remembered experience associated with the photograph has its

own value; in this, it is similar to a historical artifact, valuable for its ability to help us recall the past that we want to tell someone about. Above all, the photograph attests to the fact that Nothing is left and Nothing could be more interesting.

Exploring UrbEx photography guidebooks and websites offers unique insight into how to have the desired sublime experience long associated with visiting ruins. UrbEx photographers market their experiences of ruin sites alongside their photography skills in how-to manuals, such as Thomas's *Urban and Rural Decay* and Todd Sipes's *Urban Exploration Photography*.[46] They offer detailed instructions for replicating the experience and creating the aesthetically pleasing memorial image.

UrbEx photographers hope to capture the evanescence of a location "before it's too late"—before restoration, renovation, or destruction alter the ruins further. The guidebooks offer detailed instructions for having "authentic" encounters with ruins and for taking photographs that are rigorously structured to reveal appropriate frissons of uncanniness in order to capture the ghostly atmosphere of an abandoned asylum, hospital, factory, business, or house. Most of us don't need to be told how to do Nothing. It seems to be intuitive. But a guidebook might seem useful to someone embarking on a new hobby. And masters of the trade can be eager to share their knowledge and skills, even while withholding information about location. UrbEx photography finds beauty in decay, something to treasure out of what others don't value: the abandoned places we might otherwise regard as decrepit buildings in need of bulldozing.

Photography of ruins is not new, and there are many available models for UrbEx photographers to follow. Archaeological documentation of ancient Greek and Roman sites began as soon as camera technology was created. Arguably the first mass-produced ruin site catalogue was the *Album photographique* (1871), which depicted Paris after the devastation of the Commune. Surveys of destroyed

European cities after both world wars provided modern visual models of how to frame urban ruins. J. Dennis Thomas cites as forerunners the human rights activist Jacob Riis, the Depression-era Farm Security Administration photographers, and contemporary professionals such as Camilo José Vergara and Edward Burtynsky.

Using Texas locations as examples, Thomas suggests that the would-be explorer should keep an eye out for possible subjects in both rural and urban spaces. "Urban exploration," he says, is a catchphrase for the entire wider realm.[47] The resulting images, collected into websites or mass-market photographic books such as Martin ten Bouwhuijs's *The World of Urban Decay* (2013), Sylvain Margaine's *Forbidden Places: Exploring Our Abandoned Heritage* (2012), or the collectively edited *Beauty in Decay* (2012), offer a repetitive vision of the semi-hallucinatory state of abandoned sites. More scholarly urban decay photography books, such as Tong Lam's *Abandoned Futures* (2015) or Roland Miller's study of former NASA sites, *Abandoned in Place* (2016), emphasize historical context and documentation alongside expertly crafted images of abandoned sites. With many types of models and guidebooks (not to mention an internet search engine), a novice UrbExer can hope to achieve equivalent access and similar images.

After spending 2008–2012 conducting an ethnography of the "London Consolidation Crew" (and participating in a lot of urban exploration), Bradley Garrett described the ethos of UrbExers who "refused to let adventure, mystery and desire wither in a world rendered increasingly mundane by media saturation, gentrification, surveillance, the constriction of civil liberties, and health and safety laws."[48] Photography was essential to the experience.

The beautiful low-light long-exposure photographs explorers are becoming celebrated for exist, as Dan told me, "solely as markers to experience," even as they are "proof of what we've accomplished," as Winch claims. When I asked a London explorer called Alex why

he titled his blog residu.es, he said it was because "the text and the photos posted there are just residuals of the experience."⁴⁹

Ironically, "residuals" carries connotations both of the urban ruins that are being explored (the ruin as "what's left over") and a form of financial recompense akin to royalties. As a metaphor for UrbEx photography, Alex suggests that there's a payoff in remembering through ruins. Part of the payoff is thumbing one's nose at authority, of showing that Nothing is so sacred or well protected that it can't be hacked; another is the gratification of unauthorized access, which is why Garrett prefers to call urban exploration "place hacking." Garrett suggests that UrbExers, like computer hackers, live for the thrill of thwarting security. Similarly, UrbExers and their cameras can expose the gaps in security fences as well as building walls and office desks; hackers (arguably) democratize access. And although urban decay photography has become a form of fine art, anyone with a smartphone can take photographs of the abandoned sites they access.

The extent to which making photographs is integral to the UrbEx experience is made clear by Todd Sipes.

> Don't forget to enjoy the moment while you're exploring. Take a step back and absorb your surroundings. As much as I adore taking photographs in abandoned buildings, the experience is much more than capturing images. To me, urban exploration is about experiencing a piece of history. Being in a historical place, knowing that I may be the last person to stand there before it disappears, is a gift. Some of these places had a significant impact on our nation and some had an impact on only a handful of people. We, as urban explorers, have the fortune of experiencing museums without display cases or photographic restrictions. Enjoy these locations to their fullest and treat them with respect—and don't be too concerned with getting the perfect shot.⁵⁰

Sipes, who majored in American history, uses imagery that evokes romantic discourses of global explorers during the age of empire. Images, like exotic wild animals being hunted for taxidermic museum displays or zoos, are to be "captured." The explorer has no need of the museum because the explorer is really there. The explorer is sensitive to the ephemerality of the historical place and how Nothing is the way it was. Photographs embalm the fleeting moment that Sipes suggests the explorer pause to treasure. The explorer may be "the last person" to witness this stage of ruination and decline and as such will remain the authority on it.

Sipes and Thomas warn of the hazards that face the aspiring adventurer-witness: rusty nails that threaten puncture wounds, exposure to asbestos, and rabid squirrels, to name a few. By taking these risks, the UrbExer can seem somewhat heroic. But the internet is also, and not surprisingly, rife with false claims about supposed access and location photography. Although the UrbEx community attempts to limit information about successful access to the truly deserving, any advertisement of their exploration risks location exposure. Scholars, such as Miller and Lam, offer essays alongside their photography, some of which is explicit about location; more typically, UrbEx photography books lack any captions for the photos, effectively erasing their locations. The photos are left to speak for themselves, revealing Nothing.

Martin ten Bouwhuijs's book is atypical of popular decay photography compilations in that he provides some information about each building, giving a name, dates of construction and abandonment, and some of its history. Ten Bouwhuijs also credits the Urban Explorer Forum for this disclaimer, which appears at the beginning of the book:

> To protect the locations in this book, the names of the locations, names of villages and all other names, as well as years and other information that could lead to a particular location have been changed without being detrimental to its history. The history is composed of information from various internet sources and from local people.[51]

Ten Bouwhuijs's endeavor to protect the location actually risks citing and creating further false information. By changing the names to protect the innocent and relying on the notoriously unreliable internet for facts, the author frees himself to invent stories (or at the very least, to risk being perceived as having done so).

Only an unwritten code prevents the UrbExer from making it up as she goes. This was certainly the case with "Elena," who fashioned the website Kiddofspeed around her supposed experiences exploring a particularly dangerous kind of abandoned place: the Chernobyl Nuclear Power Plant in Ukraine. As the historian Kate Brown discovered when she went on a research trip to the site of the worst peacetime nuclear disaster in history, Elena was not the most reliable guide. In her book *Dispatches from Dystopia: Histories of Places Not Yet Forgotten* (2016), Brown confesses to having been seduced by Elena's online persona and inspired to make her own Chernobyl visit. Elena described an enviable freedom, riding "a 147-horsepower iridescent Kawasaki Ninja" across "the Zone" and enjoying unique access, which she claimed was thanks to her father's role as a nuclear scientist actively involved in the cleanup at Chernobyl. Brown characterizes Elena's "narrative voice as that of the hero of a travel novel," a model of the UrbEx ethic: "She stands firm, has no reservations or questions about what she sees, or rather, all that she sees confirms what she already knows."[52]

Elena posted photographs of her forays into abandoned apartments and civic structures throughout the city of Pripyat and villages emptied after the nuclear explosion. "The problem," Brown notes ruefully, "was that . . . Elena's Web persona was a fake. When Elena first posted the site, she had never been to the Zone. She scanned photos from coffee-table books on the accident, made up a narrative, and published it."[53] After her website became popular, Elena and her husband did actually visit Chernobyl, where they staged photographs to match the stories Elena had already posted. This fake UrbExer expertly replicated the hallmarks of the trade, creating images to match those that were typical by exploiting existing photography.

Clearly, Elena had seen UrbEx photography. So too, I suspect, had Brown, because the first image of abandonment she includes in her chapter about Chernobyl features empty chairs, framed through windows and resting on a floor strewn with litter. A casual survey of the truly vast, virtual visual archive of UrbEx photography reveals many, many relic chairs. The empty chair is an icon of abandoned sites around the world. In their images for *The Ruins of Detroit* (2010), Yves Marchand and Romain Meffre gravitate toward midcentury modern office furniture. The pilot and popular blogger Henk van Rensbergen prefers chairs with the upholstery coming undone; many others are fascinated by dental, mental, and medical examination chairs that are bolted to the floors. Bradley Garrett inserts an image of a functional wheelchair in an abandoned room in a pivotal location between his first and second chapters.[54] Sipes's guidebook features several empty chairs, including one festooned with cobwebs in the opening chapter, which guides the would-be photographer to look before you shoot. His "What to Shoot" chapter has an entire section dedicated to chairs, thanks to their ubiquity.

> The location may have been completely scrapped and destroyed, but without fail, a lone chair remains. This phenomenon is so prevalent in the exploring world that there are Facebook pages and Google+ communities dedicated to it.[55]

Chairs are useful as historical markers (style indicating period) and compositional elements. Perhaps the prevalence of chairs in UrbEx photography can be read as a reminder that, for UrbExers, it is never sufficient to be an armchair quarterback or couch potato. You have to get up, go out, find access, and get your ruin shot if you wish to emulate the best of urban exploration. UrbExers actively seek their own agency, which is something the ruins cannot do. In their natural state of decay, ruins simply exist. They will not speak unless spoken to.

The building in ruins, deprived of functionality, could express its beauty but lacks the camera that will, in a bizarrely mixed sensory metaphor, lend it a visual voice. As Sipes suggests, the UrbExer-photographer's ventriloquism becomes necessary precisely because

> you're not shooting amazing landscapes like the Golden Gate Bridge at sunset, where the scene speaks for itself. Your job is to capture beauty in unforgiving photographic circumstances.[56]

An intact, famously beautiful landscape can speak for itself; a ruin cannot. It says Nothing. The UrbEx photographer humbly offers a visual voice to the beautiful mute, attempting to create art. The prevalence of high dynamic range (HDR) photography in urban decay photography further testifies to artistic intentions. As Thomas notes:

> HDR imaging can create hyper-real or surreal otherworldly looks to images and is often used as an artistic effect. Doing a search on the internet will quickly reveal that quite a few photographers feel that HDR and decay photography go hand in hand simply because the technique adds a more vivid feel to images, can enhance the decaying aspect and even add a somewhat horrific or menacing feel to an already ghastly subject.[57]

HDR's controversial enhancement qualities make every piece of real estate look like something marvelous, every image glowing with enhanced color, but this is precisely what contributes to the desired atmospheric effects of urban decay photography. By creating a denser image in postproduction, one with finely engraved outlines and supersaturated colors, the photographer ensures that the vividness of their experience is captured in the final image. Sipes agrees in his chapter "What to Shoot": "My experience with UrbEx has taught me that combinations of organic and synthetic elements create our scenes."[58]

The organic element of urban ruin photography derives from natural beauty but also from the ways in which the ruin is becoming one with its natural environment. Weeds and trees emanating from the floors of buildings are as ubiquitous as chairs in urban ruin photography. An UrbEx photographer fascinated with this particular type of image, Jonathan Jimenez, published *Naturalia: Reclaimed by Nature* (2018). "Jonk," as he is known, traveled the world looking for plants pushing their way into structures, repossessing their environment. Just as Rose Macaulay witnessed London becoming enjungled and Georg Simmel argued that the most beautiful ruin was the one made by nature and time, not by man, so too this genre of UrbEx photography attests to the power of natural forces to reclaim what man hath wrought—as Andrew Moore captured in his Karwash Kafe photo (Figure 28).

Man-made disasters are too numerous to count, but the ones that result in scenic ruins find a special place in the hearts of Urb-Exers. Those disasters often stem, if you will, organically from economics. In his first inaugural address, President Franklin Roosevelt famously urged Americans not to succumb to their anxieties about what we now call the Great Depression: "The only thing we have to fear is . . . fear itself." Interestingly, this is often remembered as the speech about "we have Nothing to fear but fear itself," with memory transcribing Roosevelt's words into more colloquial usage. The UrbExers' greatest fear, aside from their own physical safety, is no different from the fear that most Americans during the Great Depression, or me growing up in the 1970s, had: that the landscape they value will be destroyed.

In Sylvain Margaine's book *Forbidden Places: Exploring Our Abandoned Heritage* (2009), the photographer muses that in abandoned places, "Decay became inevitable. Yet nothing was destroyed."[59] The true UrbEx photographer will never intentionally disturb decay or cause further destruction. What an UrbExer wishes to leave undisturbed, to allow to "rust in peace," should be visited, viewed, recorded, and then once again abandoned. Respectful of its age and

presence, the UrbExer will admire the ruin but do Nothing that would contribute to its inevitable decay. Whether sanitorium, asylum, hospital, metro, steelworks, hotel, castle, or church, the aesthetic pleasures of abandoned sites lie in their inscrutable presence. They are old, they will always be old, and they may not last, so they must be experienced now. And that experience of decay must also not be allowed to fade or be destroyed; in this, the UrbEx ethic is akin to that of a historical preservationist, although the UrbExer deliberately avoids taking the next step to intervene in the decay and preserve what remains. The UrbEx photograph, like a postcard from then and now, creates a visual record that says both "I was here" and "It was there." Decay is happening; it can be witnessed. Nothing will always be becoming the way it was.

NOTHING HAPPENED

IT'S BEEN SAID that nature abhors a vacuum. History is naturally interested in what happened in the past, not in Nothing or its vacuum parts. Historians don't usually spend a lot of time talking about what didn't happen. But it's not completely counterintuitive. Many, many people have commented, at many, many points in the past, that "nothing happened." What, exactly, do they mean? And do they mean it to represent something felt by not just themselves but others at the time? Others who might constitute a group or family, a generation, a society, or a nation, collectively? Looking back on the past and perceiving that nothing happened reveals a form of memory that is neither empty nor reflecting an existing void. Humans abhor most vacuums as non-life-sustaining—except those that perform household chores—so when we say, "nothing happened," we are actively remembering a historical event that we called Nothing.

§ WHEN HISTORIANS SEE NOTHING

When historians consider what people may remember that falls outside the realm of designated historical subjects, they turn to sociologists' formulation of *collective memory*. This term designates what any group of people may choose to remember or forget, despite dominant narratives about the meanings of the past (such as national, religious, family, or any social entity's foundational myths), and how these memories actively shape society and lives.

The founder of collective memory studies was a French victim of the Holocaust, the sociologist Maurice Halbwachs. In an essay first published posthumously, after World War II, Halbwachs compared historical memory and collective memory and found that, rather than being entirely different ways of knowing about the past, the two forms of memory interacted in ways that sustained human understanding of their own place in the continuum of past, present, and future.[1]

All memories, Halbwachs theorized, are held within necessary collectives; the social frameworks of memory are as crucial as any chemical brain process. He distinguished between lived experiences, which became collective memories when shared within communities, and the kinds of memories that were inaugurated as historical knowledge, because a living connection to those experiences had been transformed or lost. Collective memories are living versions of what people remember, and historical memories are the type of collective memories that people acquire through formal learning rather than through idiosyncratic experience. That is, they learn history, and then remember the past as a historical memory, one type of the myriad collective memories that underpin human social existence. We all participate in multiple collectives and collective memories throughout our lives. When Nothing happens, the impact is felt collectively but not uniformly; that is, not everyone experiences Nothing the same way, but among those who do, a collective memory is formed.

Halbwachs makes a particular distinction about what gets re-membered as "history," which bears on the present discussion: "History, I have said, is not interested in these intervals when nothing apparently happens, when life is content with repetition in a somewhat different, but essentially unaltered, form without rupture or upheaval."[2] We live our lives and Nothing, apparently, happens continuously, until disruption occurs, causing the events that are worth remembering. We experience repetition of familiar forms of life, as though history were repeating itself or as though Nothing had changed: cycles of life, landmarks and institutions that survive from one generation to the next.

"Nothing" is another name for something familiar, repetitious, and unaltered, the content of the contented life. When life was "normal," Nothing happened. It's only boring if you really wanted something else to happen. It's only undesirable if you are forced to experience a form of rupture or upheaval that you did not choose—the kinds of traumas produced by Nazis sending French sociologists to concentration camps being among the most extreme. Halbwachs had already noted that wars and revolutions—he was thinking of the French Revolution because of memories shared within his family—were the kinds of events most likely to cause the ruptures that led collective memories to turn into historical memories.

Histories of wars have been produced in Western societies at least since Virgil recorded those who sang of "arms and the man," but histories have never contained only records of disruption. During times of peace, presumably, people were happy to have Nothing extraordinary going on. But in those times, how have histories presented the absence of conflict, the status quo of peaceful life? It's these apparently neglected intervals of continuity that interest me here—what poet Ezra Pound referred to when he sardonically noted in *Canto XIII*: "A day when historians left blanks in their writings / I mean for things they didn't know. / But that time seems to be passing."[3] Do we moderns now know everything? I think not, despite the virtual (and

virtually infinite) archive of the internet, but Pound's invocation of the medieval practice of creating annals of historical events, which did in fact include blanks on the page, repays further attention.

Perhaps the era of ignoring how Nothing happened is what has passed.

Students of Western European history have been taught for generations that in the so-called Dark Ages nothing happened. It was a time when the West lost touch with the genius of the Arab world and Greek and Roman antiquity, becoming mired in religious strife and frozen through the Little Ice Age from around AD 700 to 1400. The era before the Renaissance is also referred to as the Middle Ages or the medieval period, but the epithet Dark Ages had been deemed appropriate already during the subsequent, and subsequently named, Renaissance. In other words, instead of hiding their light under a bushel, Renaissance thinkers used "Dark Ages" as a foil against which to highlight their own era's recovery of antique learning and wisdom. You could say it was their then-and-now postcard version of self-advertisement (for postcard representations of recovery, see Episode 2). As historian Reinhard Koselleck observed in his *Practice of Conceptual History*:

> The invention of the Middle Ages was a first step toward building out of historical events something like a historically immanent construction that did not have to justify itself by referring to persons, nature, or mythology. But three to four centuries went by until the eighteenth century when the Middle Ages had gradually become accepted as a specific name for a period. The notion of Renaissance became a general historical name for a period only in the nineteenth century.[4]

Although I didn't meet Koselleck or read his work until the late 1980s, I had already learned the belatedly named Renaissance's

self-congratulatory version of this history at school in the 1970s. This was still the case, I'm sorry to say, in my own child's twenty-first-century middle school experience. Current generations of students are still taught about the darkness of the un-Enlightened medieval period.

The graphic designer Saul Bass animated this inherited popular conception brilliantly in his Oscar-winning short film, *Why Man Creates* (1968).[5] Bass subtitled his film *A Series of Episodes*, speculating on the nature of creativity, and I am pleased to follow in his footsteps with the episodes in this book.

The film's first episode, "The Edifice," presents a heroically and hilariously condensed version of the standard history of Western civilization that was taught to American high school and college students throughout the twentieth century. In just under 4 minutes, through a series of animated drawings, Bass takes the viewer from cave dwellers to the Atomic Age.

The course of history is depicted as a series of blocks stacked atop one another, like a child's building blocks, forming the Edifice. In each block, cartoonish human figures and their inventions (the lever, the wheel, Doric columns, dynamite, etc.) serve as iconic referents to the great moments in the history of Western progress. Politics receives a nod at key moments, from the death of Caesar to revolutions in Paris and colonial America, to Marxism and world war. The episode culminates in an atomic cloud emerging from a stack of airplanes, cars, and pollution, with the soundtrack featuring a voice with a hacking cough in response to the pollution, unable to do more than cry, "Heeeeellllppp!" Bass clearly understands both the impulse to glorify progress, which was the hallmark of Western Civ instruction, and the concomitant impulse to agonize over modernity's innate ability to craft its own destruction.

In "The Edifice," the fall of Rome triggers the rise of the Dark Ages, which lasts about twenty brief but vital seconds. The history of Rome opens with a voice intoning "Hail, Caesar," followed by a

figure declaring that "Roman law is now in session," which triggers a fracture in the façade of the Edifice and its collapse into ruins. Rome literally falls into rubble, in a vivid, visual evocation of Edward Gibbon's multivolume classic, *The History of the Decline and Fall of the Roman Empire* (1776–89) (Figure 29).

The fall of Rome immediately heralds the onset of the Dark Ages. Bass visualizes this with solid, dark human figures carrying tall sticks, like pilgrims with their staffs (or possibly and more violently, Crusaders with pikes), accompanied on the soundtrack with a humming noise that transforms into an ominous Gregorian-style chant full of foreboding. The Dark Ages emerge by blackening the entire frame, casting a shadow across the world (Figure 30).

Bass's visual puns are clever and on point. We never hear the words "Dark Ages." We see them instead. The history of Western civilization gets even funnier in the next few moments. Animation

Figure 29. The Fall of Rome. Screenshot from Saul Bass's *Why Man Creates*, at 2:42 (https://vimeo.com/22113008).

Figure 30. The Dark Ages begin. Screenshot from Saul Bass's *Why Man Creates* at 2:45 (https://vimeo.com/22113008).

rendered as black drawing on white background suddenly transforms. The dark figures morph into a human swarm on a blue background, and the Edifice reconfigures into the first barrel vaults, a landmark in the history of Western architecture. Blackness slides up over the background, rising from the bottom to fill each successive layer, blocking civilization's "progress" and extinguishing lights in each block as it moves (Figure 31).

Bass clearly associates the Dark Ages with the dominance of the Catholic Church, first through its architecture and then through its suppression of Arab knowledge, specifically in mathematics. And at this crucial moment in Western civilization's Dark Ages, Bass shows us, Nothing happened.

Architecturally, we are clued in to the significance of this moment by the appearance of notably pointed Arab horseshoe arches (Figure 32).

Figure 31. Blackness in the background: the formation of the Dark Ages. Screenshot from Saul Bass's *Why Man Creates*, at 2:48 (https://vimeo.com/22113008).

A figure clad in a turban and flowing pants, not identified by name but almost certainly representing the Persian mathematician Muḥammad ibn Mūsā al-Khwārizmī, emerges to the left of a similarly clad fellow in a central window. He jumps up and cries, "Allah be praised! I've invented the zero!" "Whaaat?" replies the figure in the middle, looking up from his desk. "Nothing, nothing," mumbles the mathematician responsible for bringing Greek, Hindu, and Persian knowledge together in the ninth century. Nothing (zero) and Nothing (nothing will happen in Western civilization as a result of his discovery of zero) are happening simultaneously. The mathematician has discovered zero; the Europeans know Nothing; and Bass is laughing up his sleeve.

Europeans remained unaware of zero until the twelfth century, when a Latin translation of al-Khwārizmī's work appeared as

Figure 32. "Allah be praised! I've invented the zero!" Screenshot from Saul Bass's *Why Man Creates*, at 2:55 (https://vimeo.com/22113008).

Algoritmi de numero Indorum—and also gave the West its introduction to algorithms. Until then, mathematically speaking, the West was in the dark about zero.

Bass continues to poke fun at the Dark Ages in his representation of the era's cosmology, its conception of the earth and its place in the universe. With black figures clearly resembling hooded Christian pilgrims, bearing the cross as they trek through renewed Western, Gothic arches, color emerges in stained-glass windows and we hear them chant sonorously, "What is the shape of the earth? Flat. What happens when you get to the edge? You fall off. Does the earth move? Never" (Figure 33). The Dark Ages end abruptly with a screen full of stained-glass windows, devoid of humans. The blue background turns beige, and full color permeates the blocks. Suddenly windows and doors are flung open throughout the Edifice, as figures clad in

Figure 33. "What is the shape of the earth? Flat." Screenshot from Saul Bass's *Why Man Creates*, at 3:13 (https://vimeo.com/22113008).

Renaissance garb representing famous Western thinkers and explorers, who yet remain unnamed, emerge to challenge orthodoxies: "The earth is round! The earth moves! There are worlds larger than ours! There are worlds smaller than ours!"

Each time a window opens, however, the speaker is silenced by a black hand that appears from within to shut the window violently enough to shatter the glass: the intolerance of the Dark Ages persists. Bass leaves the viewer to ponder the significance of this. With the atomic blast and cry for help concluding this sequence, Bass ultimately undermines the classic version of Western civilization that twentieth-century students imbibed, by challenging the supposed success of "progress." Even though he completely neglects the histories of European empires, colonialism, and racism, and the lone female figure appears only to comment on men's genius, Bass

is making a sustained critique of European historiography. Bass's vision of the Dark Ages permeates the rest of his presentation of Western European history, ultimately challenging the triumphal narrative's premise.

Being taught that Nothing happened in the Dark Ages creates a dim legacy for what was actually a vibrant and diverse period, a legacy that recent generations of historians have attempted to revise. But for our present purposes, it's worth noting that in the midst of the medieval darkness, Nothing happened—really. We know this because Nothing got written down in annals. Handwritten by church scribes, in massive leather-bound volumes, annals were incomplete but officially sanctioned records, created over the course of centuries. They were incomplete in the same way that any history is always incomplete, for however much we strive to understand the past, its totality will always elude us; it never all gets written down. To modern eyes, however, annals can appear curiously unfinished because, although there may be entries for each year, in what looks like a calendrical spreadsheet, there may not be corresponding data for that year's events—making it look, for instance, as though Nothing happened in AD 711.

This example of a peculiar absence in AD 711 appears in Hayden White's volume of historiographical essays, *The Content of the Form*.[6] White's essay about the *Annals of St. Gall* made an impression on me when the book first appeared, partly as a revelation about the essential incompleteness of archival records and partly because I was familiar with the annals' source—the *Monumenta Germaniae Historica*, vol. 1 (1826)—from my own research on early-nineteenth-century German historical preservation. The *Monumenta* is a monumental compilation of historical sources collected into a multivolume publication, begun in the 1820s with the goal of creating a foundation for the study of German history, long before Germany existed as a state. Its collection of annals and other medieval documents facilitated research in an era when travel to archives was expensive and access to documents was highly restricted.

In the *Annals of St. Gall*, recorded in a medieval monastery that was a redoubtable center of religion and learning on the Swiss side of Lake Constance, one can read about the following occurrences of the eighth century AD. White transcribed them from the *Monumenta*'s published version, not from the original, in the following manner:

709. Hard winter. Duke Gottfried died.
710. Hard year and deficient in crops.
711.
712. Flood everywhere.
713.
714. Pippin, mayor of the palace, died.
715. 716. 717.
718. Charles devastated the Saxons with great destruction.
719.
720. Charles fought against the Saxons.
721. Theudo drove the Saracens out of Aquitaine.
722. Great crops.
723.
724.
725. Saracens came for the first time.[7]

The chronology from 709 to 725 scans as delightfully odd, especially if the reader is ignorant of medieval European history. The information that is provided feels randomly selected. Obviously, crops are important for food and fodder, and a bad winter plus bad crops sounds like a very bad and noteworthy combination. But if you are not a specialist in this era's and region's history, knowing that there was bad weather or bad crops doesn't tell you why it happened, the big question that historians always try so hard to answer.

If you want to consider the power dynamics presented in the *Annals of St. Gall*, you may be forgiven for being puzzled. The Saracens came for the first time in 725? What about Theudo driving them out

of Aquitaine in 721—weren't the Saracens already there? Wait, are we not reading about Aquitaine's history? Where is "there"? Did nothing happen in 711, 713, 715–717, 719, or 723–724? Like a photograph whose caption has not traveled with the image over time, this section of the annals does not offer a self-revealing, explanatory narrative; in effect, we know Nothing about any of it until we put the annals together with other information. We have to already know who Charles was and why the Saracens kept coming back before any of this can make sense.

Historians always look at multiple sources to compare information before making any conclusions about the past. Bizarre gaps in the records create the impression that Nothing happened for one or more years at a time—but only if you expect that every form must be filled out completely or that leaving blanks in the record, much less publishing them, is a sign of error (as we saw in the discussion of blank books in Episode 1). And after all, someone wrote something on the page during those years (possibly all at once? Because the ink is similar, possibly annually?) so clearly something happened. What kind of Nothing was it?

The recording of dates has never been merely a straightforward or natural operation but rather a matter of calculations both social and mathematical. On the relevant original manuscript page (Figure 34), we see that the *Annals of St. Gall* begin with "ANNI D[OMI]NI" (AD), the most significant year in the Christian calendar. Although on the *Annals*' page "AD" is followed by the year 709, "AD" refers to the time following the birth of Christ. Measuring time from "the year of our lord Jesus Christ" involved the designation of millennia following the first year, or year 1 of the Christian era. As we have just seen, the Dark Ages lacked the concept of zero, and so did the Julian calendar in use at the time of the *Annals*. When Pope Gregory called for calendar reform in 1582, to bring the chronological practices of the Dark Ages up to speed with those of the Renaissance, its calculators had to cope with the centuries-long accumulation

Figure 34. Annals of St. Gall, Stiftsbibliothek, Cod. Sang. 915 (http://www.e
-codices.unifr.ch/de/csg/0915/196).

of minutes, hours, and whole days that were left over after having
rounded off 365 days/year from the actual 365.242199 that occur.
As the evolutionary biologist and historian of science Stephen Jay
Gould recounts in his delightful book *Questioning the Millennium*
(1997), what didn't matter so much in Julius Caesar's time amounted
to 10 full days by the time of the Gregorian calendar reform. And
so, by papal fiat, they lopped ten days off the calendar, and Nothing
happened on October 5–14, 1582.[8]

I am indebted to my medieval history colleague Paul Milliman
for enlightening me about the nature of annals and the production
of this one in particular. He noted that because White was working
with the *Monumenta* edition, not the original, he was seeing what

the nineteenth-century editors had done to the manuscript (namely, chopped it into segments that fit their organizational precepts rather than the medieval document's; once again, the nineteenth-century scholars have a lot to answer for). The top half of the original manuscript page was copied into the document from another text before the recording of the annals, which White also could not see in the *Monumenta*. The page holds a lot of history, from the extended use of a single piece of parchment, to the recording of dates, information, and Nothing.

The creation of this document has been obscured. Scholars are uncertain as to when each entry was recorded, although clearly there must have been multiple annalists during the period of its production, from 709 to 1080. They also cannot know when or why some entries were erased, or why sequential years were inscribed but information about each year was not necessarily provided. Milliman also pointed out that this lengthy annal includes dense sections of narrative in the middle, which White did not address. At some point in its creation, the authors desired to include more carefully crafted information. And at many points they desired to include Nothing. Ezra Pound does understand correctly that sometimes historians leave blanks and sometimes they fill them in. This is less a matter of active neglect, although, of course, this is also possible, than of making choices about what to include. Even calling the annalists "historians" is anachronistic, because they would not have understood the ethics of historical practice the way that we do now.

Because Paul Milliman and I share an active concern about academic integrity, he also alerted me to the fact that "writers in the Middle Ages were horrible plagiarists, and the *Annals of St. Gall* are no exception. The actual title is *Annales Sangallenses maiores*, and the first two centuries or so of this work were lifted from the *Annales Alamannici*" (private communication, 2014). Copying extant documents is a time-honored form of recording and transmitting information. In the pre–carbon copy, pre-Xerox, predigital era,

handwritten copying was essential to preserving vital documents that were otherwise prone to decay. Copying by hand is also a form of notetaking practiced by contemporary scholars—for instance, when a historian works with materials that may not be photographed or photocopied, as I experienced, back in the day, when I wasn't allowed to make photocopies of anything in the East German state archive in Merseburg and had to write down every single word from a document because it might be important to my research. Yes, it takes hours and makes your hand sore. Ask any historian who was working before the turn of the millennium, and they will have stories to share about pain and painstaking in the archives. It might be tempting not to copy a blank page, or even to make a note about it, if its blankness was not the subject of your research. But the visible format of information is just as important as the content. And as we saw in the discussion of blank books in Episode 1, blankness is a visual form of Nothing, and as such worthy of attention.

As I often remind students, copying isn't the problem that produces plagiarism; lack of citation does. The St. Gall annalists neglected to mention their source was the *Annales Alamannici*, but this was standard operating procedure at the time. It's also one of the reasons that, when modern historians developed the ethical practices we follow now, starting in the nineteenth century, they revolutionized scholarship by insisting that one must compare multiple sources, determining which came from which and which could be said to be originals.

Plagiarism today carries high stakes. Do it in a course I teach, and you'll flunk the class. When confronted, it's not uncommon for students to act as though nothing happened. Faced with losing three units of college credit and its value in tuition dollars, they might argue that the infraction was insignificant: "It was just one line from Wikipedia. Does that really count?" (The same student might attempt to argue that it's impossible to plagiarize from Wikipedia, because Wiki entries are collectively and anonymously authored,

so you're not copying from any *one* person.) Or they might play for time, hoping that the appearance of memory failure will translate into them not having actually done what they wish they had not done (or not gotten caught doing): "Did I look at a website when I was writing my paper? I don't think I did . . . "

History may not record genuine human obliviousness as often as it does crime and punishment, but when it comes to a claim that nothing happened, the chances that something *did* are relatively high. This behavior runs through the entire spectrum of human social interactions. Consider how you might sometimes choose to act like nothing happened or to pretend nothing happened, when willful disregard for the facts, perhaps in the interest of giving somebody a break or a desire not to be held accountable, overrides other, rational motivations. In such instances we take an active interest in Nothing—by ignoring it (see the section "Agnotology: Knowing Nothing" in Episode 1) and by denying it. "It," however, remains. Nothing *happened*.

Historians have written about how Nothing happened in at least two ways. They transcribe its presence without necessarily contemplating it, or they actively write Nothing happening into their historical analyses. Scholars have found examples of historical actors stating that "Nothing happened," and from those sources they have crafted historical narratives that tell us something about the past in which these statements occurred. Alternatively, they have concluded, based on their analysis of their sources, that Nothing happened that was worth paying attention to. For instance, in her book *Babbitts and Bohemians: The American 1920s*, the historian Elizabeth Stevenson has a chapter titled "The Year Nothing Happened—1925." Obviously the chapter title is not meant to be a truth statement about reality; otherwise everyone alive in 1925 would have to have disappeared, or some kind of Gregorian calendar reform would have been required to excise 365 days between 1924 and 1926. So what constitutes Nothing worth writing about?

Stevenson designates 1925 as "uneventful," citing a 1926 yearbook to lend the credence of proximity and firsthand knowledge from a primary source. The uneventfulness of 1925 was supposedly epitomized by the postinaugural behavior of the new president, Calvin Coolidge, who went on vacation for the first half of the year. "The year 1925 was the emotional as well as chronological dead center of the decade";[9] and further, "The excitements of the year were for the most part benign."[10] Stevenson then proceeds to overcompensate for a middling year in the middle of an exciting decade: She writes an entire chapter about it. Indeed, 1924 and 1925 are the only two years of the decade to merit their own distinct chapters, which suggests that Nothing happened for a reason.

Stevenson chronicles the major 1925 news headlines regarding multiple forms of power: air power, hydroelectrical power, political scandals, and the Scopes trial. On the cultural side, she notes the publication of the first issue of *The New Yorker* magazine and major works by novelists Theodore Dreiser and Ernest Hemingway, as well as the book that arguably exemplified the 1920s better than any other, F. Scott Fitzgerald's *The Great Gatsby*. Maybe, as an author, Stevenson is aware that books are rarely published in the same year that they are written, and she prefers to think of *The Great Gatsby* as a product of many years' work that cannot solely be attributed to 1925. Maybe she just never liked the book (I can relate). But Stevenson is stuck in her own rut: Having designated the decade as fascinating enough for an entire book, she has to cope with the slow times when Nothing (much) happened and the fact that much of what is historically significant happens over an elapse of time longer than a single year. She concludes the rather dismal chapter with the summary observation that "'Culture' was outlaw in the twenties, and so was 'art.' Therefore, the twenties remained adolescent."[11] Thankfully, she seems to imply, after Nothing happened we could at least grow out of it.

Adolescents are famously quite self-centered. As they emerge into their mature selves, they respond intensively to the outside world as it

impinges on their consciousness. In other words, Nothing (much) happened until it happened to *them*. The historian Matt Matsuda recalled a moment when Nothing happened in the history of Dutch imperialism, which reflects the way in which one's perspective and investment shapes whether or not an event is remembered as significant. Reading Romain Bertrand's *Histoire à parts égales, récits d'une rencontre Orient-Occident (XVI^e–XVII^e)*, Matsuda notes how the author is able to look at Dutch and Javanese histories and find them comparable, each relying adequately on Malay sources. But an event occurs, the arrival of Cornelius Houtman in the East Indies in 1596, that is then related in quite different and distinct manners in Dutch and Javanese accounts. Bertrand's distinctive analysis calls attention to Nothing, Matsuda suggests: "The initial imperial encounter between the Dutch and the Javanese *n'a pas eu lieu*—it did not take place. . . . In effect, what is celebrated as a pivotal moment in histories of 'European expansion' is an affair of dramatic unconcern for the history of Java."[12] For indigenous Javanese, the Dutch Empire did not yet exist, and in terms of their own histories, Houtman's arrival was insignificant and the history of imperialism begins elsewhere with locally traumatic results. For the Dutch, with 20/20 hindsight and some pride, it was the onset of empire. Stevenson might call this an adolescent moment.

Willful denial of reality in defense of social or political power also facilitates claims that nothing happened, sometimes to particularly pernicious ends. In one of the most famous sports events of the twentieth century, two men met in 1938 for their second, much anticipated boxing match. An American descended from enslaved Africans defeated his German opponent. Americans could have been expected to cheer a national victory over a German foe, especially in light of remnant Great War animosities and anxieties about the recent rise of Nazism. But the significance of Joe Louis's victory over Max Schmeling went beyond mere sports, because racism in the 1930s was not limited to Nazi notions of Aryan superiority or American Jim Crow laws but was rampant in both nations.

In an attempt to uphold white supremacy, German media coverage contested the results of the fight, and the mainstream American press was no better. Joe Louis recalled in his memoirs how American Nazis showed up at his training camp to intimidate him. And as historian Paul Gilroy reminds us in *Between Camps: Nations, Cultures and the Allure of Race* (2004), white-black boxing was illegal in several states at the time.[13] In his typically trenchant analysis, Gilroy demonstrates how one of the leading American newspapers offered a racially paranoid response to Louis's victory. "Nothing had happened" at Madison Square Garden that night, according to the *New York Times* coverage; "the outcome was meaningless." Even if it was granted that Louis won the match, the outcome had to be regarded as insignificant if white supremacy was to thrive. The black American press, meanwhile, "rekindled" urgent discussions about the connections between American and Nazi German racism.[14]

Ingrained national enmities and political ideologies clashed again when "Nothing happened" in 1968. It may come as a surprise to find out that Nothing happened in 1968, since that year is to the 1960s what *The Great Gatsby* was to the 1920s. The year is synonymous with mass protests, assassinations, and war; "sex and drugs and rock and roll"; and political turmoil and domestic transformation. Americans will remember the murders of Martin Luther King and Robert Kennedy but may be less likely to recall the stunning protests and politically repressive violence in Paris or Prague or Mexico City.

1968 was a global phenomenon that began in the spring of that year. As she researched the student and worker movements in France for her book *May '68 and Its Afterlives* (2002), historian Kristin Ross became wearily aware of the many ways in which memories that "nothing happened" in 1968 have become entrenched. Regarding the May 1968 student protests in Paris, a German sociologist asserted to Ross, "But nothing happened in France in '68. Institutions didn't change, the university didn't change, conditions for workers didn't change— nothing happened." Further, the same interlocutor argued, "'68 was really Prague, and Prague brought down the Berlin Wall."[15]

The purported failure of an expected or desired event to occur is often remembered as "nothing happened," a theme I will return to later in this chapter. When measurable outcomes are considered more important than the transformative experiences that produced them, historical change may register as failure; and when the desired outcome is revolution, anything that falls short also fails. Here, the failure of the student and labor movements to enact lasting institutional changes as a result of their protests is registered as Nothing. Efforts were made but wasted. Futility is what will be remembered.

And that wasn't the end of Nothing in Paris. The interlocutor Wolf Lepenies (pointedly unnamed by Ross in the text but duly credited in a footnote) had insisted that Prague was more important than Paris. Whereas the students in Paris almost succeeded in bringing down Charles DeGaulle's government, only to see the master politician dramatically recover, student protesters and other activists in Prague were suppressed with Soviet tanks. Demonstrating for internal socialist reforms, not demanding revolution or complete release from Soviet remote control, the Czech protestors were nevertheless violently quelled. For the next two decades, they were jailed and forced from their jobs, and they went underground with their politics. Memories of the heroic Prague Spring survived in literature and art as well as among Czech communities at home and in exile. Although the immediate consequences were disastrous for the Czech protest movement, they were arguably intrinsic to the collapse of European communisms twenty-one years later.

So was Lepenies right? (Or was he "right" only if we follow the old joke, "The Left is always right"?) Ross became aware that 1968 and Nothing were indelibly linked.

The feeling that "nothing happened" in May is, of course, frequently expressed—with differing political/affective tones—throughout France today. "Nothing happened, except for the women's movement—and look what that has done to the family"—that is, nothing happened, but everything that did happen was regrettable. This is

one version. Another version sounds like this: "Nothing happened. The French State was able to absorb all that political turbulence and now all those guys have fabulous careers and are driving BMWs"—as though those French driving BMWs today were the only participants in the movement then. Or "Nothing happened politically—but culturally the changes were enormous."[16]

Ross sees two kinds of Nothing happening in these memories of May 1968: futile political protest and regrettable, long-term cultural change. May 1968 is remembered by many more people than those who participated in it: by French people who weren't in Paris and by communities in France and beyond who care about or have felt affected by the changes wrought during a spring of discontent. Lost in the shuffle of political debate is the fact that the students started protesting about conditions at their universities, from overcrowding to not being able to have dorm guests of the opposite sex. In the heady days that followed, the protests morphed from university politics to national politics. The women's movement was part of all this, but it wasn't only happening in May 1968 or only in France; it was ongoing, globally, before and after May 1968.

Some people choose to remember May 1968 as the harbinger of the destruction of their family values. As with the arrival of the Dutch tradesman, how you understand the significance of a real historical event depends on your point of view. And your perspective is deeply invested in your politics, even in your disinterest in politics. Ross registers multiple communities of memories, which reflects more accurately the way that historical change is experienced rather than the way that histories used to be written to consolidate or summarize the singular significance of a historical event.

As Halbwachs suggested and Ross confirms, multiple and overlapping collectives of memories persist and continue to shape discourses about the past, regardless of what historians write or teach. Neither collective memories nor histories are all right or all wrong, and neither has exclusive rights to the past; they are coexisting and

overlapping forms of remembering the past. After all, we remember what we learn from historians about the past; this is how history education works. Without our collective memories of learning history, no remembered past would form the basis of national or any other shared identity. With the explosion of media formats in the twentieth century that have supported new representations of the past, such as radio, television, film, and the internet, communities with investments in collective memories discovered many more ways to stake public claims to the meanings they assigned to the past.

By watching French television in 1988 and subsequent anniversaries of May 1968, Ross perceived that overlapping and competing memories have created a blurring effect, resulting in yet another version of the memory that Nothing happened.

> It is perhaps when viewing French television commemorations of the '68 events, particularly those that accompanied the twentieth anniversary of May, that the viewer is most clearly left with the suspicion that "nothing happened." Is this their purpose? Frequently, the commemorations create the impression that everything happened (and so nothing happened); a global contestation of just about everything—imperialism, dress codes, reality, dormitory curfews, capitalism, grammar, sexual repression, communism—and therefore nothing (since everything is equally important) occurred; that May consisted of students saying absolutely anything and workers having nothing to say.[17]

Unable to single out an event or change that could be marked as historically significant without linking it to many other factors, the commemorative broadcasts essentially threw up their hands in a quintessential, and collective, Gallic shrug. What did it all mean? That would have been an impartial response; but Ross calls them on it, suggesting that the commemorative broadcasts intended to mask the real political energies of the time and subvert the subversives,

to relegate students and workers to insignificance. If Nothing really happened, we could well ask, Why commemorate it on television?

Historians have caught on to how Nothing happened, even if they didn't capitalize on it; in other words, nothing in the lowercase would indicate its significance. In the cases that follow, I track distinctive historical examples of how Nothing happened. I begin with the humorous historical marker that claims "Nothing happened on this site in 1897" and consider what its appeal says about historical consciousness. Pointed political jokes about the sign have been used subversively to draw attention to official attempts to erase the past. It's also noteworthy how intentional historical markers have performed erasure, making it look as though Nothing happened on sites of actual trauma.

Looking at "Nothing happened" as a real historical object requires attention to millenarianism, the belief that the world is coming to an end. Whether the faithful expect a fulfillment of religious tenets or cults organize around arcane beliefs, the world has known many, many apocalyptic prophecies over millennia of human existence. And yet the world is still here. What happens when the world doesn't come to an end on the date predicted? How do believers in apocalyptic predictions come to terms with their "Great Disappointment" when Nothing happened at the supposed end of time?

Shifting gears from humorous historical markers and the predictable failure of millenarian prophecies, the final historical Nothing I investigate involves erasure at the highest level: official claims that Nothing happened on any given date, when a government's intention is to deny the crimes of the past, or perpetrators of domestic terrorism continue to walk in broad daylight as though they have done Nothing. The history of injustice is global and perennial and demands our attention. Looking at poetry and films that illuminate the experiences of victims, I consider how poetry makes nothing happen but does provide a public platform for otherwise stifled grievances to be heard. In Rea Tajiri's evocative *History and Memory* (1991), the

filmmaker invokes the spirits of her ancestors to witness otherwise erased crimes haunting the present. Patricio Guzmán's poetic film *Nostalgia for the Light* (2010) weaves together many forms of how Nothing happened and provides vivid illustration of the way that Nothing has changed for the victims of Augusto Pinochet's 1973 coup in Chile, whether they are alive or dead. I will attempt to illuminate one aspect of this essential history of human rights: historical consciousness as an awareness of the failure of justice to occur, a past that haunts the present and demands to be heard.

§ ON THIS SITE NOTHING HAPPENED: HISTORICAL MARKERS

The history of historical preservation can tell us a lot about when Nothing happened. Creating signage to indicate the historical significance of a place was one way that modern civilizations began to designate sites that were worth remembering and preserving. The practice has become so widespread in the United States that it has in turn become vulnerable to parody: If thousands of historical markers indicate noteworthy sites, we can poke fun at obsessive memorializing with a sign that says "Nothing happened here."

A sign of the times, the historical marker adorns roadsides, buildings, and pretty much any place that has physical presence sufficient to hold it. The internet has added a virtual dimension to the flourishing practice as well as being a resource for historical marker aficionados. The Historical Marker Database had catalogued over 126,450 "Bite-Size Bits of Local, National, and Global History" by the end of 2019, and the number continues to grow daily.[18] Collectives ranging from local communities to national governments and international agencies have designated sites of memory that merit the signage. And one way to tell just how prevalent the signs have become is to follow the history of the countersign, the visual joke that is its counterfeit. The sign appears most frequently on buildings and, particularly, at homes. The mass-produced plaque is not

large, about half the size of an ordinary sheet of notebook paper. It may be made of bronze, iron, or a facsimile of metal. The sign has been available "since at least the 1980s. You can buy one online, pre-antiquated, for about 30 bucks" (or $19.95 as of December 2019, for the cast iron version shown in Figure 35).[19]

Before I consider why Nothing happened in 1897 (and not 1896 or 1898 or . . .) and why this sign is for sale on amazon.com, I want to note that, although the internet is a rich hunting ground, because it is full of Nothing, its user sites are not usually themselves considered sites of historical significance. For one thing, they are ephemeral, thanks to the planned obsolescence of software and the continual evolution of ever-greater storage capacities and slicker imaging and content provision upgrades. Generations of internet users would be astonished if, in fact, Nothing happened online, because we associate the internet with newness. We expect constant change and would be disappointed if our feeds were not novel.

The irony here is that, of course, most online content is continually recycled, reposted, reblogged, and linked to existing content. The familiar modern notion that places and objects might become unique historical artifacts has not so much been displaced by the ever-shifting internet as it has been quoted. Each link is, in effect, a quotation of something someone else already said. The uniqueness or originality of the person who created that content is valued, but it is also quickly lost. And this is not a cause for alarm. Reposting is the internet equivalent of a nod, acknowledging the source, appreciating it, passing it along.

The same generations of online content users who expect web content to disappear can also maintain an ironic sense of historical distance. Where earlier generations of twentieth-century Americans conducted historical preservation campaigns and erected historical markers at sites esteemed for historical significance, by the last quarter of the century Americans were able to make fun of themselves for taking the past so seriously—as, for instance, with the historical

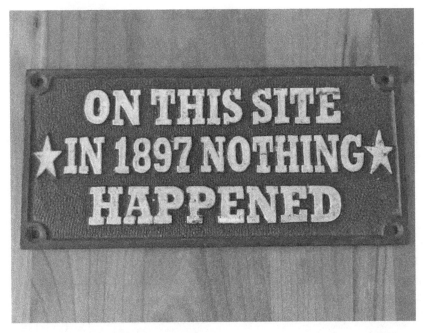

Figure 35. "Cast iron garden plaque sign" from amazon.com ($19.95; but, really, shouldn't it be $18.97?). Photo by the author.

marker that states "On this site in 1897, nothing happened." This plaque has been available for purchase, in multiple colors and designs, for decades. Its design clearly quotes the format of historical markers, boldly highlighting federal stars. On the photo-sharing website Flickr, one page, created in 2008, is dedicated to photographs of plaques that insist that nothing happened here. The photographs depict signs in a variety of locations—out in a field, on a wall—and an assortment of dates (1832, 1897, 1782).[20]

It is difficult to source the first plaque. Massive online galleries of similar signs exist, but little information other than location is provided; Q&A sites reference location or where to buy the plaque but are collectively baffled about origins. Scholars have been equally uninterested. The doyen of American collective memory studies, Michael Kammen, noted the plaque in his 1993 book *Mystic Chords of*

Memory as a humorous sidebar. It's unclear whether Kammen saw or only heard about the plaque, but he notes the existence of one on "a corner store in McCall, Idaho," in the course of discussing what the middle class chooses to remember, its milestones or its millstones.[21] The scholar James W. Loewen, author of *Lies Across America: What American Historic Sites Get Wrong* (1999), found the sign near a house on Great Gott Island, in Maine's Acadia National Park. The book scathingly assesses the historical inaccuracies and outright lies Loewen finds in historical markers across the country and offers historical information that could be used to read the sites more accurately. Loewen claims to have read every single historical marker in thirty-four states (and most of them in fifteen more, including Texas).[22] He is well aware that any interpretation of historical sites is itself not "true" but deeply contextualized. Each generation may reconsider the significance of the past and choose to remember or forget, accurately or inaccurately. But in the case of nothing happening in 1897 in Maine, he noted, "So far as I know, this marker is absolutely accurate."[23]

Humor aside, what did Loewen notice at this site? Barrenness, boredom, lack of significance? He noticed the actual experience of Nothing as historical consciousness. Whoever placed the sign there apparently agreed. Part of the subtle joyfulness of the sign is precisely not asking anyone why they put it there. Who wants to get involved in a detailed conversation about Nothing (besides, of course, me)? You get the joke; you move on. Nothing happened.

A search of Google Books reveals some noteworthy trends in references to the sign from the 1980s to the present. There are three types of books in which the sign appears frequently: travel literature, cookbooks, and fiction, all of which have cause to make specific mention of place. One of the earliest appearances of the sign was noted by *Washington Post* reporter Joan Nathan, who wrote in 1984 that she'd seen one which she believed was "a take-off on the Texas Heritage markers scattered on historical landmarks throughout the state."[24] As of the turn of the twenty-first century, Texas had over

12,000 historical markers, more than the combined total of the other forty-nine American states at the time.[25] No wonder Texas is home to one of the first reported "nothing happened" signs—familiarity breeds contempt? A 1983 Frommer's *Guide to Hawaii on $25 a Day* spotted the sign on sale for $17 at a local shop and noted that it "appeals to our crazy sense of humor."[26] In 1990 the *Chicago Tribune* reported that students at Northwestern University could stumble across the plaque on campus.[27] Pam Grout's 2010 *Kansas Curiosities* found the sign on top of the state's tallest geological landmark (admittedly, there aren't many).

> Mount Sunflower, the highest point in Kansas, used to have a cow skull sitting on it. Now it has a giant sunflower made of railroad spikes, a mailbox, and a plaque that says nothing happened here in 1897.[28]

Mountain climbers ticking off "fourteeners" (i.e., mountains exceeding 14,000 feet) and other notable peaks on their bucket lists have found the Kansas sign; so have visitors to Chicago's Green Door Tavern, a "nondescript building in Ouray, CO," a Boston burger joint, and many other locales. In her memoirs, Nancy Reagan remembers that the sign hung on the Reagan's home in Santa Barbara (*My Turn*, 1989).

Specialists on Nothing, myself included, tend to gravitate toward this sign with delight. Lawrence Krauss, the physicist and author of *A Universe from Nothing* (2012), cites a copy of the plaque which he found in the Woody Creek Tavern, in Woody Creek, Colorado, in the book's opening epigraph. Most of those who find the sign, however, have not speculated on its significance beyond the humorous reference to historical preservation mania. Yet all of those who cite the sign, providing links to its locations, have contributed to the creation of a global network of (non)historical signage.

Stumbling upon the sign for the first time can still be humorous and thought provoking. The sign's canonization in popular culture is

itself a marker of ironic awareness that anywhere, potentially, could become a historical site. No better testimony to the ubiquitous appreciation of the sign's ironic humor can be found in the following passage from Amelia Shea's 2016 romance novel, *Impatiently Patient*, in which the hero (who, perhaps not coincidentally, lives in Houston) has opened a card from a woman who, the reader anticipates, will find a particularly fond place in his heart.

> "Happy Birthday, Ethan! What do you get the guy who has everything? Something you're sure he doesn't own. Love, Emory"
>
> He stared at the card, rereading, "Love, Emory." Placing the card to the side, he ripped off the wrapping paper and stared down at his gift. It was a rectangular plaque. Obviously meant to be hung on a wall. Reading the inscription, a smile spread across his face and he laughed. "On this site in 1897, Nothing Happened."
>
> Typical Emory, giving him a gift that made him laugh. Not a gift of money or an expensive wine to impress him. This gift was thoughtful. It was an Emory gift.[29]

Seeing the plaque as a thoughtful gift rather than as merely a gag allows the hero to perceive "Love, Emory" as more than a casual expression and places her in the category of object worthy of love—rather like a sign that designates a place worthy of preservation. And when Nothing happens in a romance novel and that's commented on favorably, you know that Nothing matters.

The historian is not the only one who wonders, Who first made this? And why 1897 instead of any other year? In Britain a similar sign has been available but with a different date: "On this site Sept. 5, 1782 Nothing Happened." Several sites credit Wikipedia for the information that this date was significant during the American Revolution. Others note that if one intuits a typo on the sign, then a rerendering of the date to 1752 would invoke a real calendar date, September 5, which was lost in the transition of the British

calendar regime from Julian to Gregorian—during which time, as we've already seen, Nothing really happened. Although the logic is convoluted, it appeals to a certain geeky sense of humor. The question remains, Why does one year matter more than any other? (Or, since Nothing happened, perhaps the question should be, Why does that year matter less?)

Matt Groening and the artists on *The Simpsons* were aware of the geeky humor and subversive political implications of the sign when they referenced it in an episode in which the Simpsons visit Beijing in 2005. As they walk through Tiananmen Square, a sign appears (Figure 36). The year has been changed from 1897 to 1989, almost a century later, as though to mark an anniversary. Groening and the *Simpsons* artists evoke memories of the student revolutionaries who challenged the national government and demanded reform in the

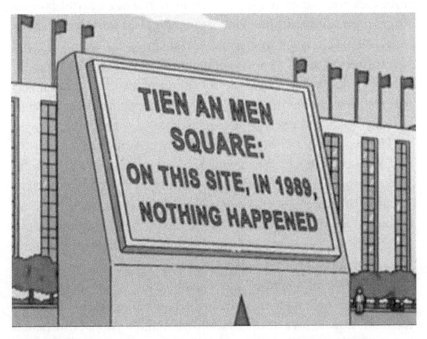

Figure 36. The Simpsons, episode 347, "Goo Goo Gai Pan," March 13, 2005.

spring of 1989, as well as the iconic "tank man" who stood alone in the middle of the street in front of approaching Chinese tanks sent in to suppress the protests. The crowd of student protestors is erased by the sign, as are the tanks.[30]

The Chinese government's complicity is further indicated by the sign's public presence at an important historic site and tourist attraction, Tiananmen Square. The sign is no longer a humorous riff on the tendency to remember and memorialize everything and anything as historical. Instead, the sign's meaning has been transformed by the artists into a commentary on the Chinese government's insistence on forgetting what actually happened there in 1989. Their effectiveness has been attested to by later generations of Chinese students, including those interviewed by NPR journalist Louisa Lim. The elite students at a premier university could not identify the historical event of the 1989 protests. When presented with photographs of tank man and other protestors, they could not identify some of the most world-famous images of an admittedly intensively photographed historical year—or preferred not to recognize them, because they were on camera and their university spots were presumably at risk if they evidenced political knowledge that they were not supposed to have.[31] Thus it was better to act as though, indeed, Nothing had happened there, because that corresponded better to the official national narrative.

The Simpsons made a pointed political comment about history and memory with a historical marker, and it resonates. Historical markers have served as sites of reflections on absence as much as presence. If a sign can mark where Nothing happened, then it can also mark where local history has been marginalized, ignored, and erased. Current signs in San Jose, California, designate the historical significance of a local Asian American community, specifically with reference to Japanese American emigration. The memories of Issei and Nissei residents are inscribed onto plaques and benches in what is now known as the Japantown neighborhood. One bench features a photograph of a historic local drugstore, Jackson Drugs, and a quote from a local resident who remembers it.

> I have been at this corner most of my life being born in the mid-wife house across the street. Nothing has changed in the neighborhood, except the people. I've seen Tokunaga go, Hashimoto's Drug store across the street become a golf shop, Tom and Mary's closed, that was the coffee shop across the street. I'm the only one left.—Bill Furukawa[32]

Furukawa insists that "nothing has changed except the people," but he goes on to list several local landmark buildings that have disappeared. This quote is inscribed on a bench opposite the former location of Jackson Drugs, which has also been replaced by another structure. Furukawa remembers the structure of his community's daily life (midwife—and, presumably, mother; coffee shop dining; drugstore for essentials) through absent structures (the drug store, the midwife's house, the coffee shop). The essential character of the neighborhood, for Furukawa, lies in its residents, but they have changed and he is "the only one left." The reasons for this change can be understood only in reference to other historical markers within close range. Another bench nearby marks the former Kawakami Building with a photo of the wood-fronted structure and a quote from another resident, possibly a relative.

> When folks came back from the internment camps many of them were helped a lot by a local businessman, Torahiko Kawakami. He worked through the Buddhist Church hostel to resettle people and to get them back on their feet. He became known as Japantown's "Ombudsman."—Wright Kawakami[33]

The history of Japanese American internment during World War II is referenced in the past tense ("when folks came back") and assumed as prior knowledge among its readers. The community's population had changed: Some left and didn't come back; some left and came back; some moved in. Even though this is an accurate history of any urban community that is still inhabited, we should also note

how diasporic memory is migratory. The historical markers are in place to remind local residents and visitors about the past because, as Furukawa believes, no one else but he would otherwise remain there to remember. But the others who might remember were themselves forcibly relocated, and some did not return; of their memories, Nothing is left on site. The memories are out there, in the form of engraved benches, but also in a diaspora.

The internment camps themselves, located across the American West and in Arkansas, have gradually received national landmark status and historical markers. However, as Rea Tajiri described in her moving and personal documentary *History and Memory* (1991), locals she met in the late 1980s in Parker, Arizona, did not necessarily want to be reminded about what used to be there during the war. Tajiri drove through the desert from California to Arizona to film what her mother had not been permitted to photograph or indeed even to see while enclosed in a train with the windows covered, en route to the "Poston War Relocation Center." (The name is a misnomer on several levels; wouldn't it have been interesting if the U.S. government had really been able to relocate the war? Or to a more central location?) To create visual memories for her mother, Tajiri filmed the desert from the vantage point of the driver's seat; she then walked and filmed the former camp site with a handheld camera. Situated on land that was "requisitioned" from the Gila River Indian Reservation on the Arizona-California border, the camp was overcrowded and utterly miserable in the summer heat, but the internees managed to create a thriving date palm grove and farm. The site was offered back to the tribe after the war, along with the shabby shacks that had been built for the internees; the tribe rejected it. After a long grassroots effort, a memorial bell and plaque were installed as a permanent monument in 1992.

When Tajiri arrived at Poston, she felt that her presence was eerily like that of Spencer Tracy's character in the 1955 film *Bad Day at Black Rock*: "reminding them of what they did not want to remember." Tracy portrays a World War II veteran seeking Komoko, the father

of a deceased comrade in arms, who was Japanese American. Tajiri's family also included veterans who served while their family was interned; one uncle chose never to live in the United States again, because, he said, "Nothing has changed." But when Tracy's character arrives in Black Rock, no one seems to know where Komoko is, and no one wants to help Tracy find him. Tracy locates the grave of the murdered father only by noticing that wildflowers are blooming there. Tajiri comments on how the wildflowers, like the remains of the date palm grove at Poston, serve as unintentional historical markers that remind locals of what they'd prefer to forget: "That was the thing about the Japanese, they made things grow." Her comment reflects not only the history of "relocation" but also of Japanese farmers' successful agricultural endeavors on the West Coast, which became the target of racist enmity and immigration restrictions. Where are the historical markers for this? Memory studies scholar Marita Sturken asks even more pointedly, "What would it mean for Americans to remember the names Manzanar, Poston, Tule Lake, Topaz, Minidoka, Heart Mountain, Jerome, Gila River, Amache, and Rohwer in the way that they know the names Auschwitz, Dachau, and Buchenwald?"[34] The names of the American concentration camps are inscribed on the Japanese American Memorial to Patriotism During World War II in Washington, D.C., dedicated in 2000. The monument, sponsored by an association of Japanese American veterans and maintained by the National Park Service, sits on federal land, but not on the National Mall; it is not centrally located.

When there is Nothing left, or next to Nothing—a town next to an abandoned camp or flowers next to an unmarked grave—memories are not entirely lost, but the desire to remember has been buried, if not erased. Tajiri notes that she once blamed her mother for failing to share those memories with her. Later, she says, she could forgive her mother for her loss of memory. She recognized that her mother "remembers why she forgot to remember": Trauma remained, and memory caused pain; in this sense, Nothing had changed.

Tajiri contemplates the erasure of her family's memories in post-war histories, pop culture, Hollywood films, historical preservation, and historical markers. Growing up, she knew Nothing about what actually happened to her family, except that "we had suffered a lot of pain." Her mother had never spoken to Tajiri about her family's experiences in the camp, until the filmmaker began to interview her and take her back to sites such as the temporary holding center fashioned out of horse stables in Salinas, California. Describing a mental image that she's had since she was a child, of her mother filling a canteen with water, Tajiri then re-creates this image as a scene for the film, using herself as actor and imagining her mother at the camp. Drawing on her sense of unease and lack of historical markers to reference, Tajiri must envision a reality that was not recorded because "Nothing was happening" that shouldn't have, according to official narratives. Lacking historical markers and having only family memories and popular culture references to guide her, Tajiri reconstructs as accurate a history of their experience as any archivally based research could have.

When she arrives at the camp, Tajiri imagines that she can use a "sort of mental divining rod" to determine where her mother had lived and realizes later that she was correct. She does archival research as well and finds a photograph in the National Archives that depicts her grandmother in a bird-carving class during her internment at Poston. Her mother had owned a carved wooden bird pin, which she wouldn't let her daughter touch: "No, don't touch! That was grandma's" was all she would say about it. Connecting her mother's few references to the past with her knowledge of how Hollywood films and American government propaganda depicted the attack on Pearl Harbor and the concentration camps, Tajiri creates and comments on the nature of visual memories.

There are things which have happened in the world while there were cameras watching, things we have images for. There are other things which have happened while there were no cameras

watching, which we restage in front of cameras to have images of. There are things which have happened for which the only images that exist are in the minds of observers, present at the time, while there are things which have happened for which there have been no observers, except the spirits of the dead.[35]

Tajiri's profound meditation on the nature of historical consciousness and its continuous, haunting presence in the absence of evidence challenges the very foundations of historical scholarship. How should historians account for, and recount, what happened when we have no surviving sources of information? We may have acted as though Nothing happened and written histories that neglect what really happened in favor of what we can document. Skeptical viewers who don't want to take Tajiri's invocation of the spirits of the dead literally should perhaps consider how what they think they know about the past has in fact been imagined in their minds based on what they have learned, read, seen, and remembered as history.

Tajiri's road trip also mirrors a quintessentially American travel experience of driving across the country to visit sites of historical significance or stopping along the way on other trips to see the historical markers that dot the highways. This wasn't my family's ritual, but many others will recall such stops with either fondness or shudders from bad flashbacks to tedium. Those who stopped out of some sense of educational imperative or historical curiosity at least felt that there was something to be learned, something that was valuable enough to be shared with children. This is one way that collective memories of history form within families, as Halbwachs understood in an earlier part of our modernity. In contrast, Tajiri and others have pointed out what's not been available to learn from, what's been erased by the absence of historical markers. Historian James Loewen's disparagement of Texas's ubiquitous historical markers is rooted in his awareness of what's not being commemorated: Reconstruction-era violence,

race riots, lynchings. He prefaces *Lies Across America* by stating that, as a child, his understanding of American history had been warped by his family's penchant for stopping "at every historical marker and monument" on their annual summer vacation trips.[36] Racism and sexism are embedded in American historical markers, he argues, and early and frequent exposure to national identity myths thus provided an unsuitable foundation for learning actual histories.

The recent efforts of the Equal Justice Initiative (EJI) to place historical markers at sites of racial violence, particularly lynching, is particularly noteworthy in this regard. I visited Montgomery, Alabama, for the first time in 2018 and was struck by the uncanny proximity of Confederate and civil rights statues, memorials, and historical markers, to which is now added the EJI's profoundly haunting National Memorial to Peace and Justice, a monument "dedicated to the legacy of enslaved black people, people terrorized by lynching, African Americans humiliated by racial segregation and Jim Crow, and people of color burdened with contemporary presumptions of guilt and police violence."[37] The historical markers added by the EJI in the past few years, both in Montgomery and around the country at historic lynching sites, restore some of what previously had been erased. The absence of historical markers had made it seem as though "Nothing happened here" not only in 1897 but over the past 400 years of human trafficking and racially motivated terrorism.

Historians know that we imagine the past by re-creating it in our minds and then writing it down as history. History books and articles then become visible, visual historical objects that preserve what the historian learned and has shared with the interested public. This is another way that collective memories form: as history education. It might be useful if we historians placed historical markers at the front of our books stating that "on this site, Nothing happened, but we ignored that in favor of writing about the evidence that we found" and then set readers loose to uncover what's missing.

§ IT'S NOT THE END OF THE WORLD

I was in the midst of working on the history of millenarianisms, or the fear that the world is coming to an end, when alarms sounded in the Hawaiian Islands. No one was immediately sure whether this was just another test, or the real thing, the initiation of a nuclear holocaust. I'm enough a child of the Cold War to have this particular fear deeply embedded in my nervous system, and like many others, even though I was thousands of miles away, I was frightened.

On January 13, 2018, plans were made to conduct a ballistic missile alert response drill on Oahu. Instead, human error caused the following message to go out across multiple communication platforms: "Emergency Alert. Ballistic Missile Threat Inbound to Hawaii. Seek Immediate Shelter. This Is Not a Drill."[38] Although the command post attempted to send out counterwarnings within moments of the mistake, it took over half an hour to confirm the error and rescind the warning. TV news and internet platforms ran banner headlines repeating, "This is not a drill. Seek shelter." Some panic ensued. But thankfully, it wasn't the end of the world. Not this time. Nothing happened.

In the middle of the Cold War, another false alarm in 1983 almost started World War III—but an experienced Soviet officer saved the world by doing nothing. As David E. Hoffman recounts in *The Dead Hand: The Untold Story of the Cold War Arms Race and Its Dangerous Legacy* (2009), in 1983 the Soviet Union and the United States had some 18,400 nuclear warheads between them, aimed and ready to launch on missiles in silos, submarines, and ships across the globe. Both sides were primed for first strike and mutual assured destruction, and nervous about launch codes. Fortunately for the entire planet, the early warning system supervisor on the Soviet side during the 1983 false alarm was Stanislav Petrov, who had considerable experience with warnings, tests, and drills predicated on the imminent end of civilization. In the middle of the night, Petrov saw a sign flashing the word "Launch" and a light indicating "high reliability," which had never happened before.

Petrov made a decision. He knew the system had glitches in the past; there was no visual sighting of a missile through the telescope; the satellites were in the correct position.

There was nothing from the radar stations to verify an incoming missile, although it was probably too early for the radars to see anything.[39]

Petrov had also been trained in a Cold War orthodoxy: that a nuclear strike would most likely begin with a massive assault, not a single missile. Even when he saw four additional launch notices moments later, he hesitated; "This was not the way to start a nuclear war," he recalled thinking not once but twice.[40] And like all of us who rely on electronic technology for communication, he knew that tech is great until it fails, and then it's not. He made a calculated decision, and was proven right minutes later when Nothing happened, again— and what a relief it was.

Stanislav Petrov passed away in 2017. I saw his obituary and made a mental note to give him credit for doing Nothing. I had not heard about him before, but his actions have not been forgotten: He received honors from the United Nations in 2003 for his work, was interviewed by Walter Cronkite, and became the subject of a documentary. Luckily for us all, his cooler head and second thoughts prevailed. Nothing happened because nothing was on the radar, and an experienced supervisor figured out what that really meant and did nothing. In the end, Nothing happened except another false alarm.

As human fears go, the fear that the world is coming to an end is reliably perennial. Whether the world will end in fire or ice, as the poet Robert Frost mused, in nuclear devastation or global warming, four horsemen plunging civilization into chaos, or extraterrestrials launching attacks on the planet, humans have long imagined, with utter confidence, how it *will* come to an end. The fact that it has not, so far, is hardly credible evidence to the contrary. To paraphrase literary critic Frank Kermode, the end has become immanent rather than imminent.[41]

The future is always uncertain and unpredictable, so prophets of doom have always found ready audiences. In the Muslim Hijri calendar, the designated end of times was 1582 (in the date terms that emerged the same year when Gregorian calendar reform occurred). The followers of the Society of God Worshippers in mid-nineteenth-century China, who sought to build a heavenly paradise on earth following what we now call the Taiping Rebellion, believed the end would come in 1853. Midcenturies seem to foster millenarianisms, or perhaps it's a coincidence of world historical imperialisms that the apocalyptic Xhosa cattle killing movement reached its apex in 1856–1857, shortly after the Millerites in America predicted that the end of the world would come in 1843 and the Taiping Rebellion had taken a turn for the worse. Millenarian fears climaxed in Burma in the 1930s. Multiple doomsday cults rose and fell during the Cold War.

Indeed, the persistence of apocalypticism has been noteworthy, despite the unsurprising way that Nothing happens on the prophesied dates of the end of the world. Millenarian movements exist in world religions and secular societies alike, and, regardless of theology or ideology, they share a common belief that some people may possess special wisdom about the future. This has long been true, and today is no different. But as the biologist Stephen Jay Gould pointed out in his highly entertaining consideration of millennialism circa 2000, it is the nature of apocalyptic movements that they *always fail*.[42] Gould is referencing the important revisionist scholarship of Richard Landes, a medievalist whose later book, *Heaven on Earth: The Varieties of the Millennial Experience* (2011), recapitulates a career's worth of research. Landes opens with a story full of wry Jewish wit.

An old Jewish tale tells of a traveler who passes by a little village in Eastern Europe (Chelm) and finds a solitary watchman looking out. Thinking that this village hardly had the wealth either to make such a guard necessary or even to pay him, the traveler asked him why he was there.

"I am here to watch for the messiah," he responded.

Years later, passing through the same region, the traveler went back to see if the man was still there. And he was.

"Nu, doesn't this get a bit boring?" he asked.

"Yes," replied the messianic watchman, "but think of the job security."[43]

So why do these movements persist and resurge? Why doesn't millenarianism die when the predicted end doesn't happen? What happened to the believers after Nothing happened? This is the crux of my inquiry into what happens *after* the world fails to come to an end every time it is predicted.

First, a word about a confusing mouthful of vocabulary. When a group of people come to believe that the world is going to change fundamentally, unavoidably, and drastically and that nothing will be the same afterward, their belief is called millenarian. Although the word *millenarian* contains the same etymological root for the idea of "the year 1000" as does the word *millennialism*, these two terms are not synonymous. Millennialism is a specific form of millenarian belief that is centered around the spiritual or psychic meaning of an era that will come into being and last 1,000 years, as is central to religious apocalyptic traditions.

What Gould calls calendrics appears to have figured into apocalyptic calculations across the millennia. The significance of centuries and 1,000-year reigns has expanded disproportionately, far beyond their intrinsically human conception. Rationally, we know that centuries are arbitrary time markers that don't really correspond to experience of historical events. But as historian Jeremy Popkin notes, the modern habit of assuming that centuries are relevant historical concepts can be dated to the Protestant Reformation and the sixteenth-century authors of the *Magdeburg Chronicles*. In thirteen volumes, each one dedicated to a century of Christian history that begins and ends in years with double zeros, the authors attempted to create a system of chronicling that was not indebted

to royal dynasties' durations or ecclesiastical epochs but was rather more neutrally numerical.[44] In this manner, they intended to create a history of Christianity.

When we consider that years ending in two or three zeros are still just names and concepts created by humans to keep consistent and predictable track of time, we might well wonder why a number designating a century seems to mean so much more than any other year. Those of us born midway through the twentieth century who actually got to "party like it was 1999" may understand why a later generation could be labeled millennials, but we hardly intended the name to convey a sense of that generation's imminent doom.

The year 2000 spawned a growth industry in research and publication about millennialisms, which has had a fortuitous effect on understanding the phenomenon. As the latest century and millennium came to an end, debates raged about whether December 31, 1999, was the last day of the era or whether it should really be December 31, 2000—just as they had in 1899–1900. In the waning years of the century, fears also emerged about the viability of computer software to accommodate the change in date format, from 19XX to 20XX—when most software had been programmed only for 19XX. The Y2K ("year 2000") phenomenon generated widespread concern, governmental policy debates, and gleeful popular culture witticisms. As Y2K came and went without an international computer meltdown, people wondered what all the fuss had been about and turned to new fears about computer viruses, the dark web, conspiracies to annihilate satellite communications, and other forms of massive technology failures. All of which feels commensurate to the utter dependence of modern societies on computer technologies: The more you have to lose, the greater the fear will be.

Although there has been a highly contentious debate among historians of the Middle Ages, it now seems that much the same thing happened in Western Europe around the turn of the previous millennium, as Richard Landes and others have demonstrated.

Whether the year is 1000 or 2000, people tend to worry in the same ways about what may lie beyond human understanding—despite the fact that nothing happened in AD 1000 or AD 2000 to initiate The End of the World. Millennialisms and millenarian beliefs persistently haunt human societies. In our current Anthropocene Era, the feared apocalypse takes the form of human-caused climate change—and we can only hope that the outcome will be the same as it has been for every other millenarian prophecy that failed.

Given the persistence of millenarianisms, it comes as no surprise that scholars have attempted to account for their durability in the face of skepticism and failure. Social scientists in the mid-twentieth century conducted research about contemporary apocalyptic movements, to see how believers responded "when prophecy fails." In a landmark 1955 book of the same title, Stanford psychologist Leon Festinger and his colleagues found that, contrary to expectation, the disappointment of failed prophecy does not necessarily result in the end of the apocalyptic movement. Rather, it becomes a launching point for renewal of faith.[45] They found that believers gathered around a Chicago medium, "Mrs. Keech," who claimed to have been contacted by "spacemen" about an imminent environmental disaster. They could sustain revelations of "disconfirmation" (learning that they had been wrong) without losing their faith, so long as they were supported within a social group of like-minded believers. They could hold in their minds simultaneously the notion that their faith was strong and the knowledge that the prophecy had failed. The researchers named this phenomenon cognitive dissonance, and the term has come into widespread usage that far outstrips its origins in the paranormal and apocalypticism. When Nothing happened and the end didn't come, the failure of prophecy inaugurated review, revision, and recalculation, not the end of the movement. Nothing happened twice: The world did not end, and the faith of the believers did not die.

It's worth revisiting the Festinger study in some detail, and not just for its tasty combination of flying saucers, telephone mediums, Dianetics, and Midwestern wholesomeness, which has kept the study in public view for more than sixty years.[46] It's still an entertaining read. Although most commentators focus on the introductory and concluding chapters about methodology, Festinger's narrative is richly detailed and lively. Critical response to *When Prophecy Fails* revealed fundamental challenges to Festinger's conclusions, as social scientists tested his results in other settings and found that groups did not behave as predicted. More crucially, scholars such as Jon Stone and Stephen O'Leary have argued that Festinger's study was fatally flawed in that it attempted to import scientific categories of analysis into a spiritual setting, applying "rational" criteria to spiritual experiences and ignoring the cognitive effects of religious faith.[47]

What if cognitive dissonance was seen as our normal state of being, and consonance or scientific rationality was considered an artificial imposition of rational categories to try to control that cognitively dissonant normalcy? As Stone writes, "One might argue that the people [studied by Festinger] were already living discordant lives. By joining with Mrs. Keech, they were bringing a measure of consonance into their lives. The prophecies were likewise means by which dissonance was being resolved."[48] What if the Festinger study is interpreted from the perspective of evangelical Christians, who are sympathetic to the emotional and spiritual significance of apocalyptic fears and who experience consonance through their faith, as Timothy Jenkins suggests in his 2013 book *Of Flying Saucers and Social Scientists*?[49] Part of the answer is that the world may still come to an end someday, and so long as anyone believes that, there will be prophecies. And part of the answer lies in how people felt after Nothing happened.

Cognitive dissonance, flying saucers, and apocalypticism are all aspects of mid-twentieth-century modernity. It has been tempting, over the past two millennia of history and of scholarship, to view

apocalyptic movements and their prophets as lunatic fringes. Although major world religions, such as Islam and Christianity, are premised on apocalypticism, the prophets who claim to have special insight into the end of times are just as likely to be branded as heretics. But the social science that produced a new category of psychological analysis coexisted in time and place with groundbreaking (or perhaps I should say, heavens-shattering) space exploration and public fascination with all possible extraterrestrials. Mrs. Keech's spacemen didn't come out of nowhere; they came from an "outer space" that was understood by contemporaries to be virtually infinite in its possibilities for life forms and newly accessible to humankind through the technology of spacecraft. The same postwar, post-atomic era produced UFO sightings over Roswell, New Mexico, in 1947.

Marian Keech's real name was Dorothy Martin. She was 54 years old when she received her prophetic revelation while living in Oak Park, Illinois, a well-to-do Chicago neighborhood. Her domicile is referred to as Lake City in the book—all names in *When Prophecy Fails* have been changed to protect the innocent, or to maintain illusions of social scientific rigor. Before her revelation that December 21, 1954, would be cataclysmic, Martin had been in contact with flying saucer enthusiasts and had studied the words of L. Ron Hubbard. She claimed to have received messages from Sananda, the leader of the spacemen "Guardians," who entrusted her to form a group of "Seekers," whose faith in the prophecy would permit their rescue on the appointed day. Flying saucers would come pick them up. The group consisted of families, neighbors, and some college students and never was larger than a few dozen. In another nod to modernity and its technologies, Martin received her messages by means of telephone calls. This much information is publicly available in the *Chicago Tribune* archives, as reporters covered Martin and her prophecy in the weeks before and after December 21 (*Chicago Tribune*, December 17–28, 1954).

Festinger and his colleagues had become aware of the group from an earlier report of anticipated alien contact and were excited to test their theories about apocalyptic predictions and cognitive dissonance in a real-life setting. They sent some of their students, who had been hurriedly inducted into both social scientific research methods and the prophecy, to infiltrate the group and observe how the followers responded after December 21. Festinger never comments on the religious affiliations of the student-observers he deployed to participate in the group, but their lack of faith in the prophecy is never in doubt. Martin and her small band of followers accepted these false newcomers enthusiastically, even registering their presence as a sign of the righteousness of their cause. The observers participated in seances, listened to Martin's reports of messages from the spacemen, and were present on the day that was to be The End. In hindsight, Festinger and his collaborators ruefully admitted that it was perhaps inevitable that the presence of these observers would affect the group's behavior, and this was in fact the case. Still, Festinger believed that after accounting for these effects, the group's response to disconfirmation could be studied authentically.

On the night of December 21–22, 1954, Nothing happened at two pivotal moments. As Martin and her followers anxiously awaited the arrival of the flying saucers in the middle of the night, they busied themselves by removing all types of metal from their clothing. Even shoe grommets had to go, and bra fasteners as well, or the Seeker would be rejected by the Guardians. Some group members had already divested themselves of their worldly goods, all financial commitments, and possessions, in anticipation of no longer needing them in the future. The group around Martin included "Dr. Armstrong," a 44-year-old physician named Charles Laughead who was a staff member at a Michigan State University hospital in East Lansing ("Collegeville") and was close to Martin and an authority figure in the group. Laughead had recently met George Adamski, author of *The Flying Saucers Have Landed* (1953), which

detailed Adamski's meeting with an extraterrestrial in Desert Center, California, and included drawings of "Venusian footprints" that the visitor left behind.[50] Laughead had recently run afoul of his institution with his efforts to recruit students into the group. He lost his job shortly before December 21 and was about to undergo investigation of insanity, at the instigation of his own sister in Collegeville. His teenage daughter also participated, if in a more skeptical frame of mind, and was among those awaiting the spaceships throughout the night.

Nothing happened. As the new day dawned and flying saucers had not arrived, consternation engulfed the exhausted group. But Martin received a reassuring call and learned that her group's faithful efforts had not been ignored. Quite the contrary: They had been rewarded. Festinger never seems to have asked how the calls from the spacemen were initiated; his observers followed Martin in only reporting what she claimed to have heard after the telephone rang. At least two calls may have come from pranksters, but Martin consistently interpreted all phone calls as confirmation of her faith. On the fateful night of December 21, Martin was reassured by the Guardians that the predicted earthquakes and floods had not materialized precisely because the group had been willing to give up all earthly things. A spaceman had in fact infiltrated the crowd around the house during the night and had felt unwelcome, according to Laughead.[51]

Reporters had been hanging around for days, and Martin had not been a cooperative subject. She shooed away reporters and refused to permit photographs in the house. After December 21 and her reassuring phone call, however, Martin reached out to the newsmen and began to cooperate in what Festinger deemed the spirit of proselytization. This was interpreted by Festinger and his collaborators as an indication of how Martin and the group were coming to terms with cognitive dissonance. They sought out public support for the remaining group rather than hiding from publicity out of embarrassment or psychic distress. Festinger argued that they needed more moral

support and so sought out converts; otherwise, the group might have disintegrated.[52] They were, however, ineffective at proselytization, whether from lack of practice or because of the stress of unfolding events and disconfirmation. Perhaps the public was more skeptical post–prophecy failure than previously. Festinger's study concludes on this note: "Had they been more effective, disconfirmation might have portended the beginning, not the end."[53]

Nothing also happened on December 21, 1954, in an incident involving a song transmitted by the spacemen. Martin received a message directing her to make a tape recording—further indication that only the most advanced human technologies were appropriate for extraterrestrial communications. In an arcane version of English, the message instructed her "by your own tape shall ye play a song and dance your own time. Use the mike and put it on the altar and sit where you are and put the hand to the mike not too close and be the first to get the direct taped posy word." Martin assembled the group around the tape recorder and then for a full hour, all sat in silence "while the writing hand of Marian Keech presumably transmitted the songs of Losolo University on tape" (Losolo was the name given earlier to the spacemen's community). Reporters were then allowed in, and while they spoke to Martin, a member of the group, Bob, attempted to replay the tape. Even after cranking the volume all the way up, Nothing was heard. "When Bob is asked, 'Why do you think nothing happened?' he shrugged and said simply, 'I don't know.'" Martin also admits to hearing Nothing when the recording is played back. Pushed to explain, she replies, "Well the reason was, I'm afraid, that I was thinking while the machine was turned on to record." Blanks in the historical record, as we have already seen, can mean numerous things. At this moment, in the winter of 1954 in Chicago, thinking is what happened when Nothing happened. Festinger concludes, "And that is all we know of the rationalization of this disconfirmation."[54]

The popularity of Festinger's study made it a college reading staple for decades, despite controversies among scholars about his

findings. Only an audience familiar with his work could have appreciated Alison Lurie's wicked and learned spoof in her 1967 novel *Imaginary Friends*.

> Could any group of rural religious cranks really have driven a well-known sociologist out of his mind, and his assistant almost out of the profession? Or were they just, so to speak, the innocent flock of birds into which we flew our plane?[55]

Lurie, who later won a Pulitzer Prize for *Foreign Affairs* (1984), had a background in sociology and found in Festinger's narrative the ideal elements of a comedy about the human capacity for believing just about anything. Lurie transposed an ethereal teenager, Verena, for the middle-aged Martin, adding sexual attraction into the fictional mix. To make the story even racier, and certainly funnier, the Seekers reject all clothing made of organic materials. Instead of removing all metal from their clothes to help the spacemen locate and transport them, Lurie's Seekers remove anything that's not made of Dacron or nylon—more indicators of the trendiness of space-age technology. On the night before their destined meeting with the spacemen, the Seekers set fire to all the clothes that they were wearing except polyester (this being the 1960s, it's impressive that they had anything on that was flammable). Lurie has a keen eye for telling details, which served her well as a cultural historian of fashion in later publications. In a comic twist on the hippie values associated with 1960s spiritualism and a send-up of Martin's fascination with space-age technology, the Seekers also deprive themselves of any food that is organic, leaving the researchers with Rice Krispies and Saltines for breakfast while awaiting further word from Ro on the planet Varna.

In *Imaginary Friends* the participant-observers are not students but rather two sociology professors, one of whom is the narrator. Lurie designated this clandestine researcher as Jewish, not unlike her own father, Harry Lurie, a Jewish American sociologist. The

senior professor in the story, Tom McCann—whose name perhaps not coincidentally bears a remarkable similarity to the name of a major 1960s leather shoe company, Thom McAn—is on a quest for sociological fame. His delusions of grandeur propel him to assume a leadership role within the sect, with hilarious results. Lurie deftly parodies social scientific practices, as the narrator, who is a recently minted PhD, struggles to maintain his professional distance from the teenage seer Verena. By subtly suggesting that McCann's pursuit of the case study that will catapult him to academic glory is not unlike the Seekers' yearning for extraterrestrial revelation, Lurie's story humanizes all the participants and reminds her audience that all realms of faith and knowledge are human constructions, subject to human genius as well as human frailties.

Lurie makes the literary case for what religious studies scholar Jon R. Stone argues is the flaw in Festinger's premise. Whereas Festinger and his colleagues hypothesized that the disappointed members of apocalyptic sects would try to convert everyone around them in a last-ditch effort to save their faith, Lurie and Stone counter that man is not so much a "rational" as a "rationalizing" being.[56] When Nothing happens and you want to know what to expect next, you might well choose to continue expecting . . . Nothing to happen. In other words, you may choose to rationalize the failure (the end that didn't happen) by considering that the data were misunderstood or miscalculated (i.e., the date for the apocalypse was wrong but the apocalypse is still coming), that more data are needed (what do we need to know in order to know better whether Nothing might happen again?), or that no matter how much data we get, we may never know more, because we are not meant to know, only to be prepared. Accordingly, scholars are barking up the wrong tree when they analyze apocalyptic movements in scientific-rational categories, as religious studies scholar Stephen O'Leary argues: "The functional significance of a prediction in an apocalyptic movement cannot be scientific: prediction in these groups serves both constitutive and

normative functions."[57] Religious beliefs can be premised on apocalypticism, as is arguably the case with Christianity as well as the Jehovah's Witnesses, even though the end of the world never happens. If you're very cynical, you could argue that's the case precisely because the end of the world never happens.

But scholars also counter that cognitive dissonance, as Stone suggests, is the modern social norm and that faith provides the consonance which sustains the millenarian group. In moments of crisis—both times of trembling before the apocalypse and times of disappointment when the Redeemer does not appear—believers will turn to prophets: "One might argue that dissonance is not a consequence of failed prophecy but the occasion for prophets to utter end-time predictions and for a group's eager acceptance of it."[58] The very apprehensions that fuel millenarian movements are not extinguished when prophecies fail; rather, they are sustaining accelerants for the flames of conviction. So when Nothing happens and the world doesn't end, believers are quite likely to continue to believe that the world will end, someday, and to find cognitive sustenance in their faith. The epigraph to Lurie's novel is "Seek, and ye shall find." Read in this context, the biblical proverb references both the consequence of human behavior and an imperative: Keep looking.

Critics of Festinger's thesis usually start off by noting what he got wrong in the introduction, where he presents a short history of religious-based millenarian movements. Discussing the nineteenth-century Millerites, who provided the foundation for the modern Seventh Day Adventist church, Festinger suggests that Millerism died after its prophecies failed in 1843; he seems to be completely ignoring the rise of Adventism. In this lapse lies the crux of the critique launched by the next generation of scholarship. Jon R. Stone, Stephen O'Leary, and Richard Landes asked the same question I asked in response to *When Prophecy Fails*: What happened after Nothing happened? What is the history of post-apocalypticism? According to Landes, it is a history of

disappointment, which is not the same thing as repetitive failure. Because Nothing happens, over and over, Landes characterizes all millennial movements as premised on failure: "The inevitable dimension of all apocalyptic belief [is] the failure of those expectations."[59] But whereas most modern scholars of millennialisms would stop there and argue that the inevitable failure of the prophecies means that people must be crazy to ever believe them, Landes offers a different tack.

> The first "law" of apocalyptic dynamics states: *Wrong does not mean inconsequential.* On the contrary, the more energetically wrong, the more consequential. The history of apocalyptic millennialism is a tale of unintended consequences.[60]

Because apocalypticisms are perennial and pervasive across human history, it follows that the consequences will be substantial. Landes depicts their influence in terms that readers today will associate with social media, as a meme, but that term itself of course was earlier used differently in scientific discourse, notably by Richard Dawkins, with comparable widespread effects.

> To use the language of evolutionary epidemiology, millennialism is a *meme* programmed to spread as rapidly and pervasively as possible. Under the right—apocalyptic—conditions, that meme can spread at epidemic speeds and breach the public transcript with explosive force.[61]

Landes calls attention to what he terms the revolutionary force of apocalypticism. With a knowing wink to an earlier classic of intellectual history, Isaiah Berlin's *The Hedgehog and the Fox* (1953; "The fox knows many things, but the hedgehog knows one big thing"), Landes coins an opposition between the roosters and the owls to illustrate two types of believers. In what he terms "The Apocalyptic Curve" there is tension between

the roosters (apocalyptic prophets who crow about the new dawn) and owls (guardians of "normal time" who dismiss such warnings as foolish and dangerous). In the course of an apocalyptic moment, roles are reversed; in apocalyptic time, roosters take center stage and owls are marginalized; but after disappointment hits and the movement reenters "normal time," the owls once again take the upper hand and write and preserve most accounts of the events.[62]

In this manner, apocalypticism is "normalized," that is, integrated into social and political forms that dominate at the time. As those forms evolve and change, apocalypticism swings back and forth like a pendulum of impending doom, sometimes sounding the clarion call, sometimes silent and secretive. What looks like repetition is Nothing happening, because the world hasn't ended . . . yet.

Taking the argument a step further, Timothy Jenkins counters that Festinger's study belittles the Seekers themselves: "This sociological account ignores the creativity and intelligence of the actors and their convictions; it portrays them as people with static categories attempting to distract themselves from the disappointment of their expectations, in the main by getting others to share in their delusions."[63] Jenkins sees the sociologist-observers as interlopers, outsiders who can't understand the religious faith of the indigenous world they've penetrated and who mistake faith for irrationality, superstition, and fanaticism; in other words, nuttiness. He contends that the authors of *When Prophecy Fails* project their own inadequacies onto their subjects, attributing "the confusion they experience to the subjects of their investigation: superstition, explained by psychology, is their only way of assembling observers and group members in the same shared system of meaning."[64]

What the Seekers understand can be communicated only among the initiates, in a language of secrecy that scientific outsiders cannot penetrate. This is what Lurie also depicted in her novel's final plot twist, with Tom McCann's ultimate conversion

to millenarian group leader. The sociologist becomes entranced with the idea that the group has access to mystical knowledge— or does he? Is it all an act? By incarcerating the researcher in a mental hospital where he may or may not be still observing the Seekers, Lurie's ending leaves McCann's final conversion in abeyance. Does he or doesn't he believe? Can social science truly understand, or can social scientists only project cognitive dissonance onto the faithful, whose true but arcane knowledge remains a closely held secret?

Secrets and Nothing seem to be related in many aspects. We have seen that secrecy produces blanks in the historical record, with black ops and black sites, and results in officially knowing Nothing (Episode 1), now in terms of faith practices and the possible inability of scholars to understand them. Petrov's heroic willingness to rely on his own knowledge and make a risky decision also was kept as a state secret for years. When it appears that Nothing is happening or that Nothing has happened as expected, secrets may be being kept.

It's no secret, though, that people tend to be relieved when the world doesn't come to an end. No matter how often we think it's going to happen, it hasn't happened yet and that means we can continue to find out how Nothing happens every time it doesn't. From the perspective of a historian, it's not the end of the world if there's still something to write about.

§ NOTHING HAS CHANGED: DEMANDS FOR JUSTICE

If I say that "nothing has changed," I may be perceiving that everything is as it has always been, quite reliably just as I remember it, introducing waves of nostalgia. But I may also be registering disgust and frustration, if I didn't like the way it was to begin with and it's still like that. You won't really know which sense I mean until I explain further. This is where voice inflections lend hints about meaning, which writing can only indicate with italics. What if Nothing *has* changed? What if we see a difference between the Nothing that is

static and the Nothing that is susceptible to change? Is this a paradox or an oxymoron? What are we to make of this? How is it that we can say, "Nothing stays the same," and still also be able to say, "But Nothing has *changed*"? Both kinds of Nothing are historical objects, abandoned in place as the ruins of historical consciousness.

Nothing is a verbal chameleon, capable of taking on the coloring of surrounding context. In terms of communicating meaning, its lack of specificity can be frustrating. This is why language rules exist. Consider, for example, the use of an adverb to qualify the adjective *unique*—as my students and family know, this one drives me crazy. "Very unique" or "entirely unique" or, worse, "really unique"—these phrases are the fingernails on my mental chalkboard, a gratingly incompetent usage of standard English that people say all the time without thinking twice about it. They merely want to add emphasis—as though something, or Nothing, could be utterly distinctive and yet not. Also, there probably ought not to be any synonyms for *unique*, which refers to something incomparable; but, of course, language use is not so rigid as its rules. And that is how languages work: They are not static. They are constantly in flux, as language users develop new terms and change word meanings over time, meaning that meaning, like Nothing, has changed.

What seems clearest about either term, *Nothing* or *unique*, is its all-encompassing singularity. Nothing is Nothing else; it is unique. And yet we use the same word, *Nothing*, to say that uniqueness is impossible when we say, "There is nothing new under the sun." We are expressing the fatalistic idea that originality (and thus uniqueness) is impossible—or at least that everything that seems to be new, isn't. Nothing really comes from Nothing in this case: There is Nothing new; there will be Nothing new, as though there is no originality, only repetition. I've already argued that history doesn't repeat itself, and the Polish poet Wisława Szymborska agrees, in her poem "Nothing Twice."

Nothing can ever happen twice.
In consequence, the sorry fact is

that we arrive here improvised
and leave without the chance to practice.[65]

From the poet's perspective, it seems that Nothing is uniquely happening each time, all the time, and then we die without the benefit of ever learning from the practiced past. From a historian's perspective, Nothing *is* unique, every time it happens—even when it seems that Nothing has changed, because Nothing happened and is still happening. The historian's job is to decide how far back to go to start to tell the story of the past. A history about Nothing follows the same path: This is the story of how we begin to remember changes that started to make Nothing happen, as the Nothing that was neglected as unimportant or reliably static, was transformed into the Nothing that changed.

Another way to express that elusive historical object is through poetry. As W. H. Auden wrote, poetry "makes nothing happen." Did Auden think that Nothing ever changed thanks to poetry? Are poets doing Nothing but writing and having no impact? I suspect Auden and most poets actually do believe that writing poetry matters. But it's worth considering how poetry has been a means to challenge the status quo, to point out where injustice has occurred and Nothing has happened to those responsible, to articulate precise grievances that have long been recognized as never having been recognized. If Nothing has changed but it should have, poetry is a powerful way to express that anger, pain, and suffering—all of which have unique histories.

Midway through his poem "In Memory of W. B. Yeats" (1939), Auden's homage to Yeats considers how "Mad Ireland hurt you into poetry." Social and religious constraints, along with politics and poverty, negatively impelled the poet's creativity.

For poetry makes nothing happen: it survives
In the valley of its making where executives
Would never want to tamper, flows on south

From ranches of isolation and the busy griefs,
Raw towns that we believe and die in; it survives,
A way of happening, a mouth.[66]

Some of this must be understood in specific reference to Ireland's history, but it can also be read as speaking to the modern condition. Auden suggests that if poetry survives, it is ineffectual as a corrective; it cannot make change happen. But it can survive despite discouragement and lack of respect—"ranches of isolation and the busy griefs"—and it can survive as "a way of happening, a mouth." If the southern flow of Yeats's creative genius resists the commercial or government powers' ("executives") attempts to stem the tide or dam the waters, it reaches the river's mouth where it opens up and out, offering its liquid to quench the thirst for poetry's unique voice—another mouth to open. Auden tempts readers not to fall into mad Ireland's maw but, like Yeats, to resist the complacency, passivity, or lack of imaginative empathy that renders poetry useless. Poetry makes nothing happen in and of itself: It does not start revolutions, render justice, provide recompense. But by making Nothing happen, poetry gives voice to cries for recognition, justice, and change.

In matters of life and death around the world and throughout history, warfare and violence stand out as times where most certainly Nothing is not happening. Historians and poets alike "sing of arms and the man" (and are thereby, arguably, both part of the problem), but they can also sing the lament of man's inhumanity to man. For example, in Peru, where the Shining Path spent the 1980s brutalizing local people and conducting guerrilla warfare against the government, the Ayacucho region was particularly terrorized. The scholar Leslie Bayers highlights the poetic response of Marcial Molina Richter, whose *La palabra de los muertos o Ayacucho hora nona* (The Word of the Dead or Ayacucho in the Ninth Hour; 1991) articulates how Nothing happened in embattled Ayacucho. The epic poem, forty-one pages including both text and imagery, is segmented into three parts bracketed by the refrain "here nothing has happened." The refrain is first encountered as a statement of apparent normalcy.

Aquí
nada ha pasado
nadie ha venido
ninguno se ha ido
menos nadie ha muerto.

Here / nothing has happened / nobody has come / no
one has gone / nor has anyone died.[67]

But the insistence that all is well comes at a cost: denial of reality. The refrain must be repeated, because if they complain or mourn publicly or if they name their oppressors, the communities risk retaliation. They are not safe. They must pretend to be fine or face consequences. The poem's title suggests that the emergency continues, "in the ninth hour" (the Spanish phrase also refers to a ritual afternoon prayer, possibly evoking pleas for intercession). At the poem's end, Richter's lines become more broken and the communities' safety remains uncertain.

y nosotros
 aquí
 no sabemos
 si seguir
 diciendo:
 Aquí
 nada ha pasado
 nadie ha venido
 ninguno se ha ido menos
 nadie ha muerto.

And we / here / do not know / whether to continue
saying: / Here / nothing has happened / no one has
come / nobody has gone / nor has anyone died.[68]

The Ayacucho region was recognized in 2003 by Peru's Truth and Reconciliation Commission as having suffered the greatest trauma in a national agony. This belated acknowledgment changed nothing and could not have changed what happened. Instead, it created official memory of what might have been ignored, as though Nothing really did happen—which is also what Richter had done, by labeling as Nothing what the people were required to remember in order to prevent further terror. As Auden wrote, poetry makes Nothing happen, or, in this case, become visible.

A similar evocation of both memory and denial, as though Nothing happened, is intensely present in the poem "Incident," by former American poet laureate Natasha Tretheway. Tretheway recalls the trauma suffered by an African American family terrorized by the Ku Klux Klan: "a few men gathered, white as angels in their gowns," who burned a cross into their lawn.

> We tell the story every year—
> how we peered from the windows, shades drawn—
> though nothing really happened,
> the charred grass now green again.[69]

This is the story of how they begin to remember. Bearing witness to the crime and reporting their own victimization, the family says, "We tell the story every year." But the repeated story gains no currency; it only reiterates the realization that their witnessing matters not: "When they were done, they left quietly. No one came." Racial injustice in the American South is so painfully familiar, so family-ar to them, that they know they cannot expect either rescue at the time or recognition of the crime in its aftermath. The surviving victims know that the implied and threatened physical violence, which has made cross burning a hate crime in the United States, if enacted, would have been even worse. So, by implied comparison, Nothing really happened.

"Nothing" here means real threats and fear, burnt grass, witnessing the incident, and the vanishing of the perpetrators. They tell the

story only to themselves, within the family and their community, those other witnesses who didn't need to be there because—apart from the obvious fact that they would have been in danger—their empathy is complete and total: They already know both what it means to say that "nothing really happened" and that nothing will happen to the perpetrators. Tretheway repeats, "Nothing really happened," at the beginning and end of the poem, first to introduce the annual memory ritual and then to note the absence of justice, when "no one came" to the family's aid or to arrest the perpetrators. The recitation of the annual story opens and closes the poem.

> When they were done, the men left quietly. No one came.
> Nothing really happened.
> By morning all the flames had dimmed.
> We tell the story every year.[70]

"All the flames had dimmed" invokes what was perpetrated in front of the house, in front of their eyes, as it becomes memory. It alludes to an anger that must be subdued for safety's sake but also to the fading hope that any justice will transpire. The story will be told and retold: "Nothing really happened." And like actors with a script, they will nuance the words differently for different audiences. Nothing *really happened*, they will insist to memory, to family and community. But in the face of the nation's indifference they will wearily repeat, "Nothing really happened," expecting Nothing in return, because when it comes to racism and white supremacy in the United States and how it is experienced, there may be fewer cross burnings, but really nothing has changed.

The unchanging fact of the human body, its vulnerability, and its life span are a central concern for Wisława Szymborska (1923–2012). Szymborska, who received the Nobel Prize for Literature in 1996, was a survivor of the German occupation of Poland in World War II. She wrote poetry throughout her nation's Communist era—sometimes in sympathy with the regime and later not. Her poems

are written in plain language, reverberating with inflections of daily speech, which is also why her poem "Torture" is so painful to read. First Szymborska considers the human body's susceptibility to pain as a constant that enables the practice of torture. Each stanza opens with "Nothing has changed," reiterating the body's perpetual vulnerability as well as the ongoing practice of torture. Then she compares torture past and present.

> Nothing has changed.
> The body shudders as it shuddered
> before the founding of Rome and after,
> in the twentieth century before and after Christ.
> Tortures are just as they were, only the earth has grown smaller,
> and what happens sounds as if it's happening in the next room.[71]

Some horrific human practices do not change over time, although each rendering will be specific to its historical context and the unique identities of perpetrator and victim. Szymborska links ancient and modern experiences as though Nothing has changed, and yet she makes a crucial distinction: The victim's cries are audible, no matter where in the world the violence may be occurring. This is something that has changed. Ancient pain can be read about but not experienced directly. Szymborska makes the world her neighbor and refuses to allow distance in time or space to prevent knowledge of horror. She refuses to remain ignorant.

Insistence upon knowledge must necessarily challenge existing silences, absences, and erasures. Memory is the result and, if shared and accepted, will foster recognition of crimes committed against humanity. If agnotology has taught us that ignorance takes on many forms (see Episode 1), it has also shown how knowledge can be willfully destroyed by those who want it dead. Ordinary language can hide as well as reveal knowledge. A euphemism such as *disappeared*, used to refer to individuals who have been killed, can indicate absence while

hiding the identity and fate of the person who has been murdered, as well as who is responsible, as we shall see in the later discussion of Chile under Pinochet. Nazi perpetrators excelled at obfuscation through euphemism in the Holocaust: "the Final Solution" for mass murder; "liquidation" for removal and murder of an entire ghetto or camp's inmates; "being relocated to the East" for forcible deportation and annihilation. On historical plantation sites across the American South, slavery is erased from memory by referring to formerly enslaved people as "servants" or "the help"; likewise, use of the passive voice erases their presence ("the fan's cord would be pulled to cool the room" eradicates the person doing the pulling).[72] Ignorance can be maintained voluntarily, if the goal is to avoid thinking about things you wish you didn't have to remember or take responsibility for. The poets Molina Richter, Trethewey, and Szymborska each give voice to the memory of unique and ubiquitous violence, but the perpetrators remain at large, as though they have done Nothing.

"Is it possible," wrote the historian Yosef Yerushalmi, "that the opposite of forgetting is not memory, but justice?"[73]

There can be comfort in having a sense that Nothing changes. Permanence means reliability, stability, continuity. The literary critic Susan Stewart observed that the beauty of a still life painting is its stillness. In her 1984 book, *On Longing*, Stewart appreciated how "the message of the still life is that nothing changes; the instant described will remain as it is in the eye of the beholder."[74] Being able to recognize anything, from a familiar face to a cleared-out street after bombing, implies that some sameness persists over time. If "Nothing has changed at all," as the pop band Bastille sang in a hit song a few years ago, then while contemplating the ruins of Pompeii frozen in time, "if you close your eyes ... [it might] almost seem like you've been here before." Ruins, as we saw in Episode 2, remind us of change over time and mortality, but they can also remind us that something from the past is "still" there in the present, as though Nothing had changed except time. Even the Holocaust

victim Ida Fink could write, in a story about the first time the Nazis came to round up the Polish Jews of her village and in anticipation of the ruin that is to follow, "It was a beautiful day in May, it was just as it always was, nothing had changed."[75] Comfort, beauty, stillness—these are things we're often happy to rely on. And yet as the beauty of poetry reminds us, the stillness of silence about the crimes, tortures, and injustices of the past will haunt us as ruins of hope in the present.

An iconic 1930s tango singer, Carlos Gardel, crooned that "twenty years are nothing" to the lover who remembers a long-lost love. The beloved's face remains dear, despite the lover's whitened temples. Writing about the history and memory of the 1973 coups in Uruguay and Chile, historians collectively authored a volume called *40 Years Are Nothing*, titled in homage to Gardel, because the pain and suffering of the coup and its aftermath remain vivid four decades later.[76] "I am afraid of the encounter / with the past that returns," Gardel's song continues, "And although forgetfulness, which destroys all / has killed my old dream / I keep concealed a humble hope / that is my heart's whole fortune." Ghosts haunt the present, despite oblivion's efforts to destroy memory through forgetfulness. Their presence reminds those who prefer to forget that an accounting still awaits. Hope will outlast them—that is the stubborn hope of the women of Calama, Chile, who walked the desert for decades, searching for the remains of their loved ones, victims of the 1973 Pinochet coup. That is the hope voiced in truth and reconciliation commissions across the globe in the aftermath of apartheid and genocide. So long as Nothing has changed, hope will struggle for the light.

The women of Calama join other victims of the Pinochet regime in Chilean filmmaker Patricio Guzmán's astonishing poetic documentary *Nostalgia for the Light* (2010). The film renders a visual-verbal meditation on historical consciousness and the pain of ghostly memories through each form of Nothing I have been discussing: Nothing happened, Nothing is left, Nothing has changed. Hauntingly

beautiful, Guzmán's work is a unique synthesis of history, memory, and calls for justice.

Guzmán was himself a victim of Pinochet's September 11, 1973, coup. During the last year of the democratically elected regime, up to and including the assassination of Chilean president Salvador Allende, Guzmán and his colleagues filmed the events as they happened, at great personal risk; one of his cameramen, a friend, was killed by gunfire. Guzmán was arrested and incarcerated along with thousands of victims in the National Stadium, held there for months while others were disappeared. His footage of the coup was smuggled out of the country by his uncle, and Guzmán followed it into European exile. The finished film, *The Battle of Chile*, premiered in 1975. Decades later, the expatriate filmmaker returned to screen the film for the next generation of Chilean students. His follow-up film, *Chile: Obstinate Memory* (1998), records their shocked and pained recognition of what they had known they had not known, performing an agnotology of the children of post-Allende Chile.

Throughout *Nostalgia for the Light* Guzmán interweaves three ways of investigating the past—astronomy, archaeology, and oral history—as practitioners of those sciences and victims of the regime remember and offer personal testimony about what has happened. At the same time, he draws connections between two realms of what are often considered to be Nothing: the infinity of outer space and the vast open spaces of the Atacama Desert, which lies along the Chilean coast at high altitude and is one of the driest places on earth. Using satellite imagery to highlight the desert's aridity and telescopic images of distant galaxies, Guzmán's camera moves back and forth between images of the universe and images of the landscape, urging us to connect the Nothings.

The Atacama Desert is home to some of the world's most powerful telescopes (some of whose mirrors were crafted in the lab underneath the University of Arizona football stadium, just down the street from my house), making it an important center for astronomy.

It is also home to two other types of crucial research objects: ancient civilizations and the human and material remains of the victims of the Pinochet regime, including former concentration camps. In those camps, Guzmán learns, some victims struggled to keep their sanity by conducting amateur astronomy, crafting their own primitive star-finding guides out of mere scraps.

Guzmán interviews astronomers and former inmates of the Chacabuco concentration camp about their experiences working in the desert under wildly different and yet fundamentally related circumstances. Chacabuco, not coincidentally, was the site of a mining camp. Guzmán considers how indigenous workers were abused "when mining was like slavery" during the nineteenth century and discusses the erasure of that memory in contemporary society: "We know nothing about the nineteenth century. There is nothing left." But on the walls of the former concentration camp, now preserved on the site, a former victim is able to trace the names of his comrades inscribed on the walls like modern petroglyphs. Guzmán drives into the Atacama with an archaeologist, discovering petroglyphs made by ancient inhabitants, who used the desert's canyons as access routes to the sea. Guzmán's camera pans from the observatory to the walls of the canyons inscribed with petroglyphs, and back. "There is nothing in the desert," he muses, "and yet it is full of history."

Visually, and indeed viscerally, Guzmán draws connections between the remains of ancient cultures, the stardust to which all humans are biologically connected, and the human remains of the Pinochet atrocities. In an extraordinary sequence, an image of the lunar surface dissolves over a series of shots into a human skull. An excavation of ancient mummified remains mirrors an excavation of a mass grave hidden during Pinochet's regime. An astronomer born in exile has returned with his mother, who specializes in massage therapy for victims of trauma; the astronomer explores the skies for the sources of the Big Bang while his mother tries to help those who cannot escape memories of their persecution. Astronomers and

archaeologists join the filmmaker to search for origins and memories. What the government tried to obliterate and bury in the desert and ocean has only become fixed in the memories of surviving victims and their families. Those memories are the ghosts that haunt the desert.

Isn't it odd that most of us believe ghosts don't really exist, that they are Nothing? Can we now look at Rea Tajiri's film again and recognize the testimony of the spirits as absent presences?

Guzmán interviews a former camp inmate who was a trained architect. The architect recalls the process of memorizing his environment during his incarceration. He intended to be able to testify to the camp's existence even if the authorities continued to claim to know Nothing about it, so he walked the perimeters of prison cells and camp buildings, counting each step, to draw precisely the size and scale of the camp each night in secret. Daily he walked and mapped, then destroyed the maps before his captors could discover them. Each day he started over again. Only after his release did he create a final record. The architect paces his apartment, demonstrating his technique to Guzmán, and then walks away from the camera sadly with his wife, who is suffering from Alzheimer's and remembers Nothing, as Guzmán frames their aging backs and gray heads against the beauty of a blooming garden. The couple offers a powerful metaphor for the pathos of Chilean memory regarding the Pinochet era: Remembering and forgetting go hand in hand, side by side, within a society as intimate as a family.

And through it all, for nearly two decades, the women from Calama sought the remains of their disappeared in the Atacama Desert, digging through its endless nothingness in hopes of finding anything that would give them the knowledge they needed, the knowledge of where their loved ones' bodies were abandoned. Twenty-six men fell victim to the "caravan of death," which rounded up suspected political opponents of Pinochet and massacred them with unprovoked

brutality. Their remains were never returned to their families; instead, they were dumped in the desert. The Pinochet regime disappeared their victims in many ways, including dumping bodies out of planes over the Pacific, digging mass graves in the desert, and redigging those same graves in an effort to disperse the corpses and mulch them into fragmentary remains. They would have preferred to have Nothing left. Amnesties granted to the perpetrators in 1978 and in the name of a peaceful transition to democracy did Nothing to alleviate the outrage of the families who grieved and understood that Nothing had changed. Isabel Allende, daughter of the murdered leader, wrote that the women of Calama "do not wish for revenge. They seek justice, but they do not believe in it. They know that the guilty will never be punished. All they want is for the truth to come out."[77]

The women organized into the Association of Relatives of People Executed for Political Reasons. Former housewives and working women, they faced the dictatorship head on. Guzmán films two of the women of Calama, Vicky Saavedra and Violeta Berríos, in the desert. Elderly now, their faces lined with the sun's impact, they cannot hold back the tears and pain that have never gone away—I would say, have never disappeared, if it were not for the painful abuse of language that has made *disappeared* a noun, a word for an innocent person's lack of presence and inability to appear. *Disappeared*, as it was officially used, is a passive term, as though no one had been responsible and something somehow happened, just as saying "The fan cord was pulled" erased the active, and necessary, presence of the enslaved person who held the cord.

The surviving victims of Pinochet's regime and their families must coexist with those who served and supported the regime. In this situation, justice is unlikely. Searching for her husband, Saavedra told Guzmán, "They took him away whole. I want him back whole." Pieces would be found, but not the intact remains; and in this sense, Nothing is left of the person who was a whole soul and

body, just as Nothing has changed in regard to demands for truth. Both are incomplete.

The recovered bones, like the remains of Chacabuco, like the bodies of the former victims alive and dead, are ruins from the past, just like the petroglyphs and fossils in the desert. Inquiry into the past through these historical artifacts shows both how Nothing has changed, in terms of justice, and how Nothing is the same, as the desert environment preserves artifacts incredibly well. Photographer Paula Allen also met with the women of Calama over several years, documenting their quest in all its stages. In one of Allen's haunting photographs, the women have gathered with friends and family for the annual placement of "flowers in the desert," which happens each October, at the site of a mass grave (Figure 37). Their shadows form a kind of projected wall, eerily like those of the walls surrounding Chacabuco filmed by Guzmán. Their shadowed heads just reach the edge of the pit, where Nothing is left of the disappeared. In 1990, when Allen made this photograph, the women of Calama had been scouring the desert for seventeen years. It was not until 2011 that they would have the opportunity to appear in a public courtroom where DNA test results and images of skeletons were presented for them to identify and accept as a final, official reckoning. But for three of the families, Allen writes, "There was nothing to receive: the tiny traces of their missing relatives had dissolved during the laboratory testing. The remains had vanished, just like the men."[78] Once again, there was Nothing left but memory.

Vicky Saavedra told Allen, "I didn't believe they had killed my brother because when you don't have a body, nothing is certain."[79] He was 18 years old at the time.

What recourse do the oppressed have, when Nothing has changed and they lack any communal or state-sanctioned power to insist on remedy for crimes as enormous as genocide, slavery, human trafficking, or mass murder? History, like poetry, can make Nothing happen,

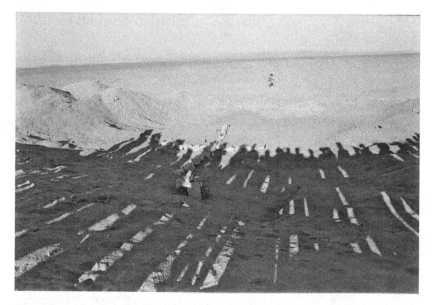

Figure 37. Paula Allen, "Relatives and friends at the mass grave, remembering the executed men. October, 1990." In Paula Allen, *Flowers in the Desert / Flores en el desierto* (Gainesville: University Press of Florida, 2013) and https://www.paulaallenphoto.com/flowers-in-the-desert-chile. Photo by Paula Allen. Reprinted by permission.

but memory has shown surprising potency as a ghostly presence. As Yerushalmi suggests, collective memories have been able to make something happen: justice, of a kind. Even though many of the perpetrators will never be held accountable in a court of law for murders they committed or sanctioned, the crimes can still be publicly addressed.

An insistence on remembering crimes committed against entire communities has led to the creation of grassroots movements that demand the right to be seen, heard, acknowledged, and addressed. In the late twentieth century, nations across the globe moved toward mediating injustice in new ways: truth and reconciliation commissions, payment of reparations, public apologies made on behalf of national governments, national memorials and museums that represent past crimes committed against minority populations. The Calama women's association in Chile was an early example of activism that

challenged an entrenched dictatorship, speaking truth to power and garnering an international audience.

The histories of the Americas are full of Nothing, by which I mean that erasure features significantly in their histories of nation formation, environment, and indigenous peoples. The utter transformation of the populations and lands of the Americas over the past millennium is remarkable. How those histories have been written, unfortunately, often reflects how Nothing has changed in terms of the power of elites to craft narratives that reflect their own power as the "natural" outcome of a civilizing process.

When those in power attempt to erase a group's voice, Nothing remains but lamentation, protest, and resolve. Victor Klemperer's diary remains a powerful testimony to the experience of Holocaust victims. He filled the initially blank book with his daily encounters with racism, anti-Semitism, and other forms of Nazi oppression. The published diary, *I Will Bear Witness: A Diary of the Nazi Years, 1933–41*, ends on New Year's Eve, 1941, with determination against all odds.

> That it was our most dreadful year, dreadful because of our own real experience, more dreadful because of the constant state of threat, most dreadful of all because of what we saw others suffering (deportation, murder), but that at the end it brought optimism—I quoted widely: *nil inultum remanebit* (nothing will remain unavenged). My *adhortatio* was: head held high for the difficult last five minutes![80]

Klemperer's diaries were rediscovered in East German archives decades after the war and published in 1995. Arguably, his desperate optimism remained unfounded. Not only did the genocide intensify in 1942, but the prosecution of the perpetrators, begun during the war, fell far short of justice for the victims. Some of the leaders took their own lives; others successfully fled abroad or hid; and many more perpetrators and enablers remained in the two new Germanies

and were integrated back into society. Debate continues about how to truly adjudicate a crime carried out by hundreds against millions transnationally, and the issue likely will never be resolved. In the aftermath of the Holocaust, other nations that experienced genocide turned to truth and reconciliation commissions in an effort to find alternative means of redress. The Nazi attempt to annihilate "racially inferior" inhabitants of the Third Reich and its conquered territories, to erase their existence and reduce them to Nothing, remains unavenged.

For a powerful counternarrative to erasure, we can look to the autobiography of Plenty Coups (1848–1932), a leader of the Mountain Crow Indian nation, and the reflections it inspired in the esteemed American historian William Cronon. Reconsidering the significance of historical narrative in light of Plenty Coups's understanding of time and place, Cronon comes to understand how memory, narrative, and Nothing intersect and challenge the unique status of history. In his 1930 autobiography, Plenty Coups had remarkably little to say about the last decades of his life, during which he represented his nation in negotiations with the American government, ran a general store, and farmed. But he remembered how a dream that came to him as a child was interpreted by tribal elders as having prophetic power. In the dream a storm devastated the land, but one tree, which housed Plenty Coups's spirit animal, remained.

On the basis of this prophecy, the Crow aligned themselves with the United States and were able to preserve their claim to some of their homelands. What remains most vivid in Plenty Coups's memory is that "when the buffalo went away, the hearts of my people fell to the ground, and they could not lift them up again. After this nothing happened."[81] The disappearance of the buffalo, a human-caused natural disaster, had devastating consequences environmentally, socially, and psychically. As Cronon notes, the history that mattered most to Plenty Coups ended with the annihilation of the buffalo herds.

> For Plenty Coups . . . subsequent life is all part of a different story.
> . . . The nothingness at the end of Plenty Coups's story suggests
> just how completely a narrative can redefine the events of the past
> and the landscapes of nature to fit the needs of its plot. After this
> nothing happened: not frontier progress, not the challenge of ad-
> aptation to an arid land, not the Dust Bowl. Just the nothingness
> that follows the end of a story.[82]

Plenty Coups lived through the end of a history. It's neither the first
nor the last time that will happen. The nothingness that ensued
became part of other histories, which no longer included buffalo,
because the buffalo were no longer there—histories written by set-
tler colonizers, who thought they brought progress to the frontier
(which was a "frontier" only to them), who brought new farming
techniques and technologies to an arid land, and who created an-
other natural disaster, the Dust Bowl. The history that mattered to
Plenty Coups had ended, but he was still there to remember it and
tell it; what happened later mattered less. The Dust Bowl, whose
causes and memories had prompted Cronon's inquiry into history
and narrative, was an event from Plenty Coups's lifetime but not
part of the history that was meaningful to him.

Cronon is concerned with both the impact of American Indian
policy and people's impact on Nature. As an environmental histo-
rian, he encourages us to not only tell "stories about Nature, but
stories about telling stories about Nature."[83] Nature is what we call
it, not its name: We named it; we created it. Nature lacks its own
voice; like historical photographs, like so many historical objects, it
requires others to speak for it if it is to be granted historical agency
at all. (What we call Nature, of course, has its own powerful ways
of doing everything, regardless of what we say about it.) What we
call Nature is perceived to be constant, present, happening. We rely
on Nothing changing in that regard, because without Nature (air,
water, earth), we could not exist. We are the ones who insist on un-
derstanding Nature, making meaning out of it, telling stories about

it or on its behalf. Plenty Coups made no such claim or distinction between the history that mattered, the history that included buffalo, and the nothingness that followed their erasure.

Cronon clearly understands the nature of historical consciousness that I have been attempting to elaborate, its relevance to the practice of history undertaken by scholars, and its relevance to collective memories. The singularity, the uniqueness of one story, does not cancel out others but must be seen, heard, and acknowledged if it is to have any bearing on justice in our understanding of the past. Communities that hold on to their own understanding of historical meaning must be recognized, as well as the environment in which it becomes natural to act as though, despite their memories, Nothing has changed. For Plenty Coups, Nothing is the way it was, and after the buffalo, Nothing happened, which became the content of another history.

THERE IS
NOTHING
LEFT TO SAY

This page intentionally left blank

IT'S TEMPTING TO LEAVE IT AT THAT. But having asserted that there *is* Nothing left to say, I feel obliged to say it: Nothing is always Something that's been left as Nothing, whether in an abandoned space or a photograph, on a historical marker, or in memory.

Someone who makes something out of Nothing can be annoying; they are making a fuss, an unsubstantiated claim on everyone's attention. Alternatively, however, someone capable of making something out of Nothing might be seen as a paragon of thrift. I'd like to reclaim the virtues of making something out of Nothing, just like the Romantic painters discussed by MOMA curator and photo historian Peter Galassi.

> It is as if the very ordinariness of the subject were a challenge to the painter's aesthetic imagination—a challenge to make something out of nothing. . . . What made a pictorial "something" out of an actual "nothing" was—literally and metaphorically—the painter's point of view.[1]

The historian's aesthetic imagination has been making something out of Nothing through three episodes—the "making" is the historian's craft, her point of view expressed through puns about ordinary matters, always seeing multiple possible meanings at any given moment.

One of my students asked me whether any Nothings became Nothing by not making it into this book. I was delighted by her perceptive question, pleased that she "got" the idea that Nothing was worth studying and that what got left out was still Nothing. I replied, yes, too many to count. I'm not going to add them here.

When Nothing comes to mind, I think about historical consciousness.

Teaching a recent course on the philosophy of history also brought back reminders that Nothing was there all along. For instance, Nothing was on the mind of the famous German critic Walter Benjamin when he wrote about the origins of photography and

what got lost in reproductions of art (on postcards and elsewhere). Like Maurice Halbwachs, Benjamin became a victim of the Holocaust. His unpublished work survived only by being given to Hannah Arendt before Benjamin attempted to slip out of France over the Spanish border, where he despaired and committed suicide. Three victims, one survivor. I was introduced to all these thinkers in graduate school in the 1980s, and now my students are reading them because I can't imagine historical consciousness without them.

In his "Theses on the Philosophy of History," formulated toward the end of his life, Benjamin argued that "nothing that has ever happened should be regarded as lost to history."[2] He wanted to think about how Marxist historical consciousness could do a better job with the past, and he was writing about the kinds of annalists and chroniclers I discussed in Episode 3, who apparently failed to discriminate between major and minor events and left no clues about how they chose to include what they included, or what they left out—just like historians do today. No matter how many citations we provide so that readers can follow up on our sources, we rarely explain why we did the project the way we did, out of all the possible formulations and narratives. The selection process is highly personal, but we tend to hide that behind the restrictions imposed by the availability and accessibility of our sources, as well as political and professional choices. Often the only way to get these clues is to read the acknowledgments in a book (mine follow here). I think Benjamin was on to something: Nothing that happened in the past must be lost to history, but historians can do a better job of explaining how we found it. Most of the past is Nothing until we notice it. That's where histories begin: with historical consciousness—noticing that the past is remembered in the present and that there's a constantly shifting line between then and now. The past may be invisible but palpable, sometimes haunting, and sometimes completely abstract and esoteric.

How far is then from now? One way to measure historical distance is to ask, Why do you care? When Nothing happened and

people were frustrated, how is that remembered? That's where the history of injustice begins. When Nothing is the way it was and only ruins remain, how is the past being remembered? That's how the history of loss begins. What if we were to understand history (defined as the narratives we tell about the past) as what we say about Nothing after it happens?

The past is already full of Nothing, but that doesn't mean it's like the photograph defined by Roland Barthes, discussed in Episode 2. He thought nothing could be added to a photograph, as it was already so replete with content and meanings. In contrast, I suggest that photographs and the past alike, already full of Nothing, *can* have Nothing added to them: We can add Nothing by designating it as a worthy historical object. The past won't overflow when we add Nothing to its fullness, because we're adding Nothing, just recognizing its typically unremarked presence. Even in the unlikely event that I should stop thinking about the past, Nothing would still happen, because when you are ready to stop or unable to keep going, you are in the present and you are done. That's when Nothing starts happening—just like after the end of the story. As Jessie, the mother of two wonderful grandchildren, reminded me: If a story has a "happy ending," then after the story ends Nothing happens. Happiness persists and you won't hear the end of it. Instead you have another version of A. E. Stallings's "curious stasis" (see Episode 1). All stories end this way: Nothing happens next and keeps on happening for every reader, forever. Even Scheherazade told a new story each night, after wrapping up the previous episode in her thousand nights of sequential tales. Sequels may imagine what happened next, but the first story is over and, in the present, you're done with it; you have stopped listening or reading. That's where collective memory steps in: Who else read the story? Who else remembers it?

Historians always have the pleasurable challenge of deciding how to start and end a narrative—not only choosing the actual first and last words but crafting a compelling argument that begins and

ends so as to frame the narrative most beautifully (another aesthetic choice). At the conclusion of Episode 3, we saw how William Cronon made a powerful assessment of Plenty Coups's historical narrative and came to the same conclusion as Jessie: He is left with "just the nothingness that follows the end of a story."[3]

Historians, like young mothers, are readers; historians, often, are or have been mothers too. Reading to learn the story, sharing the story, remembering the story, repeating the story over and over to the demanding child or to teach it to our students—this is the historian's craft writ large. Our stories are not fiction, but (even) if they are not told well, Nothing will be remembered.

THANKS
FOR NOTHING

It's a pleasure to be able to thank the colleagues, friends, and loved ones who donated Nothing to the cause over the past seven years. I appreciate your generous support and confidence in my ability to do Nothing more than I can express. I'm sorry that not all of your Nothings made it into the book, but please know that each one brought joy by offering a window onto possibilities.

To my students, thank you for your patience while my mind kept glomming onto the Nothings that emerged from our class discussions and for helping me think about the different ways that we each experience historical consciousness.

For every time she asked me how the book was going, even when Nothing was happening, a heartfelt thank you to Caroline Bach.

Gail Bernstein continues to teach me to be a better writer, as she taught generations of fortunate students, by reading with a keen editorial eye and encouraging me to do Nothing.

Fran Buss inspired me with her passion for writing about the injustices women experience; despite desperate health crises, she wrote two books to my one and urged me to do more.

Kathy Cooke talked me through all the stages of writing (doing Nothing, staring at blank pages, babbling incoherently about how Nothing was going well) and was convinced that Nothing mattered.

From rap references to museum exhibition innovations, Gabe Dale did Nothing even before he graduated.

Richard Eaton is not to be blamed for setting this whole project back three months by suggesting I look into millennialism and sharing his 1999 syllabus on the subject; thanks also for sharing *heech* in Persian writing and sculpture.

Over good coffee and great tacos, Martha Few reminded me why a colleague who understands Nothing and still wants to talk about History is invaluable; you are missed in Tucson!

Meg Jackson Fox shared so many ways in which Nothing was happening in the art world and her infectious enthusiasm for it.

I'm lucky that Kei Hirano reads food and philosophy blogs and shares Nothing whenever he sees it.

The BBC announced on April 18, 1930, that Nothing happened so there was no news and they played music instead: Molly Kalkstein found this gem and also shared blank books made by photographers.

Fabio Lanza voted early and often for doing Nothing: Thanks for sharing and translating Chinese and Italian examples, reading work in progress, and sending encouragement.

Carmen Lyon found Nothing in her favorite music and enhanced the soundtrack accompanying my work.

Vicky Spelman, professor of philosophy to other lucky Smithies, put me onto agnotology and absolutely not-boring sources on boredom.

Nanette Svenson saw that my "ado about nothing" was relevant to everyone who has ever criticized a government agency or NGO for doing . . . not enough; *there's* a history someone should write! Along with Beth O'Neall, my oldest friends served as early readers and cheerleaders; everyone should be so lucky with their third-grade buddies.

A dear friend and constant advocate, Julia A. Thomas shared Buddhist references, found Patrick McDonnell's charming *The Gift of Nothing,* and bolstered me with wonderful poetry.

Thanks to Hans Werner Bitzer and Ingrid Knoblauch, who have shared their home and been my Berlin family since 1989, for assistance with image permissions. I'm also indebted to colleagues from the University of Arizona Department of Art History: Kate Palmer Albers, now in Los Angeles, for her insights into photography and its history; and Kimberly Mast for assistance in locating and scanning images.

The staff at Stanford University Press came through with this volume despite pandemic conditions and earned my lifelong gratitude. Thanks to Emily Jane Cohen for seeing the potential of Nothing before she left the Press, Margo Irvin for picking up Nothing and running with it, Jessica Ling and Cindy Lim for making Nothing look right, and Mimi Braverman for delightful conversation woven into her careful copyediting. Two anonymous readers offered insightful peer reviews that guided me towards clarifying the book's architecture and spared me some potential embarrassments. For helping me make Nothing more clearly visible, you as readers as well as I can be grateful to them.

I'm incredibly fortunate to receive loving sustenance from my family, from my husband, who lived with bad puns for years, to the oblivious delights of our grandchildren. The supremely talented copyeditor, Elizabeth Crane, volunteered her services and fixed that which must be changed before it even got to the publisher. Since she's not a great fan of history, I respect and appreciate her skills more than sisterly affection can express. Kimberly Vance's lively, creative mind and musical talents provided constant and stimulating resources for my work. She has given me Nothing but joy. As Paul Simon sang in "Under African Skies": "Take this child, Lord / From Tucson, Arizona / Give her the wings to fly through harmony / And she won't bother you no more."

NOTES

INTRODUCTION: EPISODES IN A HISTORY OF NOTHING

1. Alessandro Portelli, "The Death of Luigi Trastulli: Memory and the Event," in Alessandro Portelli, *The Death of Luigi Trastulli and Other Stories: Form and Meaning in Oral History* (Albany: SUNY Press, 1991), 1–26.

2. Cited in Raymond D. Fogelson, "The Ethnohistory of Events and Nonevents," *Ethnohistory* 36(2) (1989): 133.

3. Francis McKee, "From Zero to Nothing in No Time," in Graham Gussin and Ele Carpenter, eds., *Nothing* (Singapore: August Media, 2001), 16.

4. See, for example, Fran Leeper Buss, *Memory, Meaning, and Resistance* (Ann Arbor: University of Michigan Press, 2018).

5. Carolyn Steedman, *Dust: The Archive and Cultural History* (New Brunswick, NJ: Rutgers University Press, 2002), 76.

6. It should be a truth universally acknowledged that Jane Austen's *Pride and Prejudice* is one of the finest novels ever written in the English language, closely followed by her *Persuasion*. *Emma* is another matter; I never liked it, but I was persuaded by a fellow Austen fan to give it a second chance, whereupon I found Nothing and knew that Jane Austen *gets it*.

EPISODE 1: STUDYING HOW NOTHING HAPPENS

1. I am not a musician, so I would like to thank mi mariachi Kimberly Vance for sharing her expertise in music performance and composition.

2. John Cage, *Silence: Lectures and Writings*, 50th Anniversary ed. (Middletown, CT: Wesleyan University Press, 2011), 109.

3. Craig Dworkin's list of performances of Cage's *4'33"* offers the following "Recommended recordings: following the world premiere recording by Aldo

Orvieto on *Da Capo* (IB Office 3, cassette, 1985), try Frank Zappa's acoustic rendition on *A Chance Operation* (Koch 7238, 1993), or Lassigue Bendthaus's electronic version on *Render* (KK Records 115, 1994); the definitive recording of *0'00"* is by Peter Pfister (hat ART CD 2-6070, 1991)." Craig Dworkin, *No Medium* (Cambridge, MA: MIT Press, 2013), 145. Dworkin also elaborates on silent compositions and recordings by numerous composers. See also Jay Winter's discussion of Cage in relation to the historical significance of silences: Jay Winter, "Thinking About Silence," in Efrat Ben-Ze'ev, Ruth Ginio, and Jay Winter, eds., *Shadows of War: A Social History of Silence in the Twentieth Century* (Cambridge, UK: Cambridge University Press, 2010), 3–31. On silence as much more than the absence of noise, see Alain Corbin's lovely short treatise: Alain Corbin, *A History of Silence: From the Renaissance to the Present Day* (Cambridge, UK: Polity, 2018).

4. *Chicago Manual of Style*, 17th ed. (Chicago: University of Chicago Press, 2017), 5.129, "Present tense."

5. A. E. Stallings, "The Historical Present: Robert Fagle's Bold Solutions to the Problem of Virgil," *The American Scholar* 76(1) (2007): 135.

6. Augusto Corrieri, *In Place of a Show: What Happens Inside Theatres When Nothing Is Happening* (London: Methuen Drama, 2016).

7. Robert N. Proctor, "Agnotology: A Missing Term to Describe the Cultural Production of Ignorance (and Its Study)," in Robert N. Proctor and Londa Schiebinger, eds., *Agnotology: The Making and Unmaking of Ignorance* (Stanford, CA: Stanford University Press, 2008), 1.

8. Proctor, "Agnotology," 11.

9. Proctor, "Agnotology," 13.

10. Jodi Rudoren, "Proudly Bearing Elders' Scars, Their Skin Says 'Never Forget,'" *New York Times*, September 30, 2012, https://www.nytimes.com/2012/10/01/world/middleeast/with-tattoos-young-israelis-bear-holocaust-scars-of-relatives.html.

11. Herman Melville, *Typee, A Peep at Polynesian Life* (New York: Wiley & Putnam, 1847), 249–51.

12. Greg Dening, "Performing on the Beaches of the Mind: An Essay," *History and Theory* 41(1) (2002): 16–17.

13. Patrick McGuinness, "A History of Doing Nothing," *Poetry* 182(4) (2003): 195.

14. Dante Alighieri, *To Hell and Back: An Anthology of Dante's Inferno in English Translation (1782–2017)*, ed. Tim Smith and Marco Sonzogni (Amsterdam: John Benjamins, 2017), 274. This translation of Canto III was created by Allen Mandelbaum.

15. See Ginger A. Hoffman, Anne Harrington, and Howard L. Fields, "Pain

and the Placebo: What We Have Learned," *Perspectives in Biology and Medicine* 48(2) (2005): 248–65.

16. My discussion of the Dallas Bed Rest study is drawn from Rick E. Lovett, "Get Up, Get Out of Bed," in Jeremy Webb, ed., *Nothing: Surprising Insights Everywhere from Zero to Oblivion* (New York: The Experiment, 2013), 192–97.

17. Lovett, "Get Up," 197.

18. Valerie Jamieson, "Boring-ology: A Happy Tedium," in Jeremy Webb, ed., *Nothing: Surprising Insights Everywhere from Zero to Oblivion* (New York: The Experiment, 2013), 182.

19. "Andy Warhol, *Empire*, 1964," https://www.moma.org/collection/works/89507.

20. A. Roger Ekirch, "Sleep We Have Lost: Pre-Industrial Slumber in the British Isles," *American Historical Review* 106(2) (2001): 343–86.

21. Marc Augé, "Non-Places," in Alan Read, ed., *Architecturally Speaking: Practices of Art, Architecture, and the Everyday* (London: Routledge, 2002), 7–12.

22. Augé, "Non-Places," 8.

23. Martin Heidegger, "What Is Metaphysics?" in D. F. Krell, ed., *Martin Heidegger: Basic Writings* (London: Routledge, 1993), 89–110. I'm not going to go into Heidegger or existentialism or Nothingness, leaving that to better-informed specialists, but I can't resist this gem. As philosophers struggled with the question "Why is there something rather than nothing?" Heidegger linked the problem to being and time, without ever thinking about this in a specifically historical manner. The philosopher Rudolf Carnap famously made fun of Heidegger's enigmatic prose, paraphrasing the same line from "What Is Metaphysics?": "Indeed: the Nothing itself—as such—was present. . . . What about this Nothing?—The Nothing itself nothings." See A. J. Ayer, ed., *Logical Positivism* (New York: Free Press, 1966), 69.

24. Rebecca Solnit, *Hope in the Dark: Untold Histories, Wild Possibilities*, 2nd ed. (Chicago: Haymarket Books, 2016), 71–72.

25. http://www.jir.com/history.html (accessed March 31, 2019).

26. See Justin Weinberg, "Tyron Goldschmidt Has Written Nothing to Deserve a Drink," *The Daily Nous*, February 22, 2016, http://dailynous.com/2016/02/22/tyron-goldschmidt-has-written-nothing-to-deserve-a-drink/.

27. Tyron Goldschmidt, ed., *The Puzzle of Existence: Why Is There Something Rather than Nothing?* (London: Taylor & Francis, 2013).

28. John R. Gillis, "Memory and Identity: The History of a Relationship," in John R. Gillis, ed., *Commemorations: The Politics of National Identity* (Princeton, NJ: Princeton University Press, 1994), 7–8.

29. Lisa Gitelman, *Paper Knowledge: Toward a Media History of Documents* (Durham, NC: Duke University Press, 2014), 21.

30. Gitelman, *Paper Knowledge*, 27.

31. Helen Rees Leahy, "Exhibiting Absences in the Museum," in Sandra Dudley, Amy Jane Barnes, Jennifer Binnie, Julia Petrov, and Jennifer Walklate, eds., *The Thing About Museums: Objects and Experience, Representation and Contestation* (London: Routledge, 2011), 250–62.

32. Leahy, "Exhibiting Absences," 256.

33. For the Stefan Brueggeman, Karin Sander, and Robert Barry art exhibits, see the exhibition catalog: Martina Weinhart and Max Hollein, eds., *Nichts/ Nothing* (Frankfurt: Schirn Kunsthalle Frankfurt, 2006).

34. "Alison Rossiter, United States 1953, Photography," Wide Walls, https:// www.widewalls.ch/artist/alison-rossiter/, quoting from embedded Getty Images video.

35. See, for example, Chet van Duzer, *Sea Monsters on Medieval and Renaissance Maps* (London: British Library, 2013).

36. Liedeke Plate, "Amnesiology: Towards the Study of Cultural Oblivion," *Memory Studies* 9(2) (2016): 145.

37. Although *Hogan's Heroes* can be cringe-worthy in its depiction of Nazis as so clueless and ineffective that one can't imagine them being a threatening force in war, much less conducting the Holocaust, that's precisely the point. Some of the actors in the show, including John Banner, who played Schultz, were Jewish refugees from Hitler's Third Reich who lost family in the Holocaust; and one, Robert Clary, was a camp survivor. They found poetic justice in ridiculing Nazis. The show "worked" for a generation that remembered the war and the Holocaust as part of their own lifetimes.

38. I thank former graduate student and now colleague Meg Jackson Fox for alerting me to the ways that Paglen photographs places where Nothing is happening.

39. Trevor Paglen, *Invisible: Covert Operations and Classified Landscapes* (New York: Aperture, 2010), 144–47.

EPISODE 2: NOTHING IS THE WAY IT WAS

1. A first draft of Episode 2, "The Fall of the Wall: Living Through Historical Change," was presented at the German Historical Institute, London, in 2013.

2. Roland Barthes, *Camera Lucida: Reflections on Photography* (New York: Hill & Wang, 1981).

3. Barthes, *Camera Lucida*, 93.

4. Eva Mahn, *Nichts ist mehr wie es war: Eva Mahn, Bilder 1982–1989* (Heidelberg: Edition Braus, 1992), 64.

5. Helga Paris, *Helga Paris: Fotografien/Photographs*, ed. Inka Schube (Berlin: Holzwarth, 2004), 162.

6. See Joel Smith, *The Life and Death of Buildings: On Photography and Time* (New Haven, CT: Yale University Press, 2011), 51.

7. Barthes, *Camera Lucida*, 107.

8. Susan Sontag, *Regarding the Pain of Others* (New York: Farrar, Straus & Giroux, 2003), 89.

9. Paul Betts, *Within Walls: Private Life in the German Democratic Republic* (Oxford, UK: Oxford University Press, 2013).

10. W. G. Sebald, *On the Natural History of Destruction*, trans. Anthea Bell (New York: Random House, 2003), 5.

11. Raphael Samuel, *Theatres of Memory: Past and Present in Contemporary Culture* (London: Verso, 1994).

12. Barthes, *Camera Lucida*, 89.

13. Rupert Ashmore, "'Suddenly There Was Nothing': Foot and Mouth, Communal Trauma, and Landscape Photography," *Photographies* 6(2) (2013): 300.

14. Rose Macaulay, *The Pleasure of Ruins* (London: Weidenfeld & Nicolson, 1953), 1.

15. On the term *Ruinenlust*, see Brian Dillon, *Ruins* (Cambridge, MA: MIT Press, 2011), 5; and Dora Apel, *Beautiful Terrible Ruins: Detroit and the Anxiety of Decline* (New Brunswick, NJ: Rutgers University Press, 2015). I surveyed a couple dozen German print dictionaries and online dictionary databases—historical, etymological, and colloquial, from the eighteenth century to the *Grimmische Woerterbuch* to the present—and could not find the word *Ruinenlust*. A search of Google Books produced one early nineteenth-century usage in an obscure pamphlet, *Bürgerzeitung oder freimüthiges Gemeinde-Blatt* (1823). Although Macaulay appears to have found inspiration for her book's title in Henry James's writing on Italy c. 1909, no one seems to know the origins of the term *Ruinenlust*.

16. Macaulay, *Pleasure of Ruins*, 23.

17. Macaulay, *Pleasure of Ruins*, 23.

18. Sarah Lefanu, *Rose Macaulay: A Biography* (Bristol, UK: SilverWood Books, 2013).

19. Lara Feigel, *The Love-Charm of Bombs: Restless Lives in the Second World War* (New York: Bloomsbury, 2013), 448.

20. Lefanu, *Rose Macaulay*, 231; Feigel, *Love-Charm of Bombs*, 151.

21. Feigel, *Love-Charm of Bombs*, 153.

22. Feigel, *Love-Charm of Bombs*, 151.

23. Feigel, *Love-Charm of Bombs*, 156.

24. Primo Levi, *Survival in Auschwitz*, trans. Giulio Einaudi (New York: Simon & Schuster, 1996), 11.

25. Lefanu, *Rose Macaulay*, 227.

26. Lefanu, *Rose Macaulay*, 230.

27. Rose Macaulay, "In the Ruins," *The Spectator* (November 18, 1949), 660.

28. Macaulay, "In the Ruins," 660.

29. Macaulay, "In the Ruins," 661.

30. According to Leo Mellor, Macaulay derived her heroine's name from Shakespeare's Othello. "Desdemona: My mother had a maid called Barbary. / She was in love, and he she loved proved mad / And did forsake her. She had a song of willow / An old thing twas, but it expressed her fortune / And she died singing it." Leo Mellor, *Reading the Ruins: Modernism, Bombsites, and British Culture* (Cambridge, UK: Cambridge University Press, 2011), 194.

31. Rose Macaulay, *The World My Wilderness* (London: Collins, 1950), 162.

32. Macaulay, *The World My Wilderness*, 162.

33. Macaulay, *The World My Wilderness*, 187.

34. Macaulay, *The World My Wilderness*, 74.

35. "A Guide to Warfare on Postcards," Metro Postcard, http://www.metropostcard.com/warintro.html.

36. "Themes of World War One: Destruction and Devastation," Metro Postcard, http://www.metropostcard.com/war7d-destruction.html.

37. Hannah Arendt, "The Aftermath of Nazi Rule," *Commentary* 10 (1950): 342.

38. Arendt, "Aftermath of Nazi Rule," 343.

39. Arendt, "Aftermath of Nazi Rule," 344.

40. Sebald, *Natural History of Destruction*, 1.

41. Sebald, *Natural History of Destruction*, 28.

42. Helmut Puff, *Miniature Monuments: Modeling German History* (Berlin: De Gruyter, 2014), 73.

43. See Apel, *Beautiful, Terrible Ruins*.

44. J. Dennis Thomas, *Urban and Rural Decay: How to Capture the Beauty in the Blight* (Burlington, MA: Focal Press, 2014), 19.

45. For a more detailed discussion of UrbEx photography guidebooks, see my chapter in Siobhan Lyons's volume, part of which is reprinted here by permission: Susan A. Crane, "'Take Nothing But Photos, Leave Nothing But Footprints': How-to Guides for Ruin Photography," in Siobhan Lyons, ed., *Ruin Porn and the Obsession with Decay* (London: Palgrave Macmillan, 2018), 83–102.

46. Thomas, *Urban and Rural Decay*; Todd Sipes, *Urban Exploration Photography: A Guide to Creating and Editing Images of Abandoned Places* (Berkeley, CA: Peachpit Press, 2015).

47. Thomas, *Urban and Rural Decay*, 3–11.

48. Bradley Garrett, *Explore Everything: Place-Hacking the City* (New York: Verso, 2013), xiv.

49. Garrett, *Explore Everything*, 20.

50. Sipes, *Urban Exploration Photography*, "Conclusion," n.p.

51. Martin ten Bouwhuijs, *The World of Urban Decay* (Atglen, PA: Schiffer, 2013), n.p.

52. Kate Brown, *Dispatches from Dystopia: Histories of Places Not Yet Forgotten* (Chicago: University of Chicago Press, 2015), 43.

53. Brown, *Dispatches from Dystopia*, 40–41.

54. Garrett, *Explore Everything*, 23.

55. Sipes, *Urban Exploration Photography*, n.p.

56. Sipes, *Urban Exploration Photography*, n.p.

57. Thomas, *Urban and Rural Decay*, 154.

58. Sipes, *Urban Exploration Photography*, n.p.

59. Sylvain Margaine, *Forbidden Places: Exploring Our Abandoned Heritage* (Paris: Jonglez, 2012), 60.

EPISODE 3: NOTHING HAPPENED

1. My understanding of Halbwachs's distinction between historical memory and collective memory relies on my reading of the Ditters' translation of his work rather than Lewis Coser's translation, which has become the standard in the booming field of memory studies. See Maurice Halbwachs, "Historical Memory and Collective Memory," in Maurice Halbwachs, *The Collective Memory*, trans. Francis J. Ditter Jr. and Vida Yazdi Ditter (New York: Harper & Row, 1980), 50–87. This chapter unfortunately does not appear in the translation that is typically referenced in scholarly literature: Maurice Halbwachs, *On Collective Memory*, ed. and trans. Lewis Coser (Chicago: University of Chicago Press, 1992).

2. Halbwachs, "Historical Memory," 85.

3. Ezra Pound, *The Cantos of Ezra Pound* (New York: New Directions, 1998), ll. 1674–76.

4. Reinhard Koselleck, *The Practice of Conceptual History: Timing History, Spacing Concepts*, trans. Todd Samuel Presner et al. (Stanford, CA: Stanford University Press, 2002), 119.

5. Thanks go to my dad, who brought this treat home from school along with a film projector to share with his kids in the early 1970s. I've never forgotten it.

6. Hayden White, *The Content of the Form: Narrative Discourse and Historical Representation* (Baltimore: Johns Hopkins University Press, 1987). White was a towering figure in my graduate education, a scholar whose work in intellectual history was powerfully influenced by literary theory in ways that the Western historical profession only reluctantly embraced, if at all. He passed away in the

spring of 2018, as I was revising this text. Though I never met him, I can't imagine how I would have conceived of this book without having read his scholarship. Thanks to the generous assistance of Georg Iggers, a senior scholar of German historiography whom I happened to meet in a Brentwood, California, café while I was writing my dissertation, I published a freshman appreciation of Hayden White: Susan A. Crane, "*Metahistory* Received," *Storia Della Storiografia* 25 (1994): 51–63. Collectives of historians deserve to be remembered, as does serendipity.

7. White, *Content of the Form*, 6–7.

8. Stephen Jay Gould, *Questioning the Millennium: A Rationalist's Guide to a Precisely Arbitrary Countdown* (New York: Harmony Books, 1999), 142–44.

9. Elizabeth Stevenson, *Babbitts and Bohemians: The American 1920s* (New York: Macmillan, 1967), 153.

10. Stevenson, *Babbitts and Bohemians*, 166.

11. Stevenson, *Babbitts and Bohemians*, 171.

12. I thank Matt Matsuda for alerting me to this historical non-event. See his comments in the collective review (in English): Matt K. Matsuda, "L'histoire à parts égales: récits d'une rencontre Orient-Occident, XVIe–XVIIe siècle, de Romain Bertrand (Paris, Le Seuil, 2011)," *Monde(s)* 1(3) (2013): 147–69, https://www.cairn.info/revue-mondes1-2013-1-page-147.htm#, par. 5.

13. Paul Gilroy, *Between Camps: Nations, Cultures and the Allure of Race* (London: Routledge, 2004), 167.

14. Gilroy, *Between Camps*, 169.

15. Kristin Ross, *May '68 and Its Afterlives* (Chicago: University of Chicago Press, 2014), 19.

16. Ross, *May '68*, 20–21.

17. Ross, *May '68*, 22.

18. https://www.hmdb.org/.

19. Maureen Monahan, "11 Offbeat Commemorative Plaques," *Mental Floss*, July 11, 2013, http://mentalfloss.com/article/51605/11-offbeat-commemorative-plaques.

20. Flickr, https://www.flickr.com/photos/tags/onthissitein1897nothinghappened.

21. Michael Kammen, *Mystic Chords of Memory: The Transformation of Tradition in American Culture* (New York: Vintage, 1993), 687.

22. James W. Loewen, *Lies Across America: What American Historic Sites Get Wrong* (New York: New Press, 1999), 455.

23. Loewen, *Lies Across America*, 411.

24. Joan Nathan, *An American Folklife Cookbook* (New York: Schocken, 1984), 113.

25. Loewen, *Lies Across America*, 195.

26. Loewen, *Lies Across America*, 211.

27. Jessica Seigel, "Unhistory: A Suspiciously Long Prepositional Phrase

Wasn't the . . . ," *Chicago Tribune*, November 11, 1990, http://articles.chicagotribune
.com/1990-11-11/news/9004030323_1_plaque-parking-ticket-campus.

28. Pam Grout, *Kansas Curiosities: Quirky Characters, Roadside Oddities, and
Other Offbeat Stuff* (Guilford, CT: Globe Pequot, 2010), 233.

29. Amelia Shea, *Impatiently Patient* (Indianapolis: Liquid Silver Books,
2016), n.p.

30. My thanks to my China history colleague Fabio Lanza for sharing this image.

31. Louisa Lim, *The People's Republic of Amnesia: Tiananmen Revisited* (Oxford,
UK: Oxford University Press, 2014). See the review and interview on Vox: Max
Fisher, "25 Years After Tiananmen, Most Chinese University Students Have Never
Heard of It," *Vox*, June 3, 2014, https://www.vox.com/2014/6/3/5775918/25–years
-after-tiananmen-most-chinese-university-students-have-never. As a participant-
witness, Philip J. Cunningham also recorded how Nothing happened repeatedly,
until something very major (the tanks) did. See Philip J. Cunningham, *Tiananmen
Moon: Inside the Chinese Student Uprising of 1989* (Lanham, MD: Rowman &
Littlefield, 2014), 245–68.

32. "Jackson Drugs," Historical Marker Database, https://www.hmdb.org/
marker.asp?marker=52498.

33. "Kawakami Building," Historical Marker Database, https://www.hmdb
.org/Marker.asp?Marker=52550.

34. Marita Sturken, "The Absent Images of Memory: Remembering and
Reenacting the Japanese Internment," in T. Fujitani, G. White, and L. Yoneyama,
eds., *Perilous Memories: The Asia-Pacific Wars* (Durham, NC: Duke University
Press, 2001), 47.

35. This excerpt also appears in Sturken, "Absent Images," 38; and in David
William Cohen, *The Combing of History* (Chicago: University of Chicago Press,
1994), 145. I first saw Tajiri's film at a conference on experimental history writing,
organized by Robert Rosenstone at Cal Tech in 1992, and have been screening it
for students ever since. Its experimental format, interweaving multiple video, text,
and audio tracks, can make for challenging viewing but remains highly rewarding.

36. Loewen, *Lies Across America*, 15.

37. Equal Justice Initiative, *Lynching in America: Confronting the Legacy of
Racial Terror*, 3rd ed. (Montgomery, AL: Equal Justice Initiative, 2017), https://
eji.org/reports/lynching-in-america/.

38. "Timeline of the Hawaii False Missile Alert Shows How Drill Went
Wrong," CNN, January 30, 2018, https://www.cnn.com/2018/01/30/us/hawaii
-false-missile-alert-timeline/index.html.

39. David E. Hoffman, *The Dead Hand: The Untold Story of the Cold War Arms
Race and Its Dangerous Legacy* (New York: Doubleday, 2009), 11.

40. Hoffman, *The Dead Hand*, 10.

41. Frank Kermode, *The Sense of an Ending: Studies in the Theory of Fiction* (Oxford, UK: Oxford University Press, 1969), 25. See also Eugen Weber, *Apocalypses: Prophecies, Cults, and Millennial Beliefs Through the Ages* (Cambridge, MA: Harvard University Press, 1999).

42. Gould, *Questioning the Millennium*, 62.

43. Richard Landes, *Heaven on Earth: The Varieties of the Millennial Experience* (Oxford, UK: Oxford University Press, 2011), 3.

44. I say "neutral" guardedly, with reference to calendrics. Popkin points out that the Protestant authors had an anti-Catholic agenda and that each century contained a list of Catholic Church corruption and misdeeds. Jeremy Popkin, *From Herodutus to H-Net: The Story of Historiography* (Oxford, UK: Oxford University Press, 2015), 53.

45. See Leon Festinger, Henry Riecken, and Stanley Schachter, *When Prophecy Fails: A Social and Psychological Study of a Modern Group That Predicted the Destruction of the World* (Minneapolis: University of Minnesota Press, 1956).

46. See Vaughan Bell, "Prophecy Fail: What Happens to a Doomsday Cult When the World Doesn't End?" *Slate*, May 20, 2011, https://slate.com/technology/2011/05/apocalypse-2011-what-happens-to-a-doomsday-cult-when-the-world-doesn-t-end.html; Julie Beck, "The Christmas the Aliens Didn't Come," *The Atlantic* (December 18, 2015); and Whet Moser, "Apocalypse Oak Park," *Chicago Magazine* (May 20, 2011).

47. Jon R. Stone, "Prophecy and Dissonance: A Reassessment of Research Testing the Festinger Theory," *Nova Religio: The Journal of Alternative and Emergent Religions* 12(4) (2009): 72–90; Stephen D. O'Leary, "When Apocalyptic Prophecy Fails and When It Succeeds: Prediction and the Re-Entry into Ordinary Time," in Albert Baumgarten, ed., *Apocalyptic Time* (Leiden: Brill, 2000), 341–62.

48. Stone, "Prophecy and Dissonance," 84.

49. Timothy Jenkins, *Of Flying Saucers and Social Scientists: A Re-Reading of When Prophecy Fails and of Cognitive Dissonance* (New York: Palgrave Macmillan, 2013).

50. Festinger et al., *When Prophecy Fails*, 39–41.

51. Festinger et al., *When Prophecy Fails*, 187–88.

52. Festinger et al., *When Prophecy Fails*, 211.

53. Festinger et al., *When Prophecy Fails*, 233.

54. Festinger et al., *When Prophecy Fails*, 184–85.

55. Alison Lurie, *Imaginary Friends* (New York: Coward-McCann, 1967), 1.

56. Stone, "Prophecy and Dissonance," 73.

57. O'Leary, "When Apocalyptic Prophecy Fails," 342.

58. Stone, "Prophecy and Dissonance," 82.

59. Landes, *Heaven on Earth*, 35.

60. Landes, *Heaven on Earth*, 14.

61. Landes, *Heaven on Earth*, 9

62. Landes, *Heaven on Earth*, Chapter 2 abstract, https://www.oxfordscholarship .com/view/10.1093/acprof:oso/9780199753598.001.0001/acprof-9780199753598 -chapter-2.

63. Jenkins, *Of Flying Saucers*, 88.

64. Jenkins, *Of Flying Saucers*, 88.

65. Wisława Szymborska, *Poems New and Collected: 1957–1997* (Brighton, UK: Roundhouse, 1998), 20.

66. W. H. Auden, "In Memory of W. B. Yeats," in W. H. Auden, *Collected Poems*, ed. Edward Mendelson (New York: Modern Library, 2007), 245.

67. Leslie Bayers, "Words of the Dead: Ruins, Resistance, and Reconstruction in Ayacucho," in Michael J. Lazzara and Vicky Unruh, eds., *Telling Ruins in Latin America* (New York: Palgrave Macmillan, 2009), 147.

68. Bayers, "Words of the Dead," 158.

69. Natasha Tretheway, "Incident," in Natasha Tretheway, *Native Guard: Poems* (New York: Houghton Mifflin, 2006), 41.

70. Tretheway, "Incident," 41.

71. Wisława Szymborska, *Miracle Fair: Selected Poems of Wisława Szymborska*, trans. Joanna Trezciak (New York: Norton, 2001), 46.

72. See Jennifer L. Eichstedt and Stephen Small, "Symbolic Annihilation and the Erasure of Slavery," in Jennifer L. Eichstedt and Stephen Small, *Representations of Slavery: Race and Ideology in Southern Plantation Museums* (Washington, DC: Smithsonian Books, 2002), 105–46.

73. Yosef Yerushalmi, *Zakhor: Jewish History and Jewish Memory* (Seattle: University of Washington Press, 1998), 117.

74. Susan Stewart, *On Longing: Narratives of the Miniature, the Gigantic, the Souvenir, the Collection* (Baltimore: Johns Hopkins University Press, 1984), 29.

75. Ida Fink, "A Scrap of Time," in Carol Rittner and John K. Roth, eds., *Different Voices: Women and the Holocaust* (St. Paul, MN: Paragon House, 1993), 42.

76. Pablo Leighton and Fernando Lopez, eds., *40 Years Are Nothing: History and Memory of the 1973 Coups d'Etat in Uruguay and Chile* (Newcastle upon Tyne, UK: Cambridge Scholars, 2015).

77. Paula Allen, *Flowers in the Desert: The Search For Chile's Disappeared* (Gainesville: University Press of Florida, 2013), viii.

78. Allen, *Flowers in the Desert*, xxvi.

79. Allen, *Flowers in the Desert*, 14.

80. Victor Klemperer, *I Will Bear Witness: A Diary of the Nazi Years, 1933–41*,

trans. Martin Chalmers (New York: Random House, 1998), 456.

81. Cited in William Cronon, "A Place for Stories: Nation, History, and Narrative," *Journal of American History* 78(4) (1992): 1366.

82. Cronon, "A Place for Stories," 1366–67.

83. Cronon, "A Place for Stories," 1375.

CONCLUSION: THERE IS NOTHING LEFT TO SAY

1. Peter Galassi, *Before Photography: Painting and the Invention of Photography* (New York: Museum of Modern Art, 1981), 27.

2. Walter Benjamin, "Theses on the Philosophy of History," in Walter Benjamin, *Illuminations: Essays and Reflections*, ed. Hannah Arendt (New York: Schocken, 1969), 254.

3. William Cronon, "A Place for Stories: Nation, History, and Narrative," *Journal of American History* 78(4) (1992): 1367.

INDEX

Page numbers in italics indicate illustrations.

Printed in the USA
CPSIA information can be obtained
at www.ICGtesting.com
JSHW022247190124
55570JS00002B/2

9 781503 640115